Retouching Your Photographs

Jan Way Miller

Photography by Scott Smith

AMPHOTO

An imprint of Watson-Guptill Publications, New York

Many thanks are due to others who have contributed information and labor to this project.

My photographer, Scott Smith and his wife, Becky, have not only provided excellent work but have also proven themselves to be very special people with their patience and understanding throughout this project.

Carol Holland, an excellent negative retoucher and personal friend, not only aided me in professional guidance through the writing of chapter four, but also contributed by doing the negative retouching shown in this chapter.

McDonald Photo Products, Inc., Eastman Kodak Co., Lacquer-Mat Inc., and Badger Airbrush Co. have all contributed literature and/or illustrations that have been utilized in pertinent areas. Their help is very much appreciated.

Many people have posed or provided subject matter portrayed throughout this book. Rick Eilers, Lyman Hollis, Mona Crawford, Margaret Chalker, Miriam Sloan, Ann Lee, Shelly Stephenson, Cindy Hembree, Larue Ramsey, and Jerri Gardener should also know that I am very grateful for these special contributions. They are an integral part of the book.

I also wish to express appreciation to Marisa Bulzone, Senior Editor of Amphoto, who was willing to take a chance despite my unproven abilities. Her professional guidance and enthusiasm has been invaluable. Betty Vera has also done a beautiful job of organizing, arranging, and editing my work into a sensible and attractive form.

I feel that I should thank my customers who have been very understanding when book work delayed some of their work. I should also like to thank my previous employer, Raun Stoltz, and previous co-workers from whom I have gained much knowledge and received encouragement during my own learning experiences.

And last, but not least, I would like to thank my family, who have not only been especially supportive, but have run errands, posed for pictures, typed, and relieved me of household duties. Most of all, I want to thank my husband who tells me that I can make my dreams come true.

First published 1986 in New York by AMPHOTO,
an imprint of Watson-Guptill Publications,
a division of Billboard Publications, Inc.,
1515 Broadway, New York, NY 10036

Library of Congress Cataloging in Publication Data

Miller, Jan Way.
 Retouching your photographs.

 Includes index.
 1. Photography—Retouching. I. Title.
TR310.M55 1986 770'.28'4 86-17473
ISBN 0-8174-3831-9
ISBN 0-8174-3832-7 (pbk.)

Manufactured in Japan

2 3 4 5 6 7 8 9 / 91 90 89 88 87

Editorial Concept by Marisa Bulzone
Edited by Betty Vera
Graphic Production by Hector Campbell

Contents

Introduction

Welcome to the world of photographic art correction. You are about to begin an adventure in creativity. You may open this book as a beginner, eager to learn a fascinating hobby, or as an experienced artist or photographer determined to master the techniques necessary for total photographic control. Whatever your reason, I believe you will find what you are looking for: not only basic techniques, but also some advanced methods to help you perfect your skills.

Photographic art correction, or retouching, is the application of dyes and other art materials directly to a negative or photograph to eliminate flaws and mistakes that are not within the photographer's control.

Every day, we are constantly bombarded with examples of photographic perfection: television, magazines, and billboards show us gorgeous models with flawless complexions that exude beauty and "class." But when the model is not so perfect, and the photographer not so experienced, the results cannot be the same. Often, our expectations are not realistic, for the camera only has the ability to document what is put before it. Much to the dismay of both the photographer and the customer, it picks up every flaw and wrinkle that is there.

Of course, there are many tricks of the trade that a good photographer can use to fool Mother Nature. Lighting and camera techniques can work wonders, and darkroom techniques also can make a drastic difference. It is best to try to obtain good photographs without doing any retouching, but often this is asking the impossible. Art corrections, when properly done, can give the finished product a professional touch—and very possibly can make the difference between the success or failure of a photograph.

If you are a photographer striving to succeed in the professional world, you should consider art corrections an absolute necessity. The competition in photography today is tremendous, and it seems there is a photographer on every corner. Your best chance to compete lies in your ability to offer a quality product.

If you are an artist interested in retouching as a career opportunity, you will find several avenues open to you. Custom labs are always looking for qualified artists. Photography studios often keep an artist on staff, and these jobs offer a perfect opportunity for the inexperienced retoucher to get valuable hands-on working experience.

Freelancing is a viable alternative to the nine-to-five job, especially if you want to work only part time. As a freelance artist, you can work at home and choose your own hours. An artist who can handle all phases of photographic art correction will find no shortage of customers. Custom labs, photography studios, freelance photographers, advertising agencies, and the general public all can offer freelance retouchers a steady stream of customers. As a retoucher, you also can count on being able to develop a regular clientele of repeat customers who provide a steady flow of work.

Restoration also offers opportunities for photographic artists. Many people today own fragile old photographs that have not withstood the test of time. Restoring fading and crumbling photographs is a booming business today, and artists with the skills to do this are in great demand.

Hobbyists will find photographic art corrections to be an excellent creative outlet. If you photograph for fun, you may not be able to afford the services of a retouch artist—or you may simply prefer to learn the basic retouching techniques yourself.

Amateur photographers will find that these techniques aren't difficult to master, in most cases, and that a few touches here and there will make a dramatic difference in the quality of their work.

How It All Began

Photographers have used retouching techniques as a major tool since the invention of the first camera. Early photographers had no choice but to resort to artwork in an attempt to compensate for the flaws in their primitive equipment. Despite the problems they faced, these pioneer photographers created many masterpieces. Their knowledge and understanding of lighting far surpassed that of many photographers working today. They used art corrections to their greatest advantage, hiring the talented artists of their day to do the retouching. Often, such an artist invested more time and effort in perfecting the print than did the photographer.

It was in the early days of photography that negative retouching first came into existence. The negatives were often 8 × 10 or larger, and photographers could only print positives the same size as the negative. It was not difficult to make corrections on negatives of this size. By holding the negative up to a window and allowing the light to shine through, the retoucher could see the image well enough to darken lighter areas with graphite and to etch out darker areas, creating a flawless complexion in the portrait's subject. Many of these retouchers, perhaps, went overboard in their corrections. In many early portraits, faces tended to have an artificial, "masked" look, and often the texture of the skin had a "wormy" appearance due to heavy retouching.

With the invention of the enlarger and the smaller negative came the need to make corrections directly on the enlarged print. Dyes were used to fill in areas that were too light. This process became known as spotting because it was generally used for correcting small spots created by dust on the negative. Charcoals and pastels were often used to enhance soft, unclear facial features. Such retouched prints were a cross between drawings and photographs, and sometimes it was very difficult to tell which they actually were.

Before the development of color photography, retouch artists often colored prints by hand. Oil paints and pastels were applied to the surface of the photograph in an attempt to make it more realistic. The result was some of the most beautiful work ever. Many of these photographs were true art.

The abrupt transition to direct color photography was a drastic change indeed. Photographic artists suddenly found themselves with a new product they did not know how to work with. Negative retouching was very different on color film, as were all the other correction techniques known at that time. Retouch artists had to begin the slow process of learning their trade all over again.

Because of the more sophisticated technology, the heavy retouched look was gone, and in its place was the realism that had been the photographer's goal for many years. Many photographers discontinued making major art corrections in favor of a more natural look. As a result, some very talented artists found themselves out of work; others struggled to survive the changing times. Gradually, artists learned to use dyes to retouch color negatives smoothly. Special dyes were designed to blend with the colored print emulsion, and wax-based pencils were used for reducing density on color prints. Kodak developed an excellent product known as dry dyes for making large-scale color corrections.

The State of the Art Today

Once again, retouch artists have found a place in the field of photography. The development of color retouching techniques has been a slow process, but during the last few decades, these artists have begun to explore the full potential of their craft.

Whereas the idea at one time was to keep portraits as realistic as possible, many photographers today believe that "natural" does not always mean "best." People tend to view themselves through rose-colored glasses, looking past their flaws and imperfections to focus on their more pleasing aspects. Every portrait photographer has heard statements such as "I didn't realize my wrinkles were that bad." Although it is imperative that portraits avoid looking unnatural, anything that will make a customer look better is definitely to the photographer's advantage. Properly done, artwork will make a portrait look more professional. It can make the difference between a fair photograph and an excellent one.

Art corrections are invaluable not only in portraiture but also in commercial and other types of photography as well. Most quality product shots have had the help of an artist. Products are enhanced by strengthening lines and eliminating glare or reflections. Airbrushing is often used to exaggerate and enhance a product's features. In scenic work it is often the only way to remove distracting eyesores such as highline wires and trash, not to mention the human tendency to make errors.

Great strides are being taken to ensure photographers the highest-quality custom artwork available. Many color labs have large art departments with fully trained staffs. Smaller labs often work closely with freelance artists in order to offer the same quality of service to their customers.

Photographic art correction is definitely the wave of the future. When retouching is used in conjunction with sophisticated photographic techniques, the photographer is sure to come out on top. And one hand washes the other, for working with photographers also gives retouch artists a chance to succeed.

How to Use This Book

This book is divided into three parts. Part One is a preparatory section whose purpose is to lay the groundwork for the techniques discussed in Parts Two and Three. It is important that you not skip this section, even if you feel you already know this material; you should read through it to be certain that you don't miss any pertinent information.

Part Two deals with the basic retouching mediums individually. Throughout this portion of the book, one photograph is carried, step by step, through the complete process of art correction, and the completely retouched photograph is shown at the end of the section. Sometimes different mediums can be used to make the same type of correction, and the medium you choose is a matter of which works best for you. In this section, with only two exceptions, you can change the order of progression and skip around as you please.

The last part of the book explains advanced techniques for the artist who is experienced in the mediums discussed in Part Two and is ready to deal with more difficult corrections. Part Three covers the basics of airbrushing, opaquing, and restorations, and it wraps up with a chapter on adding color to black-and-white prints.

Some artists and photographers who read this book will disagree with certain points I have made. That is to be expected. I can only write what I know and understand to be true. I'm sure there are artists who know methods faster and better than my own. I am simply offering to share my own knowledge and experiences with you.

Part One

Getting Started

Some photographers and professional retouch artists may find much of the material in this part of the book a repetition of lessons already learned. However, even if you are an experienced photographer, you can benefit from a review of it to help put your knowledge in perspective—and you also will probably find some interesting new tidbits of information.

If you are an artist trying the photographic medium for the first time, this section is essential. It will help you begin to learn to think in photographic terms, and to look at pictures the way a photographer does.

Although this part of the book is a preparatory one, it is important not to skip it. That would be like putting the cart before the horse, and you probably would find yourself backtracking later on.

Chapter One

Identifying Your Objectives

Every serious photographer should know about art corrections, even if you don't wish to master the techniques personally. And it is also important for the artist to approach retouching from the photographer's point of view. The purpose of this chapter is to help you understand what is and is not within the photographer's control, when and why a picture needs correction, and how to deal with some of the drawbacks of doing artwork on prints.

Avoiding Unnecessary Corrections

Although the primary objective of every photographer is a beautiful, professional-looking photograph, you should do your best to avoid the need for retouching.

Art corrections can become a crutch, especially for less experienced photographers, who may tend to repeat mistakes that can be corrected easily on the print. A common example of this is the glares of light on eyeglasses or other reflective surfaces. More than one photographer has been guilty of ignoring this problem because he or she knows the artist can correct it. This is not an admirable attitude. It is best to strive for a perfect negative with every shot. Only when you have made every effort and flaws still shine through should you turn to the artist for help.

There are many ways a photographer can avoid the need for art corrections by using special care in the camera room. It is well worth the extra time and trouble to proceed slowly and make sure everything is right before the shutter clicks. It is much easier to adjust a wrinkle or button a coat at this point than to make art corrections later. Stray hairs are a common problem, but keeping a can of hair spray on hand in the por-

The photographer can avoid retouching problems by rearranging and removing clutter before snapping the shutter.

9

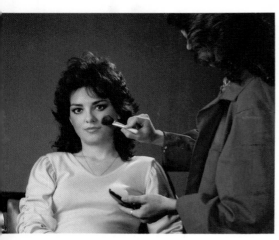

Appropriate makeup can greatly reduce or even eliminate the need to enhance the print with artwork.

trait studio is a simple remedy which will save the retouch artist hours of tedious and difficult corrections. Glare on eyeglasses can often be avoided by tilting the sitter's head slightly or readjusting the light. Some types of eyeglass frames allow the lenses to pop out easily, totally alleviating this problem. Some photographers keep on hand a variety of empty frame styles.

When you are shooting on location, keep a watchful eye for distracting objects. A piece of trash can be picked up and removed more easily on the spot than it can be retouched later. (Obviously, a lot of trash in a scene may not be worth the effort.) Telephone posts and highline wires can often be eliminated by changing the camera's position, although this is not always possible; removing them from prints is a common art correction. Cars often can be moved out of the way if their owners can be located. It is surprising how accommodating car owners are willing to be in such a situation.

When taking photographs inside a building or home, you can do a lot to control the surroundings. Correction artists often must remove an object in the background that appears to be growing out of a person's head. It would have been much easier to move the object before taking the photograph. Cords streaming across floors to their respective outlets can also present problems, and unplugging them temporarily makes good sense. It may mean resetting clocks or other appliances afterward, but that is a small price to pay for good results.

Take care to notice the lighting also, and make sure it is not being caught and reflected by the shiny surfaces of glass or metallic objects elsewhere in the room.

One of the most important things a portrait photographer can learn is professional makeup techniques. An assortment of miscellaneous makeup in different shades would be an asset to every studio, particularly if a qualified makeup artist were also available. A woman prepares herself for a portrait sitting in the same manner as for a night out on the town. But while the effect might be quite pleasing for direct viewing, it often is not enough for the camera. Heavier theatrical makeup could help produce a much nicer portrait. If this is handled tactfully and explained carefully, the subject is usually willing to accept the extra help.

Persuading a male subject that he needs help can be somewhat touchier. Men tend to balk at any mention of using makeup, but if this can be arranged, it will result in a much nicer portrait. Professional actors already understand the need for makeup when appearing before a camera, and this is really the same concept. Makeup should be kept to a minimum for men. A light coat of powder cuts the shine of an oily complexion, and a cover stick can correct minor flaws. Men with heavy beards may have a "five o'clock shadow," even though they are cleanshaven. This is very difficult for the retouch artist to correct later in the photograph. But a light coat of liquid makeup will usually cover the blue shadow; or the photographer can provide shaving paraphernalia for last-minute touch-ups.

Be sure to stock some makeup remover and tissues, because you can be sure that your subjects—the men, especially—will want to clean their faces before leaving the studio.

Disadvantages of Print Corrections

Photographic artwork has several disadvantages that both the photographer and the retouch artist should be aware of before any medium is applied to the surface of a print.

A photograph with heavy artwork generally has a much shorter life span than the normal print, unless it is properly cared for. The primary reason for this is exposure to direct sunlight. Any photograph eventually fades when exposed to the harmful ultraviolet rays of the sun. This is such a gradual process that, on an unretouched photograph, it is usually undetectable for quite some time. But when a photograph with artwork begins to fade, the corrections may not fade at the same rate as the print's emulsion. If the fading process is allowed to continue for a prolonged period, the effect can be horrendous, as the artwork will show up terribly. Needless to say, this could be very embarrassing for the photographer, and such damage should be avoided at all costs.

Photographers should take responsibility for giving their customers proper care instructions for every photograph which leaves their hands, particularly when artwork has been utilized. Many studio owners hand out printed instructions with the finished photograph. These advise the customer to hang the photograph away from direct sunlight, and if it is not to be displayed, to store it properly in a closed box to prolong its life. These handouts also should warn people to keep photographs away from humid areas, and they should explain proper framing procedures. There is a special glass on the market that is designed to reduce the effect of ultraviolet rays on photographic prints. Called UFB plexi-glass, it is quite a bit more expensive than standard glass. For an important photograph that is sure to be displayed for years, the extra protection is well worth the cost. There are also retouching and finishing lacquers which have UV (ultraviolet) inhibitor added for this same purpose. I have heard conflicting opinions as to the actual benefit of using these lacquers, but it does not hurt to take every available precaution. If the retouch artist does not use UV spray, the photographer may wish to see that a final UV spray is applied.

Another distinct disadvantage of retouching photographs is the fact that corrections are often noticeable. A trained eye can usually see where they have been made. Obvious retouching can be very harmful to a photographer's chances in a competition, for it is definitely a factor in jurors' scoring of prints. Any print to be entered in competitions should have as little artwork as possible; but when corrections are necessary, they should be applied by an experienced artist who can do the highest quality work.

Customers may or may not notice corrections in a photograph. The average layperson sees surprisingly little. Very poor artwork often goes unnoticed because most people are untrained and don't look for such flaws in photographs. It is usually the photographer who expresses dissatisfaction with poor retouching before the customer ever sees the print.

The problems with customers generally come about when a specific correction has been requested and the customer knows exactly where it has been made. The customer may scrutinize the worked area, without knowing how corrections are made or what results to expect and be hard to please.

Another disadvantage of retouching is that the finish of the photograph may have to be changed. Many types of artwork require that the print be sprayed first with retouch lacquer, which produces a flat finish with a tooth rough enough to permit certain art materials to adhere. Many photographers, of course, prefer to use a matte finish on their portraits, as it tends to soften features and give the overall photograph a more subtle quality. But photographs that are to be used for competition or reproduction do not need this flat quality; they will do much better if the natural gloss of the photograph can be retained. If a correction can't be avoided and the print must be sprayed, the surface can be revitalized with high-gloss lacquer; however, this is never as desirable as the original gloss of the paper.

Analyzing a Picture for Correction

All good photographs are based on the rules of composition. A photograph should grab the viewer's attention, draw it immediately to the subject, and keep it there. The combination of background, lighting, and composition must be right for this to be accomplished. Much can be done in the darkroom to enhance a composition by using special cropping and burning techniques. However, it is not at all unusual for a photographer to require added help from an artist. And the artist must have a basic understanding of composition in order to improve on it.

The subject is the focus of any photograph. There are two basic types of subject matter: those which, like landscapes or street scenes, fill the entire picture; and subjects such as portraits or groups of people, which constitute only part of the photograph while the remainder is filled by background. In the latter case, the subject should be the most conspicuous element in the composition by virtue of size, contrast, or position.

When the subject isn't the center of attention, you must figure out why, and what can be changed to make it so. Precropping can sometimes suffice, but when the problem has to do with distracting elements or lack of contrast, art correction becomes necessary. Darkening light areas in the background allows the subject to attract the viewer's eye. Lightening dark areas, such as bumps or lines on the face, can allow the eye to view the subject as a whole, instead of being pulled toward an unimportant detail.

The human eye naturally follows light, and so the composition of a photograph should be arranged so that the eye is led in an orderly progression from one element to another, resting longest on the principal object. When you glance across a picture, your eye tends to go from the dark areas to the light ones. Every light area in the photograph attracts the eye. The force of this attraction depends on its relative size, shape, position, and amount of contrast. Everything in the photograph must fall into harmony with the subject matter. Small areas, either light or dark, that are away from the subject will be distracting. The same is true for areas that are unusual in shape or are located near the corners. If a photograph seems spotty, cover each area in turn with your finger and notice how it affects the overall composition. A white area in a predominantly black background tends to pull the eye more than a black spot on a white background. All offending bright spots should be removed or subdued.

Straight lines also can be very distracting in a photograph. These lines tend to catch the eye and carry it with them, and so they should not be allowed to run out of the photograph. Interrupting such a line will help to keep the eye within the picture. In addition, a line should never cut a photograph in half, either horizontally or vertically, nor should it ever run parallel to any of the sides. Keep in mind that a continuous series of spots also can act as a line.

Often, when you are working on a photograph, you look at it for such an

Ultraviolet rays from the sun will, in time, cause a print to fade. When this happens, artwork on the photograph's surface will show up terribly.

extended time that you lose all perspective and no longer can read it properly. An interesting approach to this problem is to turn the photograph upside down and view it in a mirror. This gives you a fresh look at the print and allows you to see immediately what it is that first catches the eye. When viewed in this manner, hot spots and strong lines tend to jump out and dominate the composition at once, and you will know what needs to be corrected.

Composition becomes of paramount importance in competitions. Obviously, a photographer does not want an artist to get into extremes on every print.

On a standard customer order, light facial enhancement is usually all that is requested. The photographer's budget may demand that certain flaws be lived with, and so the artist is asked to concentrate only on obvious facial flaws. Some pictures just don't warrant the time and trouble needed to reach perfection.

Artists will find it advantageous, however, to be able to point out features that detract from the subject matter. Often a distracting element is not noticed until something is said, and then the photographer realizes that the flaw is indeed bothersome.

It is very important that communication be open between photographer and artist. The photographer should always be aware of what the artist plans to do to the photograph so there is an opportunity to agree or disagree with it beforehand.

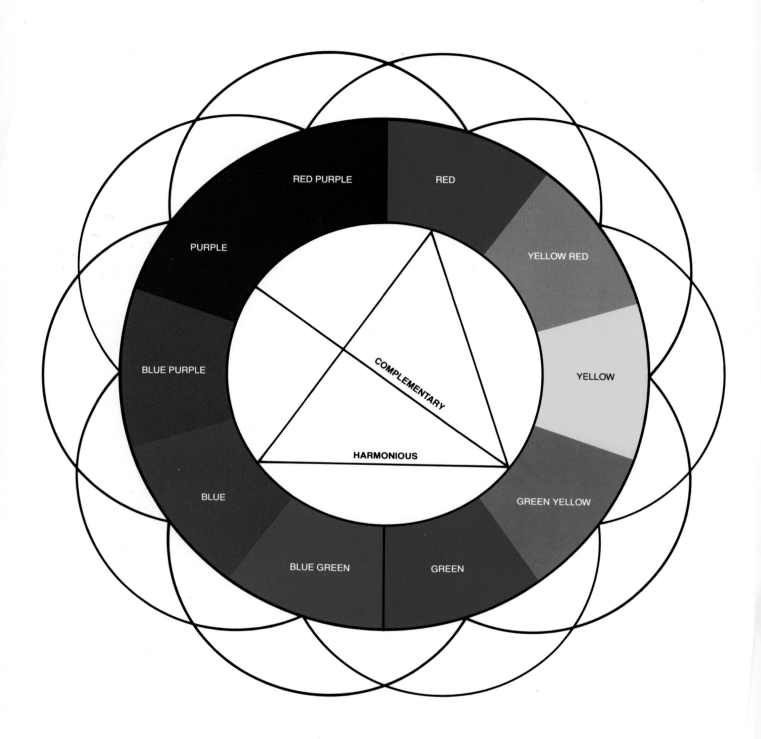

The Munsell color wheel

Chapter Two

What You Must Know About Color

To do photographic art corrections, you should be familiar with the principles of color as well as density (the lightness or darkness of a color). Photographers may already be acquainted with the material in this chapter, but a brief review can never hurt. And for artists, it is essential because color theory is somewhat different for photography than for art.

Most art corrections involve increasing or diminishing density, and/or adding or subduing color. Of course, this is a very broad definition, but with time, you will begin to think in these terms also.

Photographers who do their own color printing will be familiar with the following color lesson, which is based on the same principles used in the darkroom. Artists, however, will find it different from the color principles they have always worked with. This is because the major difference between the color wheels used by artists and by photographers is that the former is dealing with *pigments*, while the latter is dealing with *light*. Colored pigments and colored light behave a bit differently.

The artist's primary colors are red, yellow, and blue; the secondary hues of green, purple, and orange are also known as the complementary colors. The artist's primaries represent pure colors that are uncontaminated by other hues. Each of the complementaries is formed by combining two of the primaries.

For the purposes of this book, however, we will deal strictly with the photographer's color terminology. This system works better for retouching photographs because it correlates with the way a picture is printed, and

it will teach you to think of color in photographic terms.

The photographer's primaries are red, green, and blue, with the complementaries being cyan, magenta, and yellow. As with the artist's complementaries, each of the photographer's complementaries is formed by combining two of the primary hues: blue and green make cyan, red and blue make magenta, and green and red make yellow. However, unlike the artist's opaque pigments, colored light also works the other way: pairs of complementary colors have the ability to combine and form each of the three primaries. The complementaries cyan and yellow combine to form the primary green; cyan and magenta form blue; and yellow and magenta form red.

An Easy Rule of Thumb

The rule of thumb for making a primary color from two complementaries is not to use the complementary directly opposite the primary on the color wheel—its direct complement—but to combine equal parts of the other two complementary hues. For example, to form green from two complementary colors, you would not use magenta, its direct complement, but would combine cyan and yellow. Combining equal proportions of these two will produce a perfect green. Combinations having unequal proportions or different densities will form different hues of varying densities.

The same rule of thumb applies when you form a complementary color from two primaries. Do not use the complementary hue's direct primary, but combine equal amounts of the

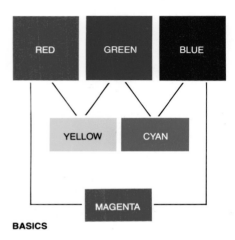

BASICS

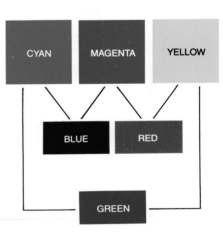

COMPLEMENTARIES

Learning how to create the basic color combinations will help you in every phase of the art-correction process.

This gray scale illustrates varying degrees of density ranging from black (full density) to white (no density at all).

When density is added to fully saturated color, it diminishes the color's intensity.

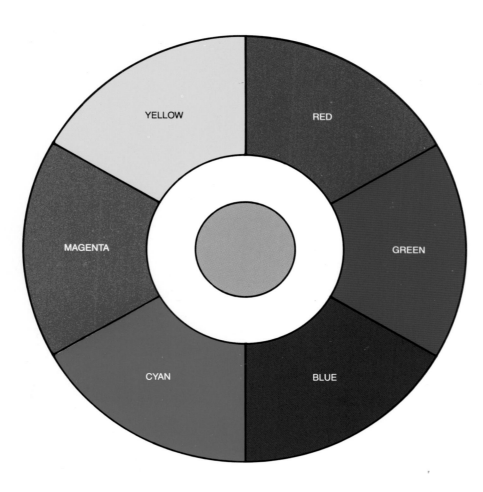

This scale shows varying degrees of density combined with color of low saturation.

The photographer's color wheel

other two primaries. For example, to form magenta from two primaries, you would not use green; instead, you would combine red and blue. Equal proportions of pure red and pure blue will produce a perfect magenta. Combinations with unequal proportions or varying degrees of density will form complementaries of different densities and hues.

It is easy to see that a mixture of red and blue will form magenta and that blue and green combine to form cyan; however, the principle that red and green combine to form yellow is hard for artists to accept. This is because they have learned to think in terms of opaque pigments and have long accepted yellow as a primary color that cannot be mixed from other hues. You must become accustomed to thinking in terms of colored *light* to truly understand this principle.

Neutralizing Colors

Each primary hue has a direct complement on the photographer's color wheel: magenta is the direct complement of green; red, of cyan; and blue, of yellow. What happens when you mix a primary and its direct complement?

One color totally cancels the other out, or neutralizes it, and you get no color at all. Depending on the density of each color in the mixture, such combinations will yield varying densities of gray.

Applying the Color Principles

You are probably beginning to understand why a knowledge of color theory is essential for the retouch artist. You cannot color-correct a photograph without it.

You'll find that white areas in photographs, for example, often reflect surrounding colors and do not appear white at all. However, it is easy to neutralize the reflected color by adding its complement. If a white blouse appears too green, you know that adding a little magenta will cancel the green. The result will be the desired white, with varying degrees of neutral gray in the blouse wherever there is density. The same principle would work in reverse if the blouse reflected magenta: you would use green to neutralize the unwanted color.

Suppose again that the blouse was too green but a cyan blouse was wanted, not a white one. By referring to the color chart, you know that green is a combination of cyan and yellow. You also know that cyan is a combination of green and blue. Therefore, you can deduce that applying blue over the green already in the blouse will give you cyan. There are two reasons for this. One is that the blue "cancels out" yellow, which was originally a part of the cyan-yellow combination of green, and leaves only the cyan. The other reason is that a blue-green combination forms cyan.

The color principles can get very confusing until you become accustomed to using the photographer's color chart and begin to learn the different color combinations. It will be helpful to you to make a copy of the chart and keep it near your work area. You will be surprised how often you'll refer to it, and how quickly you will memorize it. This theory of color is utilized in every phase of photographic art corrections, and you must understand it to achieve satisfactory results.

The Importance of Density, Contrast, and Saturation

The density of a color is the degree of lightness or darkness it has. Artists may be accustomed to referring to light and dark tones as values; photographers use the term *density* to describe tonal value.

To understand density, it may be helpful to look at a scale of tonal values ranging from white to black with many shades of gray in between. The white area in a photograph could be described as having the least amount of density; the black area would have the greatest density. In retouching photographs, increasing the darkness of an area means that its density is increased; decreasing the darkness means the density is decreased.

In most art corrections, darkness is either added or subtracted in order to make the corrected portion match the density of the surrounding area. Matching the density of a color is as important—if not more important—than matching the hue itself.

Contrast consists of differences in relative lightness and darkness of tones within a photograph. The more

the tones differ, the higher the contrast; the less they differ, the less contrast there is. Contrasts in density can make or break a photograph, depending on how they are used. Most photographs require some degree of high contrast. Photographs lacking in contrast can benefit greatly from art corrections. Sometimes more contrast is just what is needed to bring a photograph to life.

Saturation is a term that refers to the vividness of a hue. It is pure, intense color, uncontaminated by other colors. By soaking pieces of white paper in concentrated dye for varying periods of time, you can see varying degrees of color saturation.

In photographic art corrections, you must be able to differentiate between a dense color, a highly saturated color, and a highly saturated color with density. When an area needs to be matched to a surrounding area that is highly saturated with no density, this can be accomplished only by adding intense color. When the area is dense, matching this density takes precedence over matching the saturation.

The Psychological Aspects of Color

Photographic artists are often asked to use colors to enhance the mood or harmony of a photograph. In order to do this properly, they must know something about the psychology of color.

All colors have *temperature* and can be defined as being either warm or cold. The warm hues are the reds, yellows, and oranges—all the colors found in fire. The cold colors are the blues, greens, and purples, whose tints are found reflected in ice and snow.

Warm colors tend to give a photograph a sense of warmth and also make objects appear closer to the viewer. Cold colors carry a chilly tone into a picture and make objects appear farther away. It is easy to realize that, by incorporating color temperature into a photograph, you can set a mood and create a greater sense of depth.

Knowing how colors work together in a composition is important also. By examining the Munsell color wheel, you can determine which colors are complementary to one another, analogous (related), and harmonious with one another.

Complementary colors are directly opposite each other on the color wheel, and they form a complementary pair. When they are placed next to each other, they enhance one another and appear more brilliant. For example, placing a bright purple flower against bright yellow-green leaves would make a striking color contrast. For the maximum effect of hue intensity, your best choice is to use a color scheme based on highly saturated complementary colors.

Analogous (related) colors consist of any three colors neighboring each other on the color wheel. These colors are related because they share a common factor, the center color. In a photograph, related colors interact to create a mood that is quiet and soothing.

Harmonious colors are any three that are connected by an equilateral triangle on the color wheel. These colors blend together harmoniously like the individual tones that form a chord in music.

Highly saturated colors that are undiluted by black, gray, or white will produce a photograph with extremely high impact, giving the impression of power and strength.

Pale pastels that are highly diluted by white and gray are best used with delicate photographic effects to suggest a more subtle mood.

These overlapping rectangles show different degrees of saturation of the same color. Depth of color is achieved here through saturation only—not density.

Chapter Three

Equipment and General Procedures

This chapter discusses some of the basic equipment you will need in order to do art corrections, as well as various ways of arranging and using your work space for maximum convenience and comfort. A well-rounded overall view of the complete photographic correction process is also provided, and it is a good idea to review it before going on to Part Two.

Basic Equipment

The materials and equipment described here will be needed for all phases of photographic retouching; supplies specific to each medium and technique are explained in depth later on, in the appropriate chapters. For detailed information on manufacturers and suppliers of particular materials or equipment, please refer to the Appendix at the end of the book.

Easel. An easel may not be necessary for working with smaller prints, but it is essential for photographs 20″ × 24″ or larger, which are too cumbersome and difficult to manage otherwise. It is important that your easel be strong and sturdy. A lightweight easel could tip over, causing a photograph to fall and become irreparably damaged.

Work Boards. Small or unmounted photographs should be secured to a stiff board for safe handling. An unmounted print can easily become crimped. Another advantage to the work board is that it keeps the back of the photograph clean and protected from the many mediums being used. No matter how good a photograph may look on the front, a messy back is considered unprofessional.

The type of board chosen is very important. It must be stiff, with a uniform surface. Corrugated cardboard is not a good choice because the ridges will show on the surface of the photograph when pressure is applied. I suggest the foam boards that are often used in mounting. These boards are very lightweight and easy to handle, and they have a very smooth surface. They must be sprayed with lacquer before using in order to prevent the tape or glue from peeling the paper surface loose. You will need a variety of sizes to handle different sizes of photographs. I suggest leaving at least two inches of board around the edges of the photograph for easy handling.

Securing a photograph to a work board can be done in two different ways. Photographs that have a border should be taped directly to the board with masking tape. This tape will not harm the surface of the photograph, and it will protect the borders from becoming messy. Borderless prints should be secured with rubber cement. Rubber cement has a reputation for making photographs fade, but the back of the photographic paper is coated, and so the cement never reaches the emulsion. Rubber cement can also be used safely on a lacquered print as a liquid mask, which can be quite an asset in airbrushing. When you use rubber cement, you must be especially careful not to get any on the raw emulsion. In mounting a print on your work board, be careful to use only a drop on each corner of the photograph. Too much glue, and you may never get it loose. When the artwork is completed, the photograph can be lifted from the board, and the

A sturdy light box can double as an easel for correcting large prints as well as negatives.

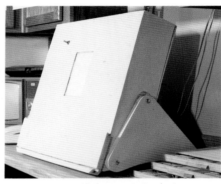

Secure a bordered print to your work board with masking tape; borderless prints can be mounted with a touch of rubber cement at each corner.

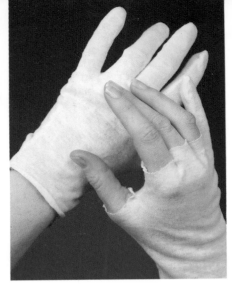

Trimmed work gloves protect the print while permitting your fingers mobility.

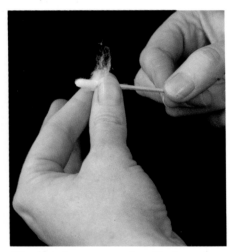

Homemade cotton swabs offer better control than the commercial ones do.

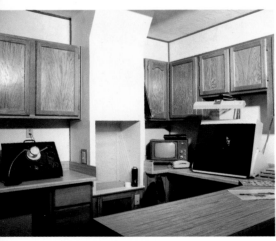

This well-organized room has plenty of convenient storage space, good light, a ventilated spray booth, and comfortable work surfaces. A special color-balanced lamp provides the correct light for retouching prints.

rubber cement will roll right off with a little rubbing. When lifting the print, do it evenly in order to avoid crimping the surface.

Gloves. To avoid fingerprinting negatives or unlacquered prints, you should wear gloves when handling them. Camera stores carry a light-weight cotton glove suitable for this purpose. I personally find these gloves very awkward to work in, and so I cut the fingers off the glove for my work-ing hand, with the exception of the small finger. This covers the part of my hand that comes in contact with the print, but it allows the other fingers freedom.

Cotton Swabs. With the exception of pencils, every retouch medium calls for the use of cotton swabs for both application and removal. Because store-bought Q-tips come in just one size and shape, you also need to know how to make your own. Purchase a roll of medical bandaging cotton. This product is 100 percent cotton with none of the nylon additives that many of the commercial cotton balls have. Pure cotton will not scratch the sur-face of a photograph. Twist the cotton onto the end of a toothpick. If the toothpick is too smooth to catch the cotton firmly, bite the tip to roughen it. This will do the trick. Be sure to have enough cotton at the very tip. Many photographs have been scratched by a toothpick protruding through. With time, you will learn how to make the right size swab for every purpose, and will be able to make it quickly. After using the swab, you can discard the cotton and reuse the toothpick for the next one.

Facial Tissue. Use white tissue to blot excess moisture from your brush. It also will allow you to read density and color properly before your brush touches the negative or print.

Setting Up Your Work Space

Where you do your artwork is very important because you'll spend many hours there, and so you should do everything possible to make it com-fortable and convenient. If you are a beginning artist, you will probably begin with a box of paraphernalia and a dining-room table. This is fine if you give special attention to the lighting in the area, but it won't be long before

you'll need more space and special storage. Then you may want to set up one corner of a room with a desk and proper lighting. This would allow you the convenience of having everything ready when you are, without the need for any take-out-and-set-up ritual. Another excellent idea is a fold-out closet, which is what I began with. If you are fortunate enough to have an extra double-door closet, you can revise it easily with shelves and a drop-down table. This kind of setup will expand when the doors are opened, and all the mess and clutter can be hidden when they are closed.

If you are extremely lucky, you may be able to convert an entire room into the "art room." This, of course, is the best choice for the serious artist, and it will result in the nicest working atmosphere of all. Although an art room isn't particularly attractive, much can be done to make it livable. A nice light color on the walls will alleviate the boxed-in feeling, and having a radio or television on hand helps to break the monotony of doing many hours of tedious work. It is also nice to have a telephone nearby to minimize interruptions and avoid running back and forth.

Of course, the greatest convenience is having all your paraphernalia within arm's reach. By properly arranging shelves and drawers, you can save much time and trouble. A ventilated spray booth is also a valuable asset, as it will draw dangerous fumes out of the room and to the outdoors, elimi-nating the need to go to another room to spray. One of the biggest problems in having an art room in your home is the amount of dust that settles from spraying and airbrushing. It is amaz-ing how much the dust tends to float into all areas of the house. Although expensive, an air filtering device is another nice addition to your work room. Access to a sink is also desir-able, for cleaning up.

I suggest that you use a comfort-able, padded chair with proper back support. Spending many hours bend-ing over a desk can be very hard on a person, and over a period of years, it can create physical problems unless you take special precautions to main-tain proper posture.

The height of your desk or tabletop should be comfortable for you, allow-ing you to have easy access to your work without unnecessarily bending your back.

Wearing the Right Clothing

Wear comfortable clothing that will not bind your arms, waist, or legs. Sitting for long periods of time can tend to cut off your circulation. You should make the effort to get up and stretch at least every hour. Also wear older clothing. Because doing artwork can get rather messy and many of the mediums are not easily removed, "dressing up" for it is a definite mistake. If you do your work in a business environment where dealing with the public is necessary, wear a smock to protect your clothing. Make sure your knees are also protected, because that is where much of the mess seems to land.

Protecting Your Eyes

Good eyesight is very important for all phases of photographic art correction. You should take every measure to keep your eyes in good condition. Have them checked regularly, and be sure your eyeglass prescription is kept up-to-date. If you normally wear contact lenses, it would be best to have a pair of glasses to wear for doing artwork. Some of the chemicals you will be using give off fumes that can damage contacts. The soft lenses are particularly susceptible. If you are a contact wearer and do not wish to wear glasses, a pair of goggles can be worn for protection.

Much of the work required in correcting photographs is extremely close up, and precautions must be taken to avoid eyestrain. When doing very close work, try to look up and focus on a faraway object every so often. This will reduce the possibility of eyestrain, and it is also a good exercise for your eye muscles. If a headache begins, take a break. You can't work well when you don't feel well. Lie down for a few minutes with a cold compress over your eyes, and see if the headache eases. Regular headaches could mean that a trip to your eye doctor is indicated.

The Correct Lighting

Proper lighting is a *must*. It is not only much easier on your eyes but also a necessity for the proper results. This cannot be overemphasized. I have to admit that I learned this lesson the hard way. I was working at a studio, and some last-minute photographs absolutely had to be put in the next morning's mail. Eager to please my employer, I offered to carry them home and finish them that evening. I removed the shade from my table lamp, positioned it behind me, and worked until the wee hours of the morning. When I finally finished, I was pleased with my work and felt that my boss would be quite appreciative. The next morning, under the proper lighting conditions, my work looked terrible! It literally looked like hen scratches, and it was not even close to being acceptable. Needless to say, the pictures did not make the morning mail, and my employer was not very appreciative. My hard work had literally been for nothing.

Regular incandescent light bulbs tend to have a warm color, and the tubular fluorescent bulbs usually produce a cold light. Neither one of these bulbs alone will suffice for doing color-correct artwork. A combination of the two, however, works nicely and will be reasonably color-balanced. If an incandescent bulb is overhead, you should have a fluorescent light to shine directly on your work; if a fluorescent fixture is overhead, then have an incandescent lamp for direct lighting.

There are several different types of color-balanced lights on the market. Some are special fixtures which encompass both fluorescent and incandescent bulbs at the same time. There are other types which come in a tubular bulb and are color-balanced. General Electric's Deluxe Cool White, the Mebeth Alvite, and both the Sylvania and the Westinghouse Cool White are good. They fit any fluorescent fixture and are worth every extra cent they cost. The best choice of all is to have this type of bulb both overhead *and* shining directly on your work.

On a comfortable day, it is nice to sit outside to do artwork. It seems to put you in touch with nature, allows for a breath of fresh air, and gives you the truest color-balanced light of all. I often take a print outside to view it under the sunlight before giving it the final spray. This allows me to double-check my work under the best possible lighting conditions.

The Overall Correction Process

Now let's take a brief look at the specific retouching techniques, which will be discussed at length throughout the rest of the book. Not every photograph will need every type of correction. However, it is important to emphasize that, even when certain steps in the process can be skipped, it is necessary to make your corrections in the proper sequence.

Negative Retouching. Negative retouching consists of applying both graphite and dye to the surface of the negative to lighten areas that are too dark on the print. Since dark areas appear light on a negative, adding density to them at this stage will result in less density when the negative is printed. Negative retouching can be used only to reduce density in smaller areas such as troublesome wrinkles and skin blemishes.

Opaque paint also can be applied to negatives to block light from small areas during the printing stage; the resulting white areas on the final print can then be corrected easily with other mediums. Opaque paint is used primarily for correcting small pinholes in the negative, but it can also be used to block out larger areas.

Graphite pencil leads are used to add density to black-and-white negatives. These leads can be purchased with special holders at art and office supply stores. They are the same type used by drafters, and they are available in varying degrees of hardnesses.

Liquid dyes are applied with a brush to color negatives not only to add density but also to color-correct problem areas. The dyes are specially designed to soak into the emulsion of the negative and become a permanent part of it.

Retouching a negative

19

Spotting a print with liquid dyes

Applying dry dyes

Spraying the print with lacquer

Spotting. The first step in making print corrections is spotting, which consists of applying special dyes with a brush to the raw emulsion of the photograph. These dyes come in a concentrated liquid form and are used to darken small areas that are too light, such as dust spots created by a dirty negative and glares reflected on eyeglasses. Spotting is one of the most valuable photographic art corrections you can make. The dyes have a very broad range of applications, which are discussed in depth in Chapter 5.

Adding Dry Dyes. Special dry dyes are added to the emulsion of a photograph to make slight increases in the amount of color and density. The dry dyes are very blendable and transparent, and they are perfect for color-correcting large areas.

Using dry dyes is the second step in print correction. It should be done before spotting, as spotting cannot be done after dry dyes have been applied.

Spraying the Print. Spray lacquers are used to change the surface of a print and also to protect the emulsion from damage. Artists commonly use retouching lacquers to give "tooth" to the photograph's surface so that pencil and other mediums will adhere to it.

When a print has been sprayed, it will no longer accept spotting dyes or dry dyes, and so this work must already be completed before spray is applied. After artwork has been applied to a lacquered surface, it must be sealed with a final coat of spray to become permanent. There are many finishes available for this final coat,

ranging from a high-gloss finish to special textured lacquers.

Applying Artwork to the Sprayed Surface. Pencils, pastels, and oil paints are applied to a sprayed print surface. These mediums are used to lighten areas that are too dark, to darken areas that are too light, and for both large and small color corrections. They can be used in whatever order you choose, depending on the specific nature of the correction.

Opaquing. Opaque watercolor can be applied directly to the surface of a print or negative with a brush. This medium is discussed briefly as a negative-retouching method in Chapter 4 and also explained at length in Chapter 12, which is devoted to advanced opaquing techniques. This watercolor has a very good covering quality. Often used in conjunction with airbrushing, opaquing is invaluable in making major corrections.

Airbrushing. For some large-scale art corrections, a mechanical device is used to blow paint onto the surface of a photograph in order to cover or soften the image. The airbrush is difficult to master, but it is considered by many people to be a "magic wand" that will correct anything. This is almost the truth, but only if the technique is handled well. Backgrounds can be altered, people can be removed or added to an image, and clothes can be changed. In the hands of the right person, an airbrush can be used to make almost any correction.

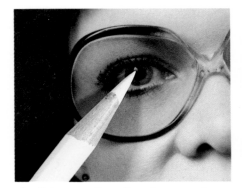

Applying pencil work to the sprayed surface

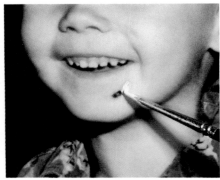

Opaquing

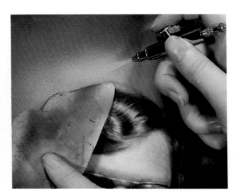

Airbrushing

Part Two

Basic Art Correction Techniques

This section of the book is intended to give you the knowledge necessary for making most photographic art corrections. Each chapter explains the uses, limitations, mediums, and techniques of a particular phase of the process.

You may choose to skip some chapters and begin with the medium you are most interested in. This is fine, and it may even be a preferable way to use this section. Starting out by mastering the medium you are most comfortable with will give you the confidence to branch out and gradually develop competence in the other mediums.

You will discover that many art correction mediums are crossovers and that there may be several different ways to make the same correction. For example, some artists prefer to replace spotting with pencils, and some prefer to replace pencils with negative work. It is best to experiment with each medium and then choose whatever works best for you.

The most difficult problem a beginner will face is knowing when to stop. Try each medium just a little at first. As you learn what results to expect and how the materials react, you then can attempt larger, more extensive corrections. Starting out with the large problems will only frustrate you, whereas beginning slowly and building your ability one step at a time will prove to be a very rewarding experience.

Chapter Four

Negative Retouching

Negatives are retouched by adding density and/or color to *darken* light areas in order to *lighten* them on the print (since light and dark are reversed on the negative). Dyes and pencils are used for this process, and the retoucher aims for a smooth, even correction that will not be obvious in the final print.

Retouching a negative produces the best results when limited to altering small spots and lines. Larger areas are best left for correction on the print. Negative retouching is usually used for portrait work, as it is perfect for removing small lines and stray hairs, smoothing bad complexions, and softening wrinkles and dark bags under the eyes. Occasionally this kind of retouching is also used to eliminate dark areas such as a highline wire stretching across a sky, very small telephone posts, and other distracting elements in a scene. These corrections are often required for commercial jobs, which invariably require further print work, as the negative work alone is rarely enough.

Advantages of Negative Retouching

Reducing density to lighten an area is one of the most difficult corrections to do on a print, but proper negative retouching can virtually eliminate the need for additional print work in many cases. At the least, it can reduce some print corrections to a minimum.

One of the biggest advantages of negative retouching becomes obvious when a quantity of prints is needed. It is easy to see that one negative can be retouched more quickly and easily than several hundred publicity prints. Negative work is very popular with studios that do huge numbers of senior portraits for school yearbooks, many of whose subjects have bad complexions. Applying artwork to the prints would be very time-consuming and would quickly eat up the studios' profits. These photographers have no choice but to utilize negative work.

Negative retouching is also desirable when a print must have a glossy finish and spray has to be avoided. This is often the case in prints for commercial use and for competition. If dark areas can be lightened sufficiently on the negative, then spotting and the application of dry dyes can be done on the print. The natural gloss of the paper can be retained, and the spraying and penciling steps avoided.

Disadvantages of Negative Work

Because negative retouching is one of the more difficult techniques to learn, I do not suggest that it be the first one you attempt. The areas to be corrected on a negative are very small, but the print made from this negative will be much larger, and so it is essential that the retouching be smooth and even. Great control and precise handling of the retouch mediums are necessary. Negative work that has been poorly done will hinder more than it will help, and it will cause additional print work instead of less.

I recommend that you first become adapted to using the spotting dyes and pencils before trying to retouch negatives. Then you should have no major problems in learning to do negative work. At the very worst, you will already know how to correct your mistakes on the print later.

It is difficult, when working on a negative, to foretell what the final results will be. Until a positive has been printed, an inexperienced retoucher cannot read the results accurately. This is the reason many artists dislike negative work, and it's the reason I do it very rarely. As a freelance artist without darkroom skills or access to lab facilities, I'm unable to make my own positive in order to check the work. It is very frustrating not to know for sure if the work you deliver is of the desired quality; and, needless to say, messing up a customer's negative is not the best way to build a good reputation.

For the artist with access to lab facilities, negative retouching can be a valuable asset. With the ability to run proofs and wash negatives, you can learn from your mistakes quickly, and eventually you'll get the technique right. Without these facilities, negative retouching can be difficult to learn.

Needless to say, poor negative work can make a big mess out of an otherwise good photograph. As an inexperienced retoucher, you will probably have to face several such incidents. Retouching is an art all to itself. Not everyone can do this type of work. It often requires a lot of trial and error to become adept. But with perseverance, a determined artist will do just fine. Truly skilled negative retouchers are in great demand and hard to find.

Basic Materials and Equipment

While some of the supplies you'll need for negative retouching will depend on whether you are working with color or black-and-white film, certain equipment is necessary for both processes.

Retouching Stand. The most important piece of equipment for negative retouching is the light box, or retouching stand, because you must be able to illuminate the negative properly. Flaws in the negative are so small that improper illumination can only result in poor retouching.

For the serious artist, I recommend the Adams Retouching Machine as the best choice. Although it is expensive,

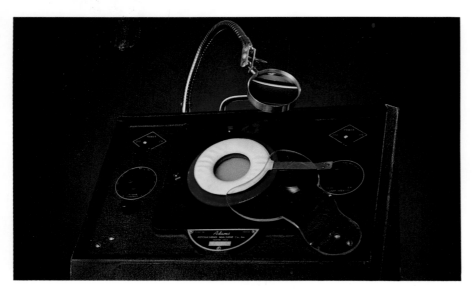

it is designed especially for negative work. This machine provides for excellent viewing conditions. Included among its features are a dimmer switch for perfect light control, a convenient holding clamp for the negative, and a vibrator control.

A homemade retouching stand is fine for most artists, as it is a real money-saver and gives you working conditions similar to what the more expensive machine affords. Although a homemade negative box does lack the vibrator and holding clamp, these items are not a necessity.

The Adams Retouching Machine, with a magnifier attached

How to Make Your Own Light Box

If you make your light box from a cardboard carton, it should be at least 24″ high 30″ wide, and 18″ deep. You will need to cut the top and front sides to produce a 70-degree angle. Use an extra piece of cardboard or heavy mat board to make a front piece that will fit into this angled area, and in the center, cut out a rectangular hole at least 4″ × 5″ (5″ × 7″ would be preferable). Tape a piece of milky white acrylic or plexiglass securely on the outside of the front piece, allowing an overlap of about ¼″ around the edges. This translucent panel will provide for uniform lighting. Do not attach the front piece to the box at this time.

Next a light fixture must be attached to the inside of the box. A ceramic fixture of the type used in storage closets would be fine. The light should be mounted at least 4″ from the viewing panel to prevent heat from the bulb reaching the negative.

A switch should be mounted outside on the right-hand side of the box. A rheostat (dimmer switch) is helpful in order to control the intensity of the light. The proper wattage of the bulb for this light fixture varies, depending on which artist you talk to, but I'm told it should be somewhere between 40 and 100 watts. The brighter bulb should be used only when a dimmer switch is also available. A dense negative could require light of a higher intensity, but viewing a thin negative through extremely bright light could cause not only retouching problems but also eyestrain and headaches. After mounting the light fixture, make an opening in the side of the box so that bulbs can be changed without the need to tear the whole box apart. Use 14 amp. grounded appliance wire to connect the light to the plug and switch.

Once the light and switches have been installed, tape or glue the front piece on, and presto, you're ready to go!

Variations on this box can be made easily. I have seen several different types, including the one I own. As long as your box has the 70-degree angle, the translucent acrylic, and a light fixture inside, you can construct it according to your own preference. Obviously, a heavier box made with wood and screws will hold up much better in the long run.

If you choose to paint the outside of your retouching stand, use a flat black or medium gray paint that will not pick up and reflect colors that could interfere with proper reading of negatives. Inside the box, however, the light needs to be able to bounce around for diffusion. A dark color would be absorbent and prevent this, and so if the inside is to be painted at all, white is preferable.

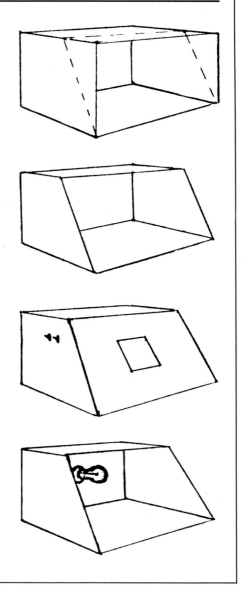

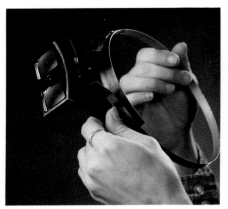

A headpiece magnifier

A homemade negative holder fashioned from an envelope

Making your own retouching stand can be as simple or difficult as you choose. Depending on your specific needs and preferences, it can be constructed from an ordinary cardboard packing box or sturdily built of wood and painted for attractiveness. Either way, your working results will be the same.

Magnifier. A magnifying glass is a necessity for retouchers. Some of the larger negatives can be retouched without one, and I prefer to do this when possible. The magnifier tends to create a sense of disembodiment that can require an adjustment on the part of the artist. On smaller negatives, however, there is no way to see some of the fine lines and spots accurately without creating a strain on the eyes. A magnifier makes the job much easier, and you will have better results.

There are two types of magnifiers to choose from. Many artists use the type that mounts directly to the retouching stand, with a flexible arm for easy positioning.

Other retouchers prefer to use a headset, a type that is available in several different strengths. The No. 7 is the most popular strength, but what is best for each individual depends upon that person's eyesight. You might want to check with your optometrist or with the manufacturer to determine the specific strength you need. If you wear glasses, you can use the headset as it fits around them. The headset also has a convenient flip-up panel which lifts the magnification when you don't need it. It is a strange-looking contraption that resembles a welder's goggles, but it works well.

While some artists may wish to purchase a special pair of magnifying glasses, this is not the best choice. You will be looking from the proof and palette to the negative regularly. Taking the glasses off and putting them back on would be inconvenient.

High-Intensity Lamp. A small high-intensity lamp should be positioned within reach. This will allow you to see both the proof and your palette clearly. The light can be turned on easily for viewing the proof, and off for working on the negative.

Kodak Opaque Black. This paint will not allow any light to pass through it during the printing process. The result is that wherever the paint is applied to the negative, the corresponding area will be very white on the print. While this area will require spotting in order to blend properly, this is usually much easier to do than removing the darkness from the print. On both black-and-white and color negatives, this paint is used to cover small pinholes which appear as tiny white spots on the negative. It can also be used to obliterate a background on a negative, but this can get rather difficult and should be attempted only when very straight, precise lines are available around the subject.

Opaquing Brush. You will need a small brush for applying opaque—one that is used *only* for this medium, as it does not mix with the dyes used for negative retouching and residue from one or the other left in the brush could cause problems. For suggested sizes, as well as guidelines on purchasing and maintaining your brushes, see page 38.

Negative Holder. To prevent fingerprinting and to avoid unnecessary handling of the negative, cut a circle in the middle of an envelope and sandwich the negative between the two layers of paper, with the facial area visible through the cutout. This negative holder allows for safe, convenient handling and repositioning.

Gloves. White cotton gloves should be worn anytime the negative is to be handled.

Kodak Abrasive Reducer. A thick, slightly gritty medium can be used on negatives to remove minor scratches and surface scum. This medium was once used heavily on black-and-white negatives and prints to reduce density. When applied with cotton and rubbed, the gritty medium would gradually abrade the surface, removing small, even amounts of density. This medium is used by only a few artists today, as it does not take properly to many of the new print papers, and removing density from a negative is pointless since these areas print up light and are not difficult to correct on the print. Using the medium to repair slight surface damage is fine, but you must be very careful with color negatives. Too much rubbing can cause penetration of the top yellow layer, with subsequent loss of yellow dye. Excess reducer should always be removed from the surface of the negative with clean cotton.

Materials for Retouching Black-and-White Negatives

In addition to the basic equipment already listed, you'll need some special supplies for working with graphite pencils on black-and-white negatives.

Retouching Fluid. Retouching fluid is used to give the surface of a negative enough tooth for pencil work to adhere.

Methyl Alcohol. Alcohol can be used to remove retouching fluid. However, the graphite will also be removed, and the pencil work must be redone.

Graphite Leads and Lead Holders. You will need graphite lead pencils (the same type used by drafters) in a variety of hardnesses. Working on areas that are very light on the nega-

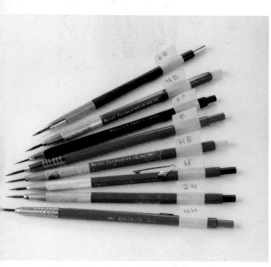

Graphite leads labeled according to hardness, in holders

Kodak Wrattan gelatin filters are helpful for color-correcting negatives

Kodak Liquid Retouching Colors and a ceramic palette

tive requires an extremely soft lead to achieve the necessary density. For areas that need only a little density, you'll want to use a harder lead to prevent the pencil from going too dark. The B leads are soft, and the higher its number, the softer the lead. The H pencils are hard, and the higher numbers indicate harder leads. Special holders can be purchased for these leads. Some artists prefer to hold the leads by hand, but they are fragile and easily broken; the holder offers protection from this. However, controlling the lead is the important issue for the artist. The way you feel most comfortable should determine how you use the leads.

Sharpening Envelope. Retouching leads must have an extremely sharp point. A dull point will not stay confined to the area being filled in, and it will result in poor retouching.

To achieve the fine point necessary, make a sharpening envelope by inserting a piece of extra-fine sandpaper, folded with its abrasive side in, into an envelope that has been cut down to size and sealed on three sides, with only the top open. This provides a pocket for collecting the dust.

Materials for Color Negatives

Color negatives are corrected with special dyes rather than graphite, and so you'll need the appropriate tools and materials for applying and removing them.

Liquid Retouching Colors. Retouching dye, which is applied with a brush, soaks into the emulsion of the negative to build both color and density smoothly.

Designed especially for this work, these dyes adapt well to the negative's surface. They are sold as part of a larger set, but only four of the colors are used regularly for negative work: neutral (the density dye), red, blue, and cyan.

Palette. The liquid retouching dyes must remain diluted during application. Ceramic palettes, available at art stores, afford a series of wells for proper dilution.

Retouching Brush. A very small sable brush is required for negative work. Sizes 0 to 000 are about the smallest ones made, and these very small sizes are especially necessary for retouching color negatives with liquid dyes, in order to keep the dye confined. Your retouching brush must have a perfect tip. For a detailed discussion of common brush problems, please refer to page 38.

Kodak Wratten Gelatin Filters. Filters are very helpful in determining the amount of color needed to neutralize certain areas of a negative. You will need a No. 25 (red) and No. 58 (green).

Kodak Photo-Flo and Ammonia. Both of these products can be used to wash a negative when retouching work needs to be removed. The choice is up to you; the relative merits of washing mediums are discussed on page 39.

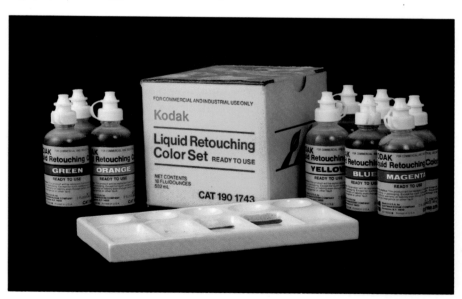

Demonstration 1
Retouching a Black-and-White Negative

Choose a practice negative in which the subject's head is relatively large—preferably, no smaller than a dime. The larger the face, the easier it will be for a beginner to retouch. Also choose a photo with obvious flaws for correction. A bad complexion or very strong wrinkles will give you a lot to practice on, and you'll be able to see your results easily. Don't worry about ruining the negative. If handled properly, the worst that could happen is that unsatisfactory retouching would have to be removed and redone.

Retouching should be done in a room that is as dark as possible. The negative will be illuminated by the light source inside the retouching stand. The high-intensity lamp is used for accurate viewing of your palette and the proof only.

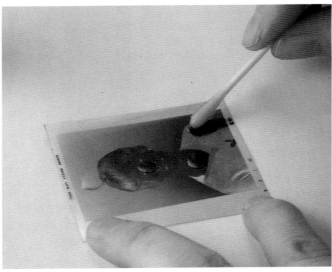

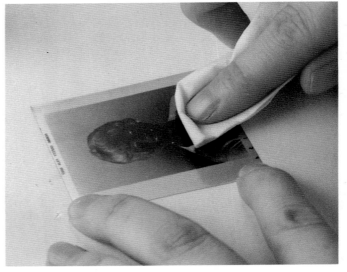

Step 1. *The first step in retouching a black-and-white negative is applying retouching fluid. With a cotton swab, apply a few drops sparingly to the emulsion side of the negative (the dull side) in the area to be corrected.*

Retouching fluid

Step 2. *Now use a soft tissue or piece of cotton to rub over the face lightly in a circular motion. This must be done quickly. If the fluid begins to set up before it has been buffed down, it will leave a slightly sticky area that will collect dust. It is also important to make sure that the edges of the fluid are feathered out. If the edge is allowed to remain as a distinct ring, this ring will also appear in the printed photograph.*

If your negative needs only a little correction, one application of retouching fluid on the emulsion side will suffice. Occasionally, a negative will require such extensive work that the fluid will have to be applied to the base side of the negative. This should be done only under the most extreme circumstances, as both the fluid and the retouching tend to be more noticeable on this side.

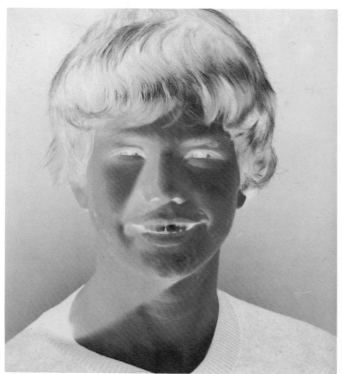

Step 3. *Next, position the negative in its holder and secure it on the retouching stand. If your machine is equipped with a dimmer switch, adjust the light to the appropriate intensity. Study the negative. Having a proof on hand is also very helpful at this point. It helps you to see easily the areas that most need to be corrected. Notice not only the very bright and obvious areas, but also the finer spots and lines. Choose the brightest spots on the negative, which are the darker ones on the proof, to begin correcting.*

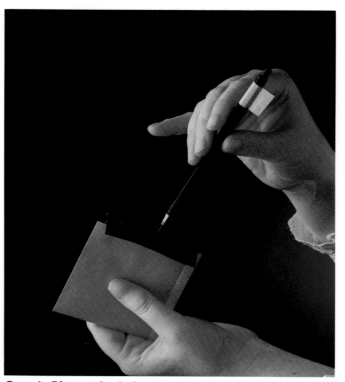

Step 4. *Choose a lead of medium hardness—the 2H is a good one to start with—and sharpen it. To do this, hold the sharpening envelope in one hand, with your forefinger and thumb holding either side of the envelope in the middle. Insert the lead into the opening of the envelope, between the sides of the folded sandpaper. With a very quick motion, move the lead up and down, simultaneously twirling it around. With each stroke, the lead should reach the area where the other hand is holding the envelope firmly together. This provides a tight spot in the envelope and creates a tapered effect. The twisting motion prevents the point from becoming one-sided and flat. This method of sharpening will result in the finest point imaginable, allowing you to retouch very small areas.*

Always wipe the excess particles of graphite from the lead with a piece of cotton to prevent their falling onto the negative when retouching begins.

How to Decide What to Correct

When you study a portrait to assess what corrections need to be made, use your common sense. You want to enhance the subject without destroying the characteristic features of the person's face. Here are some general guidelines you can follow. The same basic principles apply to correcting both black-and-white and color negatives.

Complexion problems and minor skin flaws should be totally removed. Deep wrinkles and large shadows should be merely reduced and softened a little; removing them completely would change the subject's natural contouring.

When working on dark areas under the eyes, you must refrain from removing them altogether. When retouching a black-and-white negative, use a harder lead that will blend and add density without completely covering the area. Soft, rounded contouring must remain to prevent an unnaturally flat look.

Freckles and moles are considered character marks and should not be removed unless it has been specifically requested. But it is all right to subdue them slightly.

Dark veins often show on people's arms, hands, and legs. These should be removed.

Many men have a five o'clock shadow, which makes the bottom half of the face appear lighter on a black-and-white negative. Although a sensitive correction, this area should be blended as much as possible. Use a harder lead and avoid dark, obvious lines.

Step 5. *If you have a retouching machine, turn on the vibrator, which will produce a slight tremor so that when the lead is applied to the negative, lines will automatically become diffused and softer. If you do not have a vibrator, you must learn to achieve a soft effect by avoiding straight, harsh lines. Some retouchers make figure eights or move the graphite lead in an S shape for a softer look.*

Hold the lead very lightly; a tight grip is not necessary and will only tire you faster. Touch the lead to each light area to be corrected and allow the tip to graze the surface gently. Touch only the areas that need greater density. If you don't confine the lead, you will have circles around each correction.

Starting out with a lead that is in the middle range allows you to judge the needs of your particular negative. Touch the lead to one of the brightest spots. If the graphite does not adhere well enough to fill it with sufficient density, then you know that a softer lead must be used in these areas. If the lead went too dark, then you could be touching the negative too heavily, or your negative could be the denser type that requires a harder lead.

Continue to hit all of the brightest areas, blending them in with the surrounding areas as closely as possible. Work over the entire face, correcting all the areas that fit the hardness of this particular lead.

Depending on the corrections remaining to be done, change to either a softer or harder lead and, in turn, add the needed density to these areas.

If there are bright areas that you are unable to fill satisfactorily with lead on the emulsion side, turn the negative over and work on the base side. Apply retouching fluid as before.

Step 6. *If an area remains that is too white and tiny to fill with the lead, you must resort to opaque. With a very small brush, lightly touch the opaque to cover the area. (Never use your retouching brush with the opaque. These two mediums should not be mixed, and separate brushes should be used for each.) Keep the opaque confined to very small areas. When printed and enlarged, these areas will appear white and require spotting. The smaller this spotting job, the better the final results will be.*

Removing Retouching from a Black-and-White Negative

If retouching must be removed from a black-and-white negative, the entire negative will have to be cleaned. Attempting to clean only a specific area will leave a ring that will show up later on the print.

Previous retouching can be removed by adding more retouching fluid and wiping the area dry. However, if a negative has been reworked a number of times, adding more fluid may make the area excessively tacky. In this case, methyl alcohol can be used to remove both the previous fluid and the work. Retouching fluid must then be applied again before new pencil work can be added.

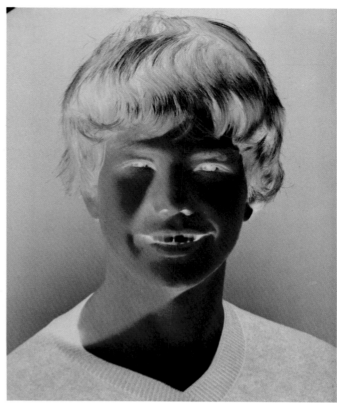

After Retouching. *Compare the retouched negative, and the print made from it, with the way the negative and proof appeared before. Corrections have been made smoothly, without losing the natural contouring of the subject's face. The print made from a retouched negative may require some minor darkening of areas that are too light, but there should be no dark areas that need to be lightened.*

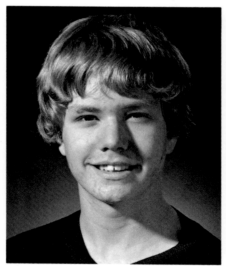

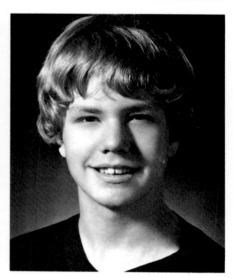

Demonstration 2
Retouching a Color Negative

Select a color negative that you do not particularly care about in order to practice retouching techniques—preferably one for which you also have a print available for easier comparison.

Position the negative in its holder and secure it on the retouching stand, with the base side of the negative out. If you have a dimmer switch, adjust the light to the appropriate intensity.

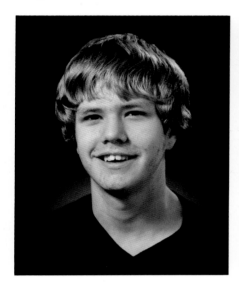

Distinguishing the Base Side from the Emulsion Side of a Color Negative

On some color negatives it is difficult to tell which is the base side and which is the emulsion side. The emulsion side of a roll-film negative is toward you when the edge printing appears reversed. The emulsion side of a sheet-film negative is toward you when the film is held so that the code notch is in the top right-hand corner.

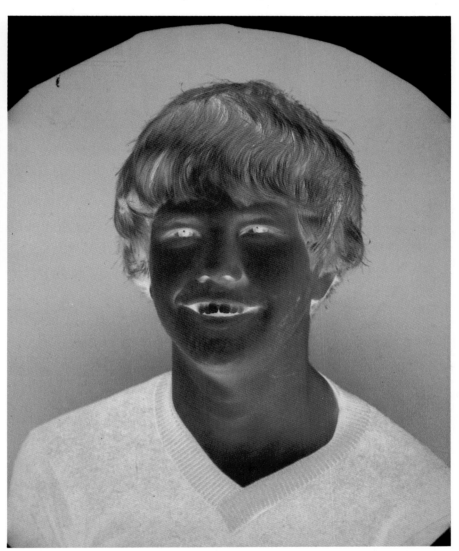

Step 1. Examine your color negative. Notice the green areas and also the areas of lowest density, which denote areas that will be dark on the print. Comparing the negative to the proof will enable you to read the negative more easily. Decide what kind of corrections the negative will need.

Then prepare your palette. Put a few drops of the neutral dye into one well. If the negative has small green spots caused by a bad complexion, they will have to be neutralized with red dye. If it is needed, put a few drops of the red dye into an- *other well. Does the negative have extremely light areas under the eyes, or do facial and neck wrinkles show as extremely dark areas on the proof? If so, mix one drop each of blue and cyan in a third well. If you are working on a portrait of a black person who has very dark skin, you will also need to mix a well that contains one drop each of magenta and blue plus three drops of neutral. Use this mixture in place of neutral. Dilute the dyes by 50 percent. Two drops of dye require one drop of water.*

Eliminating Pinholes with a Stylus

Pinholes in negatives are often corrected with opaque, but they also can be eliminated by using a needle-like stylus on the base side of the negative. (Never attempt this technique on the emulsion side.) Place the stylus (a needle held by a lead holder) slightly off the center of the pinhole. With a little bit of pressure, push in and toward the center of the pinhole. Now lift the stylus slightly and at the same time push it toward the center. This operation roughens a minute portion of the base in the center of the pinhole, changing it so that it will hold back light in that area. If the stylus is used with a retouching machine, increase the vibration to the highest speed and very carefully touch the center of the pinhole with the point of the stylus. The pinhole will fuse out.

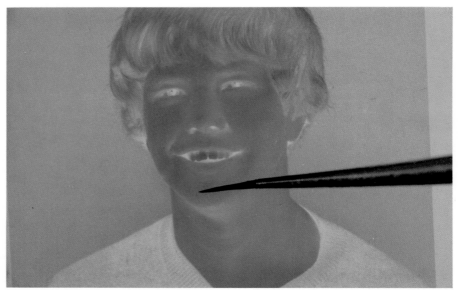

Step 2. *If your negative has green areas, insert a No. 58 green Wratten filter behind it to make these spots even more prominent, and begin with the red dye. Dip your brush into the dye and blot it on a piece of tissue, removing excess water so that your brush is not too wet. While blotting, turn the brush to form a point. Be sure to pay attention to the strength of your diluted dye. When dye stands exposed to the air, it begins to evaporate. After a while, you have a stronger dye than you began with. Always check to be sure your dye is properly diluted: observe its strength when you blot your brush, and add a drop of water to the well in your palette if necessary.*

Very lightly touch the red dye to each light green spot on the negative with the tip of your brush. Build up the dye deposit by stippling the area on the negative. Allow the dye to dry for a few seconds before applying further coats.

Continue applying red dye to the green areas of the negative until the density appears to have been built up by about 50 percent. In other words, stop before the area is completely filled in. When it reaches the halfway point, the green will be counteracted, but the area will still show a little because it will be lacking density. Then remove the green filter and apply neutral dye until the correction blends perfectly with the surrounding tones.

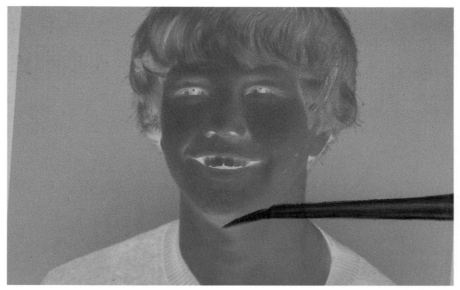

Step 3. *Lightening deep shadows is a two-step process. First insert the red filter behind the negative. Rinse your brush thoroughly to be sure no other dye color remains, and dip it into the cyan-blue mixture. Apply this mixture until your correction is almost blended into the surrounding area.*

Step 4. *After the cyan-blue mixture has been applied, replace the red filter with the green one. Apply red dye over the light areas that continue to show.*

Step 5. *Areas on the negative that do not require color correction can be filled using the neutral dye.*

Removing Dye from a Color Negative

If too much dye is applied to the base of a color negative, the excess can be removed by spongeing with dampened cotton. Never exert heavy pressure when washing a negative, as the surface could become scratched easily. Allow the negative to air dry. To remove dye completely, sponge the negative with a 5 percent ammonia solution or wash it in luke-warm water for several minutes. When washing with warm water, add a few drops of Kodak Photo-Flo to the water and swirl the negative in this solution for one minute. Hang the wet negative by a clamp clipped at the very corner. Do not allow the clamp to touch the image area, as it will create a crease that will show on the final print. The dry negative can be cleaned of surface scum with anti-stat film cleaner. This product will also remove retouching fluid.

After Retouching. *When the retouching is finished, the subject's complexion should look smooth and even on the negative, but having a new print made from it will help tell you just how good a job you did. The final print may need some minor spotting, but no major surface work should remain to be done.*

Additional Tips for Correcting Color Negatives

Yellow teeth often can be corrected by applying a very light coat of yellow dye. Dark and receding teeth can be helped with a light coat of neutral dye.

It may be desirable to soften shadows without removing them completely. Shadows in which no green is apparent can be softened with neutral dye. If any green is present, neutralize it with red dye first and then apply a little neutral dye merely to soften the shadow.

Freckles that are large and dark should be subdued, but moles should be left alone unless you have been specifically requested to remove them. If so, eliminate the mole in the same manner as you would remove dark wrinkles.

Blue dye is useful for subduing or removing the bluish color of veins and beard shadows. Blue areas in the subject appear yellowish orange on the negative. Apply blue dye until this color has been neutralized. If additional density is needed after making the color correction, use the neutral dye to build up the density until it matches the surrounding area.

Retouchers are often asked to remove sprigs of hair that are out of place. While this can be done on the black-and-white negative—even though it invariably requires further print work—I do not recommend attempting this correction on a color negative. The results can be horrendous. It is better to correct stray hairs on the color print.

Eyeglasses often cast dark shadows across a person's face. As with other shadows, these can be softened, but totally removing them usually requires print work for best results.

On very thin negatives, retouching will look very obvious. This fact should be explained so the customer will be aware of this special problem from the outset.

On very dense negatives, areas that require correcting will be difficult to see, even with the light adjusted to its brightest intensity. Again, the retoucher should make the customer aware of this. The final print could look as if the artist had missed correcting many areas, when in actuality, it was impossible to see them at all on the negative. A proof can be very helpful in correcting dense negatives.

Using Other Mediums on Color Negatives

Color can be added to specific large areas by applying dry dyes to the base side of the negative. This medium is discussed thoroughly in Chapter 6, and the application instructions for negatives are the same as for prints. Just remember that colors applied to the negative will be the opposite color when printed.

Dry dyes are useful for lightening or enhancing the color of hair, clothing, and so forth, as well as for adding color to otherwise neutral objects. To lighten a specific area, add the same color that you see in the negative.

Dye that has been steamed into the negative can be removed by washing it in running water at 20 C (68 F) for eight to ten minutes.

There are retouchers who correct color negatives with colored pencils instead of dyes. This method is not as good, and it often results in grainy, obvious work. As an artist who has often had to correct this, I feel that you should learn the best method only. I do not suggest making pencil corrections on color negatives.

What Happens When You Over-Neutralize Color?

This color print shows what happens when color is over-neutralized on a negative. If too much red dye is used to neutralize reddish skin blemishes (which appear as green areas on the negative), when the colors are reversed in the color printing process these areas will print as light green splotches.

Over-neutralizing color is the worst problem negative retouchers have. Because the results of over-neutralizing can look terrible and are very difficult to correct on the print, washing the negative and beginning all over is often the best way to solve the problem.

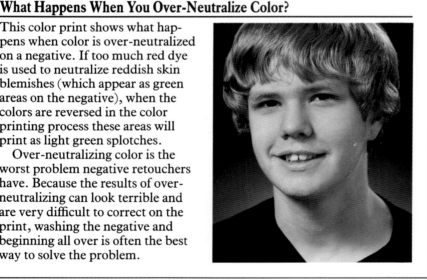

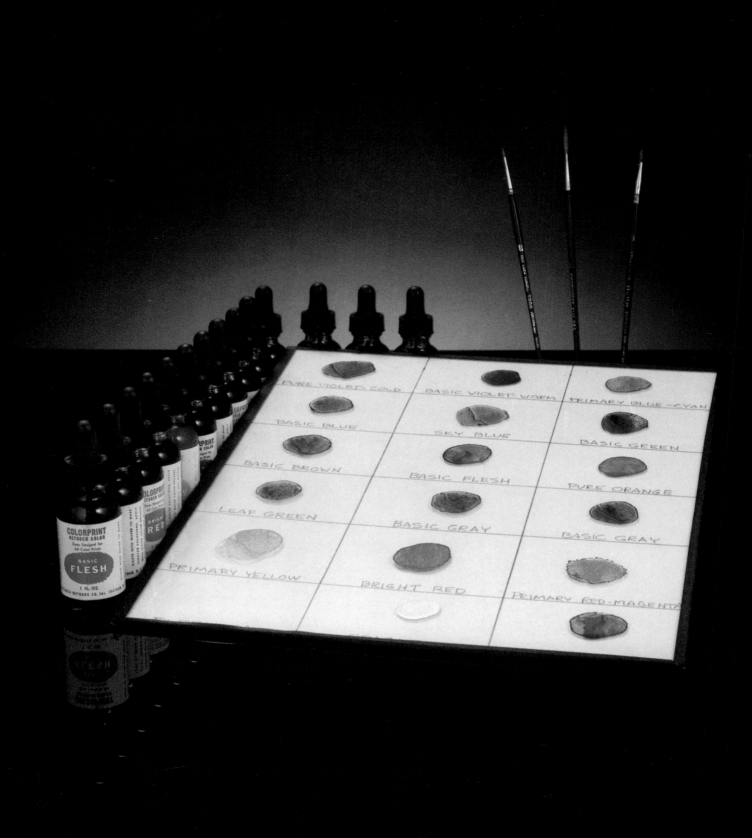

Chapter Five

Spotting

Applying spotting dyes is not only the first step in print correction but also the most stimulating one. These special dyes, used for darkening smaller areas that are too light, soak into the photographic emulsion to become a permanent part of the print. Many problems faced by photographers every day can be corrected very quickly with some dye and a touch of the brush. Most professionals are familiar with this medium and utilize its potential completely. Although spotting dyes are difficult to work with, once you have mastered them you will find them versatile as well as virtually undetectable. The dyes have few limitations as a medium, and they are sure to become invaluable to you.

Spotting dyes are used not only for eliminating the simple dust spots that haunt all photographers but also for making more extreme corrections such as removing glare reflected on eyeglasses and opening closed eyes. Much can be done with these dyes to strengthen a soft, out-of-focus image and to smooth out a bad complexion. They are also excellent for correcting the "red eye" found so frequently in candid shots.

The most exciting application for spotting dyes, however, is in the enhancement of photographs. Portraits can literally be brought to life with them, and there are limitless improvements that can be made in scenic shots, from adding birds in the sky to putting flowers in the grass. Very often a small, subtle addition is exactly what a photograph needs. Your only boundaries are your imagination and your ability to control the medium. I hope you will learn to appreciate these dyes as much as I do. They are my favorite medium, and I consider my skill with them to be among my greatest assets as a photographic artist.

Disadvantages of Spotting

The spotting dyes actually have only three limitations. The first is that they can only *add* density. Wherever the brush touches, the area will go darker, and so you must be very sure your brush doesn't come into contact with areas you don't want to darken. Anytime density needs to be subtracted, rather than added, another medium must be used.

Secondly, you can achieve smooth, natural-looking corrections with the spotting dyes only if you confine them to smaller areas—no larger than your thumb, if you are using washing and blending techniques, and no larger than the diameter of a pencil for drybrush work. Areas larger than these should be left until later and darkened with another medium.

An outstanding advantage of the spotting dyes is that, because they become part of the photograph's emulsion, the natural gloss of the paper can be retained. However, herein lies the third disadvantage, for you can avoid the need for spraying a photograph's surface only if the dye work is minimal and no washing is done.

Heavy dye work will leave a slight buildup of residue on the print's surface, which is noticeable on glossy papers. And washing will leave a light water ring that cannot be eliminated without spraying the photograph—which tends to diminish the reproducibility of commercial photographs. Although a corrected print can always be given a final spray with high-gloss finish, the results are never quite as good as the natural gloss of the paper. It's better to use restraint with the spotting dyes, and to avoid making mistakes that will have to be removed later.

Correcting "Red Eye"

A spot or line that is colored can be counteracted and brought down to a neutral gray by adding its opposite hue (refer to page 13 if you cannot remember which color is its complement). To correct the photo shown here, a little cyan dye removes the red from the eyes like magic.

Materials and Equipment

Spotting does not require a lot of complicated paraphernalia, but it must be appropriate for the purpose and work well to enable you to control your medium.

Spotting Dyes. The dyes used for spotting come in a concentrated liquid form and are much too strong to apply directly to the print. It is for this reason that they are dropped onto a palette, allowed to dry, and then diluted with water before application. There are many different brands to choose from, but some brands tend to undergo drastic color changes after a short period of time. For this reason, I strongly recommend the retouching colors offered by Retouch Methods Co., Inc. (Their address can be found in the Appendix in the back of this book.) These dyes come in a set of fourteen colors. Some of the shades are intense, saturated colors, and others have varying amounts of density in them. Experimentation is the best way to get acquainted with the individual shades. A safety tip: I have heard that these dyes are carcinogenic if ingested—so *never* put a dye-saturated brush into your mouth.

Palette. Spotting dyes must be used from a palette. There are many different types of palettes, and what is "best" is really a matter of personal choice. Some artists prefer to use a smooth dinner plate; others like a sheet of plastic. I prefer a glass palette because the surface allows for easier color blending; the plastic surfaces I have tried seem to cause the dyes to roll around in a manner that I don't like.

My palette has areas designated for each dye color, but the labeling is underneath, on a sheet of white cardboard cut to the same size as the glass and taped to it around the edges. This way, the labeling stays neat and clean, and there is no need to relabel each time I use my palette. The cardboard also acts as an insulator for the glass so that it is less fragile and breakable. I prefer to use an 11″ × 14″ sheet of glass. Smaller sizes can be used, but they get somewhat crowded with all the different colors. I allow two spaces each for the flesh and the basic gray, as these are the two colors used most frequently. When fresh dye has been applied to the palette, it should be set

aside and allowed to dry before using it. I have had many accidents with spotting dyes because of my impatience. One time, I managed to get my sleeve into wet dye and inadvertently wiped it all over the photograph. On another occasion, a tissue lying next to some wet dye soaked it up, and when I picked up the tissue to dust the print, I unintentionally wiped dye on the print. I have learned the hard way to allow my dyes to dry thoroughly before using them.

Be sure your palette is resting on a level surface to dry. Even the slightest incline will cause the dyes to run into each other and become intermixed. When your palette is dry, be sure to store it properly between uses. It should be either covered or turned upside down. If it is allowed to sit uncovered, dust and lint will settle down onto the dyes, and this residue will be transferred to the surface of your photograph. When you notice this happening, your palette should be washed and new dyes applied.

Brush. The brush used for spotting is probably your most important piece of equipment. With a bad brush, it is impossible to master these dyes. Sable brushes—which are really made from the sable's less glamorous cousin, the weasel—seem to have the finest tips.

A brush does not have to be expensive to be good. When you purchase a new one, examine the point of the brush very carefully. It should taper out very gradually to a straight, fine point. Unfortunately, new brushes are dipped in a solution and formed to a point. Until this hardened solution is flaked from the bristles and they are wet, it is difficult to judge the point accurately.

There are three common problems to watch for specifically. One is the hooked brush. If the very tip is curved like a fishhook, don't buy it. Some brushes also tend to fork at the very end. If the bristles separate and try to go different directions, the brush can never be controlled. The third common problem to watch for is the blunt brush. The bristles should not end suddenly at the tip. The brush must have a fine, tapering point in order to handle the minute work required in spotting.

Once you have mastered the spotting dyes, even the smallest of areas can be handled with a rather large

brush, as long as that brush comes to a very fine point. I prefer to use a No. 2 brush because it allows for a larger reservoir of dye and less time is spent going back to the palette for more dye. Most beginners, however, feel more comfortable starting out with a smaller brush such as a No. 00. I suggest getting three brushes in different sizes ranging from No. 00 to No. 4. With practice you will find the one you're most comfortable with. You will also find that the smaller size will fit certain purposes, and the larger one is best at other times.

When you find a brush that works well, treat it like gold. Really comfortable brushes are few and far between. Always rinse the brush thoroughly before and after using it. Dust and lint will settle into the brush and could cause damage to the bristles. A clean brush is a healthy brush. Never use the spotting brush with any other medium, as other substances could leave a residue that would not intermingle with the dye properly.

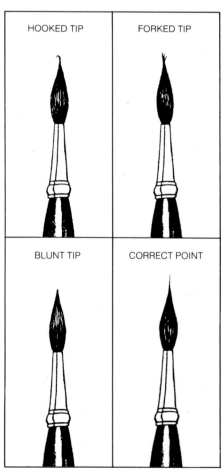

Select a good-quality brush with bristles that come to a perfect fine point.

Brush Holder. A holder for your brushes is an optional piece of equipment—you can also store your brushes horizontally, as long as the bristles are not hampered or in disarray—but I recommend storing brushes vertically if possible. Holders are available commercially, or you can make your own. Mine is a block of wood with holes drilled into it, which works just fine.

Facial Tissue. White tissues will be needed to blot excess dye from the brush. Tissue works better than paper towel or other materials because it is more absorbent. An extremely dry brush is used for most spotting purposes, and so this is important. Blotting on white tissue gives you one last chance to check color and density before applying the dye to the print. Colored tissues would give you a false reading.

Ammonia. You will need some ammonia for removing mistakes, but be very sure to purchase clear ammonia instead of the cloudy variety. This can generally be found at a local pharmacy, and it is the remover recommended by the dye manufacturer.

Some artists use saliva for removing spotting dyes, although this method is very controversial. I have photographs that were retouched in this way nearly ten years ago, and although I can see no visible change, I have heard that, with time, saliva will break through the cyan layer of the emulsion and cause it to turn bright orange where it was applied.

Artists once used Photo-Flo to remove spotting dyes, but this proved to be a big mistake. It was discovered that any residue of Photo-Flo left on the surface will eventually break through the cyan layer, and it is difficult to tell if it has all been removed. Many artists use plain water, although I have heard the same charges against it. Water is also a very weak remover, and often it does not remove enough. Ammonia is, perhaps, the safest and best choice.

Water. A glass of water should be kept nearby, as you'll need to dilute the dyes before applying them to the print. Please be very careful with the water, however, and don't spill any on your photograph.

A handmade holder works well for storing brushes so that bristles can be kept neat and the tips protected.

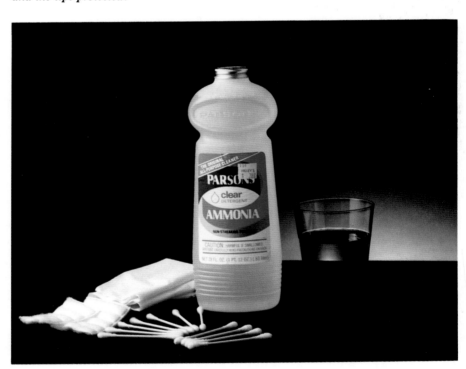

Don't forget to include clear ammonia, white facial tissues, cotton swabs, and a glass of water among the materials you'll need for spotting.

Stabilizer. Since stabilizer is used during the final development of a photograph, some artists feel it's a good idea to mix a little into the spotting water so that retouched areas will not change color in the future. Stabi-lizer is an optional item, and not every artist uses it, but it never hurts to take every precaution. (But don't get any into your mouth—it tastes terrible!) Stabilizer can be purchased at any camera supply.

Demonstration 3
Drybrushing Small Spots

If you are settled and have everything you need at hand, you are ready to begin learning to use the spotting dyes. Although a wide range of photographic problems can be corrected with these dyes, you'll start out with the dry-brush technique that is used for eliminating the light spots caused by flecks of dust on the negative during the printing process. This is probably one of the most common print corrections you'll be asked to make as a retoucher.

Choose a scrap print that is not important, for practice—hopefully, one with many dust spots that need to be corrected. Make sure the print has not been sprayed: spotting must be done on a clean, unlacquered print. Tape or glue your print to a work board and wipe it clean of any dust particles.

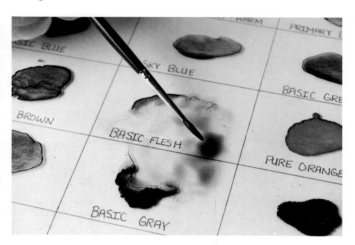

Step 2. Since your first objective will be to tone down these bright spots until the density nearly matches that of the surrounding area, you'll need to mix a puddle of warm gray dye to work with.

Dip your brush in the water and transfer some water to your palette. Mix a puddle with the basic gray, and add just a small touch of the flesh color to this. Most dust spots can be corrected primarily by building up the density, or the amount of darkness, in them. Since this is your main purpose, don't worry about trying to match the color at this stage; just concentrate on achieving the right amount of density. The most common mistake people make in spotting is using the dye too dark. Be sure to use a diluted mixture that is lighter than the area to be matched. If it turns out to be too weak, you can always strengthen it.

Step 1. One of the first steps in spotting, as in any retouching technique, is to "read" the photograph for corrections. Examine your practice print closely and locate all the dust spots or other small areas that are too light and need to be darkened. The photograph shown here, which is the one I use in my classes for teaching all the phases of retouching, has a few dust spots that should be eliminated. You may also notice a variety of other problems in the photograph, but these will be corrected with other techniques later on in the book.

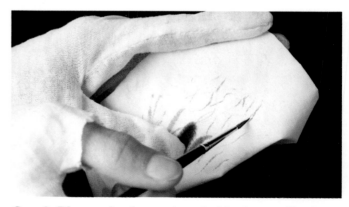

Step 3. Blot your brush on a piece of white tissue, rolling it as you blot in order to form a good point. Notice the color on the tissue. It should be a very watered-down warm gray, but not too orange. Blot your brush until practically all the dye seems to have been removed and it is barely marking the tissue. It may be hard to believe that the brush has enough dye left in it to work with, but it does.

Step 4. *Beginning with a lighter area of the photograph, choose a white dust spot and touch your brush to it very carefully. Hold your brush lightly and use a very light touch. Remember that only the very tips of the bristles need to touch the print. The only way you should know your brush is actually touching the print is because you can see the color changing. If you exert enough pressure on the brush to feel the paper pushing back, the bristles will bend and they'll be touching—and therefore, darkening—a larger area than you intended. It's all right to let your brush touch the print for long periods of time, but you must keep the brush moving so that too much dye does not collect in one area and darken the spot too much. Many beginners tend to jab at a spot for fear of applying too much dye, but if your dye is properly diluted, there is nothing to worry about.*

Allow the spot to dry between applications of dye. If your brush is dry, this should happen almost immediately. If not, the spot will appear bluish until it is dry, and you will not be able to get a correct color reading until the spot has dried. If there seems to be a puddle that is bleeding outward, your brush is too wet and you should reblot it. If the dye seems to be making no difference, don't despair. Weak dye is not a major problem—just keep applying it, and you should see a gradual buildup of density.

It's easy to touch a spot once too often and get it too dark. Don't be in a hurry. Stop at regular intervals and look at how far you've come. It helps to have two prints so that you can judge the "before" and "after" accurately. You may be surprised to find that just knocking out the brightness is often enough. Totally removing a spot is less important than making sure it no longer catches the eye.

With a little practice, dust spotting will become second nature. An entire print can be spotted in minutes, spending only seconds on each spot. As a beginner, however, do not worry about speed. Take time with each spot, and do it right. Quality should be your first concern, no matter how long it takes. The best artists are usually the slowest. As you become accomplished, your speed will naturally increase.

CORRECT PRESSURE TOO MUCH PRESSURE

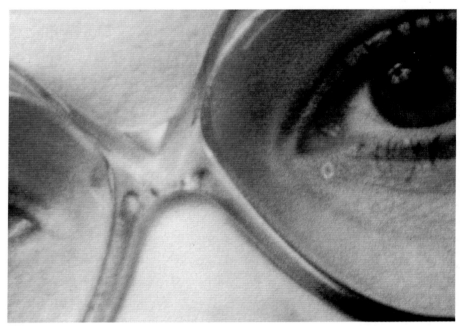

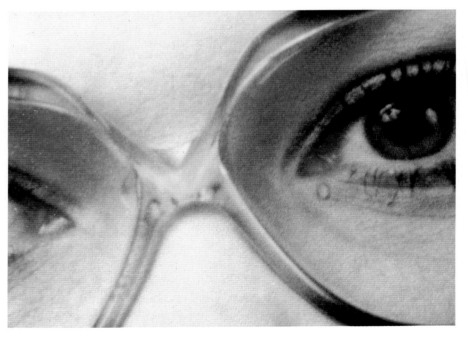

Tips for Correcting Dust Spots

Basically, there are three rules in dust spotting to remember at all times:

1. Dilute the Dye. It is always much easier to add more dye, if the density is too light, than to remove it later after it has become too dark.

2. Use a Dry Brush. A wet brush cannot be controlled.

3. Keep the Dye Confined. Everywhere the dye touches will go darker, so only touch those areas which need to be darker.

If you find that you are hitting to one side of the target regularly, try turning the print upside down. Your eyes may be playing tricks on you, and changing your angle of approach could solve the problem. I turn my prints regularly to get the best angle.

Nine times out of ten, small dust spots can be corrected just by building up the density with gray to blend the spot into the rest of the photograph. You'll rarely need to add color, but when this is the case, bring the density up first. Then, if the spot appears to be too cold, add a warm color over it. The flesh tone usually suffices. If the spot is too warm, add a cold color such

as green or cyan. (Refer to Chapter 2 for more information on color-correcting.) If adding color over the density makes the spot too dark, then either your original correction had too much density or the color you added was not diluted enough. The only situation in which adding density does not help is when you are correcting spots in areas of highly saturated color. These areas can be corrected with color only, and no density needs to be applied.

Avoiding "Doughnuts" Around Spotting Corrections

Among the most common problems that develop when you try to eliminate dust spots is the formation of a ring around the correction.

LIGHT RING DARK RING

If your corrected spot is more or less the right density but is surrounded by a darker ring, this is probably caused by one of two things. Your brush

could be too wet, causing dye to bleed outside the limits of the spot you are correcting; if the spot is blue and swollen, this is probably the case. The other possibility is that you are not confining your brush to the dust spot—you may be exerting too much pressure on the brush and touching a larger area than you intended. In either case, any area outside the dust spot that is touched by the dye will also go darker. You can get rid of the "doughnut" by washing off the dye (see page 45) and trying the correction again, or you can wait until later and cover the dark area with another medium.

A corrected dust spot with a light ring around it is usually caused by not bringing the dye all the way to the edge of the spot. If more dye is in the middle of your correction than around the edges, proceed with caution. Every time the center is touched again, it will get that much darker. Concentrate on hitting the light circle around the edge. Using a dotting motion may help, but this problem is not easy to correct. If the center gets too dark, then the correction will have to be washed out and redone or covered with another medium later on.

How to Correct Lines and Squiggles

Spotting lines and squiggles is difficult—stray hairs are the worst. When spotting something of this nature, concentrate more on knocking the brightness out and subduing rather than completely removing it. Stroke the brush in the same direction as the line. If you cannot keep the brush within the confines of the lighter area, try dotting instead. It is very easy to end up

with a line that is dark on either side, and still light in the middle. Use slightly more concentrated dye for this type of correction, and stop as soon as the brightness is out. It is better to stop while you're ahead than to go too far. If a portrait has an overabundance of stray hairs, it is better to leave these corrections for another medium.

Demonstration 4
Wet-Blending Larger Areas

A different method of spotting is required for reworking larger areas of a print with the spotting dyes. This technique requires not only using a wetter brush but also pre-wetting the emulsion of the print in the area to be spotted, in order to promote the bleeding-out of the dyes and give a softer effect. Using the drybrush technique on these larger areas would result in very rough, obvious retouching.

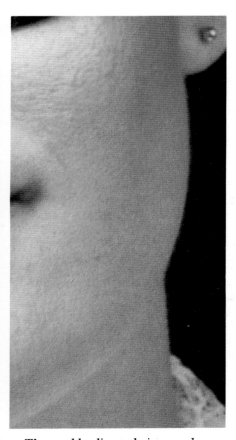

Step 1. *Set up your spotting materials as before, and select a practice print that has some light areas that need to be darkened or blended. The problems in the photograph shown here may suggest some corrections to look for in your print. The most obvious problem is the glare reflected on the eyeglasses. The scar on the model's lower left cheek can be removed almost completely by blending with the dyes, and the strong line of the chin can be softened in the same way. Notice also the corners of the mouth, which curve in different directions. In this demonstration the spotting dyes will be used to bring the corners up to a nicer smile. (Later on in the book, the original corners will be removed with another technique.) This blending method is also excellent for toning down objectionable highlights in other parts of a print, such as hot spots in the background.*

Notice that the model's forehead is much too light for the rest of her face. This is too large an area to correct with spotting, and it will be darkened later with another medium, as will the white blouse, which is too bright and detracts from the subject. However, spotting dyes can be used to bring some lost detail back to the collar, bow, and necklace, as well as to create a second earring to match the one the model is wearing.

Step 2. *Since the spotting dyes can be used only for darkening areas, retouching a scar involves toning down the highlights on the raised areas of the scar to match the surrounding flesh tones. To mix your dye, use the same basic gray and flesh colors as for dust spotting, but naturally, you'll use proportionally more of the flesh in order to match your subject's skin tone. For wet-blending, your dye solution should be highly diluted.*

Pre-wet the scar area with clean water on a Q-tip; then dip your brush into the dye mixture, blot the brush, and wet-brush the brightness down. Your brush should be wetter than for dust spotting, but not drippy wet. Again, be sure to touch only those areas that need to be darker. Use more pressure on the brush for this technique; what is incorrect in dust spotting is correct in blending, in order to cover large areas smoothly. In this type of spotting, color corrections should be made as you go. If the wet area turns blue, keep this in mind when color-correcting.

The wet-blending technique works beautifully: notice that there is barely a trace of the original scar left in the retouched photograph. What is left can be lightened later with pencils, but for many purposes, spotting would be considered enough.

The strong line of the chin has also been softened by wet-blending. This type of correction must be done extremely carefully. The dye should be brought up to the dark line but not into it, since you don't want this line to be any darker than it already is. The closer the brush is to the dark line, the dryer it should be. Bleeding out would be harmful in such a minute area.

Step 3. *Now notice the mouth. Using a semi-wet brush, I have drawn the corners of the mouth up, trying very hard to simulate the character of the lines that curved downward. You must take care, in this type of correction, to keep the line soft enough. The edges should feather out gradually to give a natural effect. A sharp line would look very artificial. It is sometimes necessary to wash over this kind of correction later, in order to soften it sufficiently. Admittedly, the mouth now looks a bit strange with two corners, but when the lower ones are removed, the effect will be a big improvement.*

Step 4. *The technique for removing reflections from eyeglasses varies a little from one situation to another because each photograph will present slightly different problems. The crucial thing to remember in toning down reflections is to build up the density slowly and evenly. If you get in a hurry and your work starts looking uneven, it will be much harder to get nice results. Look very closely at the glare spot, and notice the fine vertical lines going through the middle. This glare would be easier to handle without them. As the density is being built up, work around the vertical lines and avoid touching them with the brush. They do not need to be any darker. Notice the stairstepped effect of the glare. The first goal is to build the density until the surface appears to be level. Use the dye very lightly and alternate between the gray and flesh tone. The right combination, built up slowly, will blend in quite well. If the color gets off-balance, refer to the color chart on page 13 to correct it. If certain areas begin to get dark, work around them. Wash the area regularly with a Q-tip to keep the spotting smooth, and to prevent any buildup of residue. Don't be upset if your first few attempts at this type of correction are less than satisfactory. This is a difficult procedure, even for the experienced artist. Other methods can be used later to smooth the work completely, if necessary.*

When detail has been lost and needs to be rebuilt, the technique is similar to the one used for altering the corners of the mouth. Use a semi-dry brush, and wash the spotting with a Q-tip to keep it soft. Strenthening separation lines in the clothing, as well as

making the necklace a little darker and more prominent, will add contrast to this overall light area. Pick out the darker areas and add a little density to them. Be especially careful with the dye in the lighter areas. It is so easy to create an artificial drawn-in effect. When adding nonexistent details, such as jewelry, it helps to have a photograph to look at.

After Spotting. Compare the "before" and "after" prints. Although there is still much to be done, spotting has helped considerably. Spotting dyes, when handled properly, greatly minimize the amount of other work to be done at later stages—and these dyes are also much less noticeable than many other mediums.

Some things are so important that they bear repeating: Remember, do not go too dark with the dye; keep it confined; and use the proper technique for the purpose. Give yourself time. With practice, the skill will come.

Removing Spotting Mistakes

To remove mistakes, dip a cotton swab in ammonia and apply directly to the problem area. Let it sit for about one minute; then sponge up the excess liquid. Wet another cotton swab with water and wash the area. Some types of paper will turn very blue when wet, so don't let this take you by surprise. The area will return to its normal color as it dries. The washed area will leave a water ring on the surface of the paper. This is particularly obvious on a glossy surface. Steaming the surface of the print (discussed in the next chapter) will sometimes remove water rings and surface marks left by the spotting brush. This will not always remove water rings created by heavy washing, and the only way to correct this is either to spray the print or to rewash the entire print. Rewashing is not recommended, as it could remove other dyes that should remain, and it could also shorten the life of the print. If one application of ammonia does not sufficiently remove the error, repeat the process.

If you choose to try saliva for removing an error, the process is a little different. Be sure your mouth is clean, without any foreign agents. Anything you have been eating or drinking could have harmful ingredients that might be transferred to the photograph. Thoroughly wet a cotton swab with saliva and apply it directly to the mistake. Rub the area with firm, but not rough, pressure. The dye will lighten immediately. Often this is all that is needed to blend the dye as you originally wanted. Sometimes it will be necessary to rub for a full five minutes, or more, for the area to lighten sufficiently. It is safe to continue the rubbing process until tiny orange dots begin to appear in the emulsion. If this happens, stop immediately. The process has reached its limit, and the area cannot be washed anymore. The orange spots mean that the cyan layer is being rubbed off, and this will only get worse with continued washing. It is very unusual for a spot not to have been removed completely long before this point, however. If washing can no longer be continued, the remaining dye can be corrected later with another medium. Spot the orange dots in the emulsion with cyan dye to neutralize them. If the spots go too dark when you do this, they can also be corrected later on.

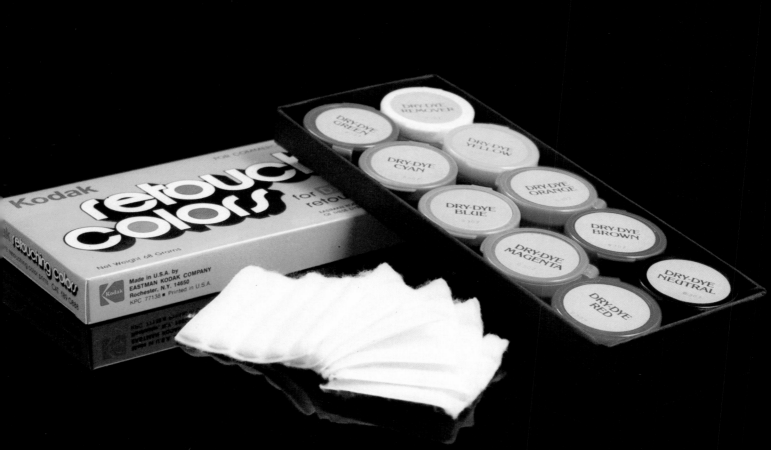

Chapter Six

Adding Dry Dyes

Dry dyes are among the easiest and most exciting mediums available for retouching photographs. These dyes come in a solid cake form and are used for adding color and density to large areas on a print. Because Kodak's dry dyes—now called Kodak Retouching Colors—used to be known as Kodak Flexichrome Colors, the process of adding dry dyes to a print is sometimes referred to as "Flexichroming" by artists who have been working with them for a long time.

Advantages of the Medium

Photographers who are familiar with color printing techniques will immediately realize the value of these innovative dyes. They are likely to have experienced the frustrations of printing a photograph with a beautiful blue sky, only to have the subject print too blue as well. Trying to handle this kind of problem in printing is practically impossible because any color correction affects the entire print uniformly. The dry dyes give the photographer an entire new method of control, as color can be added to individual areas of the print in a smooth and transparent manner. One coat of dye is equal to approximately five units of printed color. If more color is needed, this can be accomplished by steaming the dye and repeating the process as many times as necessary. If one coat adds too much color, it can be lightened easily by buffing it down before steam-setting the dye.

Like the spotting dyes discussed in Chapter 5, dry dyes are applied to an unlacquered print. When properly set, they soak into the emulsion and become a permanent part of the print. They can be used on all types of print papers without marring the surface in any way. It should be noted, however,

that the glossy paper does not accept dry dye as readily as do the other surfaces, and it will require repetition of the application and setting techniques.

Dry dyes can be used subtly, as in adding a blush to a baby's cheek, or boldly, as in making a sunset more striking with brilliant colors. Skies can be made bluer, grass can be made greener, or makeup can be added to the face of a person who is wearing none.

Dry dyes can be very exciting for the beginner. Other mediums must be struggled with and conquered before you can be pleased with your results. Not so with the dry dyes. You can see dramatic changes in seconds. When "before" and "after" prints can be compared, it's often hard to believe what a difference has been made. Color is an important part of today's photography, and when it is right, a photograph exudes quality.

The Limitations of Dry Dyes

There are not many disadvantages to dry dyes as a medium because they are so simple to use. Perhaps the most obvious drawback is their costliness, but they are well worth the money. They are very concentrated and require such a small amount of dye for each job that it is doubtful a retoucher would ever need to replenish the supply. Perhaps this is the basis for the high cost of the dyes. This product is likely to be a one-time expense.

If not used with restraint, dry dyes can result in a very flat, artificial look. Colors applied too heavily can look obvious, and necessary highlights can be excessively subdued. These problems can be avoided simply by learning how to use the medium properly.

Dry dyes react very severely to water and darken immediately on

contact. For this reason, it is very important that liquid never come in contact with the dyes. This is also why all spotting must be completed before adding dry dyes. If you were to spot over them, the wet brush would cause the dyes to turn dark wherever it touched the surface. It is also important that spotting be thoroughly dry before dry dyes are applied. Any damp spot on the print would be disastrous.

If you talk or laugh while applying dry dyes, small drops of saliva could spatter the work, creating very dark spots. When working with this medium, it's best to keep your mouth shut! You must take care to avoid other kinds of accidents, too. A student in one of my classes was using dry dye to apply blush to a girl's cheeks and picked up a wet Q-tip previously used for washing. When the dry dyes reacted to the moisture, the red immediately set into the emulsion, and the portrait suddenly had bright, blood-red color gushing from each cheek. The only way to correct the problem was to cover the mistake, which was difficult and tedious. The student persevered and corrected his mistake reasonably well, but he learned a valuable lesson.

Dry dyes should never be used with water on a brush, as this could damage the photograph. The manufacturer warns that it causes the eventual removal of cyan dye from the surface.

Materials and Equipment

The equipment required for working with dry dyes is not particularly complicated, and certain supplies are a matter of personal choice. But your criterion for choosing any material or piece of equipment should always be how suitable it is for the purpose at hand.

Dry Dyes. Even though the dry dyes are expensive, one set of dyes is likely to last for many years. But as a cost-cutter, you might wish to divide your set of dry dyes in half and share the expense with another person. To do this, obtain some small cosmetic jars that have tight lids, and clean them out well. Melt the dry dyes just enough to liquefy them thoroughly, and divide the liquid. A microwave oven works quite well for this. (I don't recommend using a regular oven, as the heat would melt the plastic containers in which the dyes are packaged.) Stir both jars with a toothpick to distribute the dye evenly. Refrigerate them for about an hour, and then return them to room temperature.

Some artists put their dry dyes in tubes. This involves melting the dye, adding glycerin, and filling empty lipstick tubes. Although tubes are very convenient to use, the dye manufacturer strongly warns that glycerin causes dry dyes to make a print fade eventually. Without glycerin, the dyes would be too dry and crumbly to use in tubes. Even though using tubes is a widespread practice, I believe it's best to heed the manufacturer's warning.

Dye Remover. Included in your set of dry dyes is a medium called dye remover, which is for removing unset dyes. Although it works fairly well, there have been questions as to its safety. If residue from the remover is left on the photograph's surface, it could eventually break through the cyan layer, causing the area to turn orange. The manufacturer instructs the user to buff all residue off the print thoroughly, but it is impossible to know for sure that it has been sufficiently buffed off. As a general rule, it is better not to use this remover except in the most dire emergency. Avoid getting dry dyes on any area where you don't want them.

Cotton Squares. Compressed cotton squares are used for applying dry dyes to large areas of a print. The squares known by the brand name Coets, which usually can be found where cosmetics are sold, are soft enough not to scratch the surface of a print. Cotton balls generally should not be used, as they are not always made of pure cotton; sometimes they contain nylon fibers that could damage a photograph's surface.

Cotton Swabs. Q-tips or homemade cotton swabs are used for applying dyes to smaller areas where the color must stay confined. (See the instructions on page 18 if you wish to make your own swabs.)

Steamer. Dry dyes must be set into the print with steam in order to become permanent. There are several ways to accomplish this. Vaporizers, face machines, and humidifiers are some of the products that produce steam. My choice is a baby-bottle warmer, an inexpensive device that puts out a nice, steady stream of steam in a matter of seconds. Whatever you use, make sure it does not spit droplets of water along with the steam. Many vaporizers do this, and it can make them an unwise choice.

Retouchers often set dry dyes by breathing on the print, and although this may be the most common method of producing steam, it is not the best. Huffing and puffing warm, moist air on a print may set light coats of dry dye satisfactorily, but this won't suffice for heavier coats. If you do try this method, be careful not to hyperventilate, especially when working on a large print. And you must take care not to emit tiny drops of saliva that could land on the print and darken the dry dyes.

Viewing Filters. Although they are an optional item, color print viewing filters are a valuable aid in making color corrections with the dry dyes. They are sold in sets that also include instructions for using them.

Mix Dry Dyes to Make Your Own Colors

Kodak Retouching Colors are sold in sets of nine colors: yellow, orange, brown, neutral, red, magenta, blue, cyan, and green. At one time, a flesh color was included in each set of dry dyes. This has since been discontinued, and it is a shame. I find that I need a flesh color quite often, and it is difficult to obtain by using just one of the other available colors by itself. But it is possible to mix dry dyes to make your own colors. Here are the formulas I use to make three additional colors that I need regularly:

Flesh: Equal parts of red, yellow, and brown.

Cool Purple: One part blue to one-quarter part magenta (this purple is especially good for toning down areas that are too yellow or orange).

Warm Purple: One part blue to one-half part magenta.

The dye cakes can be divided by slicing them into equal parts with a heated knife. For more accurate measurements, melt the dye thoroughly in a microwave and use a measured dropper (available at pharmacies) to siphon off the needed amount. If you are using droppers, be sure to use a new dropper for each color to prevent contamination. Put the removed portions in a new container. Small containers are sometimes sold at variety and specialty stores, or you can use cosmetic containers of a similar size and shape. Previously used containers should be cleaned out thoroughly so that no residue from the previous product is left. Remelt the dye in its container. Don't allow it to cook—just melt it until no lumps remain. Stir thoroughly with a toothpick to intermix the colors. Use a different toothpick for each color. Put a lid on each jar of color and refrigerate for about an hour; then return to room temperature.

Demonstration 5
Color-Correcting with Dry Dyes

When you have set up your usual gear and assembled the special materials needed for working with dry dyes, prepare your practice print by cleaning the surface gently with a cotton square. You may use the same photograph you used for spotting, but make sure the print is completely dry and that there are no fingerprints, residues from spotting, or scratches on the surface. These could cause the dry dyes to collect and become too dark in places. Make sure your print has not been sprayed.

Step 1. *Mount your print to a work board and read it for color corrections. You'll be looking for large areas that might benefit from color enhancement or that are too light and need a little toning down. In this demonstration, the model's pale complexion will be given a warmer glow overall, and the brightness in the forehead will be toned down to focus more attention on the rest of the face.*

If you have viewing filters available, look at the photograph through them. Viewing an area through each color of filter will show you what the area will look like when that color is added to the print. Otherwise you will have to use your own judgment. Adhere to the color rules you learned in Chapter 2 and refer to the chart on page 13 if necessary. With a little practice, you won't have much difficulty choosing the correct color.

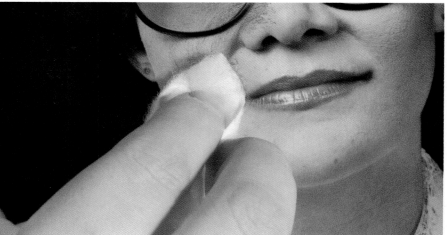

Step 2. *Select the base color with which you will make your color corrections and breathe gently on the cake of dye to moisten it slightly. This will make the dye easier to pick up and spread. Pick up a generous amount of dye by rubbing a cotton square, Q-tip, or your finger over the cake of dye. (Do not use your fingers if your hands tend to sweat, as the moisture could cause the dyes to react.) With a circular motion, smooth the dye over the desired areas on the print. If there is an insufficient amount of dye to spread over the entire surface uniformly, you must apply more dye before steam-setting the color. Otherwise, it won't blend smoothly with subsequent coats.*

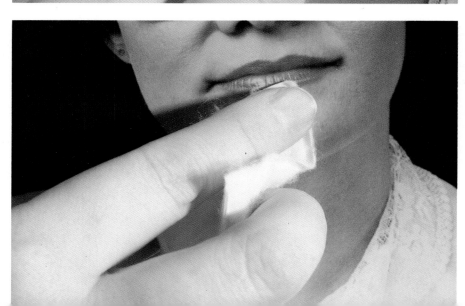

Step 3. *Smooth out the dye by buffing lightly with pure cotton. Take care at this point to avoid getting the color in light areas where you do not want it, such as the whites of the eyes, teeth, and blouse or shirt collars. After the initial buffing, go back into highlight areas such as the forehead, cheeks, chin, and nose. Rubbing harder, buff the dye down some more. It is very important that these highlights remain as crisp and clean as possible, as this is what gives a portrait its dimension.*

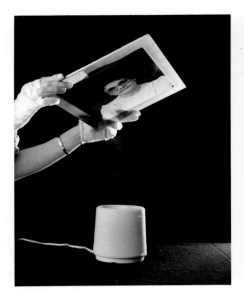

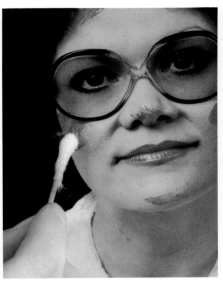

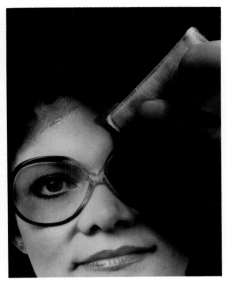

Step 4. *The emulsion of the paper will accept only one coat of dye at a time, and so the surface must be steamed to set the dye before another coat can be applied. To do this, pass the print slowly over the source of steam. Avoid letting the print get too damp, and check for any possible "spitting." When the surface marks caused by the dye application disappear, you have steamed the print sufficiently. Do not touch the print until it dries, and make sure that the print is completely dry before you apply the next coat of dye. Alternate the applications of dye and steam until you have achieved the desired results.*

Step 5. *In addition to the base color of the complexion, some additional blush applied to the cheeks, forehead, and chin will create a rosy glow all around the face. A little red on the tip of the nose will make a particularly distracting one less obvious. If you are working in relatively small areas, use a Q-tip as an applicator so that the color will be confined to the places where you want it. This is particularly important when you are applying lip or eye color. The Q-tip can also be used for blending to some extent.*

Step 6. *The red must be buffed down satisfactorily to avoid a gaudy look.*

Generally, dry dyes can be applied successfully to faces, clothing, and other large areas where the color does not have to be absolutely even. But in a large area with very little density such as a very bland, white sky, it can be difficult to keep the dyes smooth. I do not suggest attempting this type of correction unless you are able to use the unevenness of the dyes to your advantage—by adding clouds to the sky, for example, so that the blotchiness can work as an asset.

Adding lots of density also can be accomplished better with another medium.

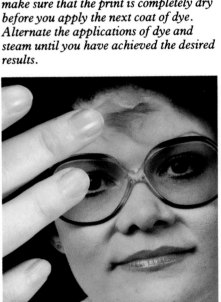

Step 7. *To darken an area that is too light and contrasty, add the neutral dye, steam it, and repeat the process until the density is brought down. The color marked "neutral" is supposed to denote density, but it is not truly a neutral gray, and you'll probably need to color-correct as you go.*

Avoid These Common Mistakes

This photograph shows two of the problems you must try to avoid when applying dry dyes: wet spots, which turn the dye dark and blotchy, and smudges of dye color in areas where it is not wanted. Both of these problems are extremely difficult to correct.

Thorough buffing in highlight areas is very important, as this badly retouched example shows. The unattractive muddy highlights make the model's complexion look unnatural and flatten the natural contours of her face.

 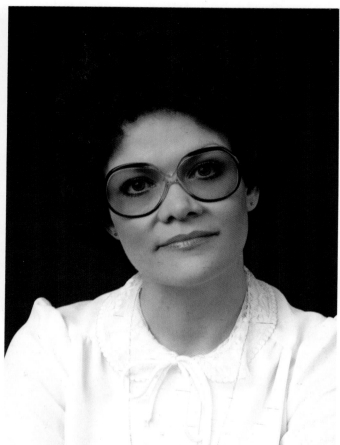

After Adding Dry Dyes. A comparison of the same print before and after correction with dry dyes reveals the dramatic changes that have taken place. This is why it is helpful to have a duplicate print on hand for reference. Because the complexion has been given a rosier glow, the entire portrait is beginning to take on more warmth. Toning down the brightness of the forehead has made it easier to focus attention on the subject's eyes and the lower part of her face.

How to Remove Dry Dyes from a Print

Steam-set retouching colors can be removed with ammonia in the same manner as the spotting dyes are removed. (See page 45 for complete instructions.) The ammonia, in turn, should be washed off the surface of the print completely with water. Ammonia can endanger the life of the print and, over a period of time, cause a washed area to fade. Washing is never advisable, and should be avoided whenever possible.

McDonald Pro-tected Photographic Lacquer with UV Inhibitor

Matte Special

McDonald Pro-tected Photographic Lacquer with UV Inhibitor

Lustre

McDonald Pro-tected Photographic Lacquer with UV Inhibitor

Clear Gloss

McDonald Pro-tected Photographic Lacquer

Pro-Texture

PARKS 2215

T-3000

Lacquer Thinner

High strength lacquer solvent and cleaner

Moderate evaporation rate

DANGER! POISON! FLAMMABLE. MAY BE FATAL OR CAUSE BLINDNESS IF SWALLOWED. VAPOR HARMFUL. SKIN AND EYE IRRITANT. See other cautions on back panel.

ONE QT. (32 FL. OZ.) .95 LITER

Chapter Seven

Spraying the Photograph

Spray lacquers are used on photographs for two purposes: in order to alter the surface of the photograph, and for protection. A sprayed photograph is protected from fingerprints, humidity, and sticking to the glass after being framed. The sprayed surface is also less likely to sustain emulsion damage if scratched or if liquid is spilled on it.

Spray lacquers go on clear and smooth. They dry fast, their excellent adhesion prevents them from peeling, and added plasticizers keep them from cracking. Available in a range of finishes, lacquers are used both during the retouching process and afterward to seal in artwork and provide the desired finish. There are also textured finishing sprays and lacquers which create special effects.

Retouching lacquers give a photograph's surface a rough, gritty texture called tooth. This flat, matte finish accepts pencil, oil, and pastel—materials that will not adhere to an unlacquered print. If the artwork is limited to the spotting and dry dye procedures, retouch spray is not a necessity, and the original finish of the print can be maintained.

Taking Safety Precautions

Fumes from retouch lacquers are very strong, and they are potentially dangerous. Because they are combustible, you must avoid spraying near any open flame, such as a pilot light or a burning cigarette.

The fumes are also very toxic, and breathing in these vapors should be avoided. Using a paint mask, available at most paint and hardware stores, will help. A spray booth is a good idea because the ventilation system will pull the spray up and out of the room. If you don't have a spray booth, take the photograph to another area to

spray. It is hard to determine the extent of the damage that could be sustained from continued exposure to lacquer fumes, but breathing them could be detrimental to your health over a long period of time.

Fumes and residue from sprays also tend to float and penetrate all areas. My home always had a rather unique odor before my new spray booth was completed. At a school where I occasionally teach, there is a standing joke that everyone knows when I'm teaching that day because they can "smell" me.

Some people are much more susceptible to the fumes than others. If I spray outside of my spray booth, my husband gets a headache with the first squirt. Some people have strong allergic reactions to the lacquer and shouldn't use it at all. Pregnant women should avoid using spray or breathing the fumes, as the developing embryo could be adversely affected at certain stages. Infants and small animals, such as pet birds, also can be more strongly affected than a larger person.

Spray lacquer fumes can damage contact lenses, particularly the soft variety. These should not be worn near the spray without protective goggles.

Spraying lacquers also spreads a dusty film that will float all over your work area, requiring regular dusting. A spray booth and an air-filtering device can help alleviate some of these problems.

Some Limitations of Spraying

The photographic emulsion has a tendency to contain static, which pulls airborne dust and lint to its surface. This attraction causes particles to get caught in the spray, a problem that is difficult to control even with anti-

static cloths and tack rags, a spray booth, and an air-filtering device.

Prints that require a lot of artwork often need many coats of spray, but this heavy coverage can cause two problems. One is that an unmounted print can begin to curl. When you anticipate spraying a print many times, it is best to pre-mount it. This is an especially good idea if the print requires penciling, as the heat from dry-mounting may melt pencil work and make it look more obvious.

The second problem is that when several coats of spray have built up, you may notice a slight yellowing. This is most noticeable on black-and-white prints, pictures with large areas of white such as bridal photographs, and prints with predominantly high-key colors. You'll notice yellowing much more quickly on a print that already leans toward the yellow side, rather than one that is cooler. When this happens, the yellowing can sometimes be alleviated by adding a little white oil paint to the highlight areas. Your only other alternative is to strip the lacquer off the print and redo the artwork, trying to use less spray. If a black-and-white print is to be used for reproduction purposes, yellowing will not reproduce, and you can ignore it.

Materials and Equipment for Spraying Photographs

How much you invest in spraying equipment will depend on your budget, the frequency with which you use spray lacquers, and your own preferences. Fortunately, many of the materials you'll need are neither complicated nor expensive. However, because spray lacquers can be both tricky to use and dangerous, you should take safety into account as well as efficiency when choosing your equipment.

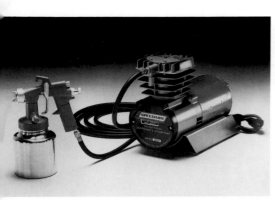

Spray gun and compressor

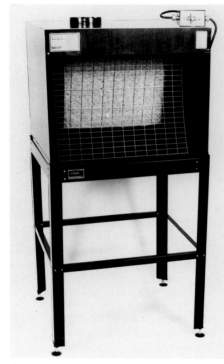

Spray booths can be purchased ready to install . . .

. . . or you can design and build one to meet your personal requirements.

Sprayer. The first choice you must make about your equipment is whether you prefer to use spray cans or spray guns. Most beginners choose the convenient cans, which may be purchased one at a time or by the case. Cans of spray lacquer are carried by most photographic supply stores. You should choose one brand and stick with it. Never combine different brands in the same photograph because the products may not be compatible. Every brand comes in a selection of different finishes ranging from flat retouch sprays to high-gloss lacquers. See the list of suggested retouch and finishing lacquers below.

Although it is easier to get a thorough and even coat on larger prints with a spray gun, the main reason many professional artists and photographers choose this method is an economic one. Lacquers are much less expensive when purchased by the gallon, and these savings will quickly offset the initial cost of purchasing a complete spray outfit.

There are two ways to use a spray gun, with pressure feed and with suction feed. When purchasing spray equipment, be sure it has both options—or that the type you select pertains to the types of lacquer you will be using. A pressure-feed spray gun allows incoming air to press down on the lacquer in the cup, forcing it out through the nozzle. This is controlled by opening the valve on the side of the spray gun. The same gun can be used with the side valve closed, which causes the lacquer to be drawn from the cup in the same manner as an atomizer. Suction feed is used for spraying basic lacquers. Pressure feed is used for spraying higher viscosity (thicker) lacquers such as the special textured finishes. These thicker lacquers should be sprayed at an air pressure of 18 pounds. WARNING: *Do not use an electric vibrator gun for spraying lacquer,* as the fumes could cause an explosion. Paint enamels and water-based materials are excellent for this type of gun, but lacquers are potentially very dangerous.

Air Compressor. Your spray gun must have an air source. The compressor must be able to provide 25 pounds of continuous pressure. Be sure it is not the kind of compressor that pulsates. You can't achieve a smooth, even coat with pulsating air. This compressor should have a gauge and regulator to control the air pressure, and a moisture trap for drying the compressed air. Most manufacturers of lacquers also sell the spray gun and accessories.

Spray Booth. As discussed earlier, a spray booth is not a necessity if you spray in an area other than your main work area or where adequate ventilation is available. It is, however, quite a nice luxury, and it is almost a "must" if you spray frequently.

Most manufacturers of lacquers also produce spray booths, which have features such as a fan-cooled blower motor that is enclosed in steel for spark protection, a lighted interior, a remote on/off switch, an air/rain trap, and special filters designed to work in conjunction with the blowers and exhaust to ensure safe disposal of spray contaminants. You have the option of purchasing a spray booth or building your own. See the specifications on this page to make a spray booth that should suit your needs.

Lacquers. Keep on hand retouch lacquer and also a semimatt and a high-gloss finish, as well as a variety of special textures.

Lacquer Thinner. You will need to be able to remove both lacquer and artwork that are unsatisfactory. However, lacquer thinner will not remove spotting dyes or dry dyes—only lacquer and art materials that have been applied over it can be removed. Lacquer thinner can be purchased from most paint suppliers.

Lacquer Retarder. Humidity in the air causes "blushing," which gives the sprayed print a whitish or cloudy appearance. If the humidity is over 80 percent and you are using a spray gun, you can add a 10 percent retarder to the lacquer to slow the drying process. Available in cans, lacquer retarder also can be sprayed onto the print after lacquering. The retarder actually resoftens the lacquer, slows down the drying time, and enables the moisture to escape. Certain geographical areas are more prone to humidity problems than are others.

Static-Free Cloth. You'll need a very soft cloth that has been treated with a static controller and will not scratch the photographic emulsion. These cloths are commonly used on phonograph records and television screens.

How to Build a Spray Booth

The specifications given here and diagrammed in the front- and side-view drawings are for a spray booth that can handle prints up to 20″ × 24″. Before you purchase materials or start construction, remember to check your local building, electrical, and fire codes. You may need to modify your booth design and specifications accordingly.

The best material for constructing a spray booth is 20-gauge galvanized steel or .040 aluminum sheet, although some local building codes may allow you to use ¼″ Masonite. One-inch aluminum angles or lightweight 1″ steel angles can be used to secure the sides together at the corners with nuts and bolts or sheet-metal screws.

You'll need a 12″ diameter exhaust fan, the kind designed and built especially for heavy-duty exhausting paint spray booths. Non-sparking, balanced cast aluminum blades are used for these fans. (You can either contact your local supplier or get information on this particular fan by contacting W. W. Grainger, Inc., 5959 W. Howard St., Chicago, Ill. 60648. Refer to Dayton # 4C020 for the 12″ blade or, if you have a larger booth, to Dayton # 4C370 for the 18″ blade.)

The fan can be mounted anywhere in the exhaust system—on top of the roof, on top of the booth, or in the back of the booth if you vent the system out the side of the work area—depending on what your local codes allow.

A fluorescent lamp mounted inside the top of the booth, with a safety glass between lamp and booth, will provide the necessary light so that you can see the entire print to be sprayed. Be sure to use explosion-proof switches on your light and the fan motor to meet your local electrical and fire codes; both switches must be located *outside* the spraying area.

An air-conditioner filter can be used to prevent lacquer-spray buildup on the exhaust fan. It should be located in a convenient place so you can change it easily. Failure to change your filter can result in loss of the air flow neces-sary for removing excess spray and odors. If flow is reduced, it can also cause damage to your fan motor by causing it to work harder.

The size of your print rack should be determined by the largest size prints you'll be spraying. If large prints in excess of 20″ × 24″ are to be sprayed, you will need a larger fan and booth. My spray booth is built to handle up to 20″ × 24″ prints. The spray rack can be made from expanded metal with an angle-iron frame. My spray-booth print rack is made from a 2′ by 4′ plastic fluorescent light fixture grid, cut down to size. Whatever material you use, be sure it can be removed or cleaned easily when spray buildup becomes noticeable.

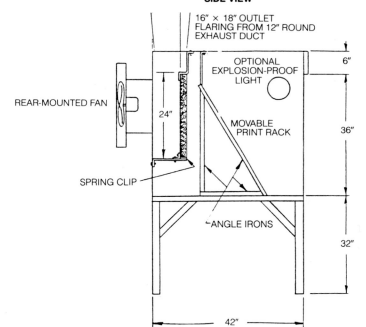

FRONT VIEW

TOP-MOUNTED FAN AND EXHAUST DUCT
PLACEMENT OF AIR-CONDITIONER FILTER FOR TOP-MOUNTED FAN
LOCATION OF FLUORESCENT LAMP
FAN AND LIGHT SWITCHES MOUNTED *OUTSIDE* BOOTH FOR SAFETY
OPTIONAL LOCATION OF EXHAUST FAN AND PRINT RACK (MADE FROM AIR-CONDITIONER FILTER)

4″ 6″ 24″ 36″ 32″ 20″ 42″

SIDE VIEW

16″ × 18″ OUTLET FLARING FROM 12″ ROUND EXHAUST DUCT
OPTIONAL EXPLOSION-PROOF LIGHT
MOVABLE PRINT RACK
REAR-MOUNTED FAN
SPRING CLIP
ANGLE IRONS
24″ 6″ 36″ 32″ 42″

Tack Rags. Tack cloths are slightly tacky and should not be applied to a raw print, as they could leave a slight residue behind. But they are very helpful, after the first light coat of spray, for wiping the print before subsequent coats are applied. The tack rag will pick up any small pieces of dust and lint that have fallen on the surface, giving you a much better chance of achieving a clean spray coat the next time around.

X-Acto Blades. Mat-knife blades are used for very carefully picking out pieces of trash that are slightly caught, but not totally embedded, in the spray surface.

Extra-Fine Sandpaper. Sandpaper is used when trash has become totally embedded in either a heavy coat or several light coats of spray. The only way to remove this kind of problem without digging an obvious hole in the surface is to sand it out smoothly. Sanding is also used in conjunction with spraying to correct other surface flaws. This method can be used for correcting scratched or torn photographs, as well as for evening out the surface when too much retouch lacquer or airbrushing has left it rough and bumpy.

Applying Lacquer with a Spray Can

Most beginners prefer spray cans to a spray gun, as they are much less complicated to use. They are also more convenient than a spray gun when spraying is done infrequently or at intermittent intervals.

All lacquers, except for the high-gloss finishes, require complete agitation each time you use them. This is done to ensure that the matting agent, which is in suspension and may have settled to the bottom of the can, is dispersed evenly throughout the solution. For this purpose an agitating ball has been placed in each spray can of lacquer. It may sometimes take a tap to knock this agitating ball loose.

Agitation is especially important for retouch lacquer, which has more matting agent added than do the other finishes. Insufficient agitation will produce a finish with too much tooth at the beginning of the can, and little or no tooth at the end of the can. A can that has been allowed to sit for a period of time and is sprayed with no agitation will produce mostly matting

agent with little lacquer. The surface of the print will look as if baby powder had been shaken over it. It is quite unnerving to have this happen to a print that has heavy artwork on it. The only way to correct it is to remove the lacquer, including any artwork that has been applied over previous coats of spray. Being in a hurry only costs you time in the long run. Take the time to agitate the cans of lacquer properly.

After you have agitated the can, before spraying the print, depress the nozzle for about one second to clear the feeder tube of any concentrated matting agent. If the spray-can nozzle should become clogged, scrape a fingernail over the nozzle outlet to clear it. Nozzles may also be cleaned by soaking them in lacquer thinner. *Don't* hold the can upside down and spray to clear the nozzle.

Test the spray pattern for proper atomization before spraying on the print. If the lacquer isn't spraying properly, try using another nozzle. Keep spare nozzles to replace ones that have become plugged or don't work well. Sometimes just giving the nozzle a turn helps. Depress the nozzle fully and be sure your finger isn't too far forward. (This will prevent droplets from forming on your fingertip and being blown onto the photograph.)

Small prints may be laid flat for spraying, but prints larger than 11″ × 14″ should be at an angle. In order to get an even coating of lacquer from the spray can, direct the spray at about a 30-degree angle to the print. Hold the spray can five to eight inches away from the print. Apply a uniform wet coat in a three-inch-wide swath across the print, working with successive, slightly overlapping strokes toward the unsprayed area, until the print has been covered.

Using a Spray Gun

Spray guns are more economical than spray cans if you do a great deal of spraying. Because spray guns must be cleaned and stored carefully, it is more efficient to group your work, if possible, and spray all photographs at one time. But when spraying is done intermittently, as in retouching, it is more convenient to use spray cans.

To make working with a spray gun more convenient, use a different canister for each finish. Use a canister

of lacquer thinner to flush out the gun when you change from one type of lacquer to another and also when you are finished spraying. Always follow the manufacturer's directions for cleaning the spray gun. Remove the nozzle after spraying, and store it in the thinner canister to keep it clean for future spraying. Don't leave lacquer in the gun for several hours or overnight.

Before pouring lacquer into the spray gun, agitate it well. As with the spray cans, all lacquers except high-gloss finishes have a matting agent which must be thoroughly blended into suspension with the lacquer each time you use them. One way to agitate a gallon can of lacquer is to hold the can down at arm's length by the wire handle and twist your wrist vigorously back and forth. The round base of the can directs the lacquer in a whirlpool motion, first in one direction and then in the other. This is more effective than simple stirring. Placing a marble in the lacquer will facilitate agitation. There are also special devices on the market designed to agitate and pour lacquers.

Keep gallon cans of lacquer tightly sealed. Precautions must be taken not to contaminate the lacquer by allowing it to dry on the inside of the cover or sides of the can.

If lacquer has dried on the cover or can as a white powdery substance, use a paper towel and lacquer thinner to remove it before pouring lacquer into the canister. This way you can avoid white specks in the lacquer finish when you spray. There are strainers available commercially, or you can strain the lacquer through two thicknesses of nylon stockings to help alleviate this problem. Naturally, all spray equipment should also be kept clean and free of dried lacquer.

For basic lacquer, be sure to use a suction-feed gun (that is, one with the side adjustment knob closed and the fluid-adjustment knob, lower rear, open approximately 2½ turns). The air-vent hole in the side adjustment knob must be open to allow air into the cup to replace sprayed lacquer. Many sprayer malfunctions are caused by blockage of this opening.

Apply high-gloss lacquer at no more than 25 pounds of pressure. The other finishes may be applied at 20 to 35 pounds of pressure.

Moisture in the air hose is the cause of many of the "white speck" prob-

lems encountered in spray-gun lacquering. A moisture trap should always be used between the compressor and the spray gun. This trap should be mounted at least four feet higher than the compressor, and fifteen to twenty feet away. Drain the trap daily. An effective trap can be constructed easily from 3/4″ galvanized pipe. (Plans for building such a trap are available from McDonald Photo Products, Inc., at no charge. See the Appendix for details.)

To spray, place your print at an angle, either on an easel or on the slanted grid in the spray booth. Turn the air cup horizontally so that you are spraying a vertical pattern of lacquer. Starting at the bottom of the print and holding the gun four to five inches from the surface, make successive left-to-right passes that overlap each other about one third as you move up the print. On each horizontal pass, be sure to start spraying before reaching the edge of the print and to continue past the opposite edge to assure a uniform coating. Beginning and ending off the surface of the print prevents a buildup of lacquer on each side.

After spraying horizontal swaths from bottom to top, immediately turn the air cap 90 degrees so that you get a horizontal spray pattern, and repeat the process with vertical overlapping strokes. The result will be a very smooth, even, wet coat that will form a waterproof plastic film, thoroughly sealing the print. Remember to spray thin, wet coats. Do not spray too heavily. Allow prints to dry thoroughly before stacking.

When using retouch lacquer, a thorough coating is necessary only for the first and final coats. The intermediate coats can be very light.

Diagnosing Problems

If you are not getting good results when you spray, studying the appearance of the print's surface may help you find and eliminate the cause of the problem.

"Ribbons." Spraying without overlapping will result in ribbonlike bands of lacquer across the surface of the print. Whether you spray with cans or a spray gun, overlap each stroke for even coverage.

"Orange Peel." A rippled surface is caused by spraying too close to the

print and too heavily. This condition also can be caused by lacquer that has thickened. Most lacquers should be used at 20-second viscosity. This can be checked with a viscosimeter, also called a viscometer. If the lacquer has thickened, it can be thinned with a good grade of lacquer thinner.

Mottled Patterns. A dull, spotty surface may result when spray is not applied thoroughly. Whether you apply a flat spray over a glossy print or glossy spray over a matte finish, you must spray thoroughly. To bring a surface from a flat matte to a high-gloss finish usually requires three or more coats of spray.

Craters. Spraying the lacquer too closely and too slowly can cause small craters in the lacquer. They also may be caused by algae in the bleach. Close examination may reveal a tiny bit of algae in the center of a small area that seems to resist the lacquer, causing a crater. To eliminate the cause of the problem, inform your photo printer that his or her bleach tank needs to be flushed with an anti-algae agent. To remove algae already on a print, clean the surface with lacquer thinner. Silicone sprays and silicone-impregnated bits of dust may sometimes cause a similar effect; these also can be removed with lacquer thinner.

Tar. Brownish-black spots of tar may be on the print before spraying, but lacquer makes them bleed out and become more noticeable. Notify your printer to use an anti-tar agent to prevent the problem from occurring. Tar can be removed from a print with lacquer thinner.

Rough, Sandy Surface. A gritty surface is most often associated with the matte and retouch sprays. If accompanied by a dusty white appearance, the problem is caused by insufficient agitation of the lacquer before using it. It also can be caused by spraying too far from the print. If you are using a spray gun, too much pressure could be causing the spray to dry before it hits the print. Spray that is applied too sparingly and not allowed to flow out into a smooth coat also can create a rough surface. This is a common occurrence in retouching because you must constantly give the print a quick squirt for additional tooth. You can correct this only by

either stripping the print or sanding the surface smooth. Unfortunately, when a lot of artwork has been applied under the lacquered surface, sanding is often the only viable solution because stripping would remove so much time and effort.

Curling. Apply lacquer in thin coats. Spraying too heavily or too often can cause a print to curl. Spray as little as possible.

Reticulation. Lifting or bubbling of lacquer from the print does not occur often, but when it does it is usually due to the presence of excessive or partially dried oil paint on the print prior to spraying. Lacquer may be applied over oil, but the coats must be very light, and the oil should *not* be allowed to dry before spraying.

Pinholes. Pinholes are caused by trapped solvents breaking through the surface when lacquer has been applied too heavily. If you are using a spray gun, moisture in the spray line also can cause this problem. Check the water extractor.

Locating the Cause of White Specks

Most spray-gun problems manifest themselves as white specks in the lacquer. Check the following as possible sources of the problem:

1. Did you agitate the lacquer completely before using it?
2. Is there moisture in the line?
3. Is the spray gun clean? To be sure, take it apart and clean it with lacquer thinner.
4. Are you holding the gun too far from the surface of the photograph? It should be held about four to five inches away from the print.
5. Is there too much air pressure?
6. Has lacquer dried on the sides of the can?
7. Has the nozzle been tightened properly? Lacquer could be getting into the air passages or the air cap and coming out as dry particles in the spray.

Blushing. A white, cloudy appearance is caused by high humidity. If possible, it is advisable to postpone spraying until conditions are more favorable. If not, then dry the print in a warm mounting press before spraying. Adding a 10 percent retarder to the lacquer in a spray gun or spraying over the cloudy lacquer surface with retarder should eliminate the problem. Placing the wet, sprayed print in a closed box to dry also can slow the drying time, allowing excess moisture to escape.

Cyan or Blue Spotting. Humidity can cause a more extreme form of blushing that appears as bluish spots. Drying the print in a warm mounting press before spraying can help to alleviate the problem. Apply medium to light coats of lacquer, and allow the lacquer to dry well between coats. In the event that blue spots have occurred, clean the print immediately with lacquer thinner, wash with water, and dry thoroughly. The blue spots will disappear, and when the print is resprayed, they will not reappear.

Orange or Pink Areas. Certain discolorations are known to appear on some prints several months after they have been finished. This problem is related to water, moisture, and contamination of the print while it was being worked on prior to spraying. It isn't a lacquer-related problem.

Overall Yellowing. Many layers of spray may cause a photograph to yellow. One manufacturer states that up to ten coats of lacquer can be applied before yellowing is noticeable. I have also seen prints that yellow over a period of several months. This may be caused by a bad can of spray, or it may be a chemical reaction. The yellow is usually in the lacquer only; stripping and respraying the print should correct the problem.

Additional Spraying Tips

Your spray area should be as dust-free as possible. Some unsuspected causes of dust in a spraying area can include: a fan in the spray booth which pulls in dust from surrounding areas; a spray booth with loose, dry lacquer buildup which may fall onto prints; bulk cotton near the spraying area; carpets; and linty or fuzzy clothing such as velours and velvets.

The temperature of both the spray and the spraying area shouldn't be below 65° F. Ideally, the humidity in the spray area should be kept at 50 percent or less, since excessive humidity can cause spraying problems such as white specks, blushing, and (very rarely) cyan or blue spotting. Avoid spraying in a cold, damp room, and don't store lacquer on a damp floor. Never apply spray to a wet emulsion; the lacquer could cause it to crack.

The print should always be wiped clean before the initial spraying, and between subsequent coats. Use a static-free cloth or tack rag on the photograph between coats of lacquer to ensure a dust-free surface. I am hesitant to use a tack rag on an unlacquered print for fear that residue left on the surface could cause problems later. It works extremely well, however, for subsequent coats of lacquer. There are special static brushes on the market which aid in controlling static, and these can be used directly on a raw print. When lint and trash do get caught in the spray, they should be removed before the print is sprayed again.

To remove particles caught in the spray lacquer, you must act quickly before it dries. Lint that is barely caught and is sitting loosely on the surface can be picked up with tweezers or by breaking a toothpick and hooking the lint on one of the small splinters that stick out. Be careful not to touch the wet surface. The mark left in the spray by the lint will usually re-level itself before the spray dries. Most lint will become unstuck when wiped with a tack rag. Particles that remain caught can be removed by scraping them up very carefully with an X-Acto blade. If this leaves a spot that shows, respray the print.

Particles that are totally embedded in the lacquer create the biggest problem. Removing them with an X-Acto blade would dig holes into the lacquer. Unless a lot of artwork has already been applied, your best choice in such a situation is to strip the lacquer and respray. If stripping isn't feasible, the surface can be sanded lightly with fine sandpaper. Be very careful, however, to make sure the lacquer is thick enough to prevent the sandpaper's penetrating through to the emulsion of the photograph. The sanded emulsion could be extremely difficult to correct. Unless the print has had numerous coats of spray, I don't recommend sanding. Depending on the location of the embedded particles, you may even decide they are not noticeable and can be lived

Sanding the surface will usually remove most particles that are imbedded in the spray. Take care to sand only the lacquer, not the emulsion.

When resprayed, sanded lacquer once more has a smooth finish.

with. Unfortunately, lint usually seems to land in lighter areas where it is sure to show up terribly. After sanding, the surface of the print will look terrible, as if you'd ruined it. It's surprising how the next coat of spray will even out the sanded area.

Freshly sprayed prints shouldn't be stacked on top of each other. Although they feel dry to the touch, the spray could still be soft underneath. Prints that are to be framed behind glass should be allowed to dry three or four days to ensure that all moisture has escaped and the spray will not stick to glass. Prints that have been sprayed actually don't need to be placed behind glass because they are already protected.

Many manufacturers now mix ultraviolet (UV) inhibitor with their sprays, either as a uniform ingredient in all lacquers or as an optional selection. The ultraviolet inhibitor is meant to block harmful rays of the sun that could fade the print. Manufacturers say that, even though 99 percent of these rays are blocked by this special spray, photos still should not be hung in direct sunlight. Any photograph constantly exposed to ultraviolet rays will eventually fade; the special spray can only delay the process.

Special Textures

Lacquer manufacturers have a large variety of finishes to offer. These not only range from very flat retouch sprays to beautiful shiny glosses but also come in many special textures that are real customer-pleasers. They add quality to the final product and also mute artwork a little, making it less obvious. If you have something to hide, texture is often the answer.

Although beautiful and popular, special textures are not suggested for competition prints. This is the only circumstance in which a high gloss is always the best choice. Judges don't want to see anything that detracts from the photography in any way.

Lacquering can be quite a headache, but it is a necessity in photography. Particularly in retouching, much of the work would be impossible without it. I encourage everyone to not only utilize retouch lacquer but also experiment with final coats as well. A photograph is never done until it has been given a proper finish.

Removing Lacquer from a Print

Different manufacturers may suggest different methods of removing spray with lacquer thinner. One way is to saturate paper towels with thinner, place them on the surface, allow them to sit until the lacquer is softened, and then wipe it off. Another method is placing the print in a tray of lacquer thinner for a few minutes and then wiping the surface clean.

I feel that the less time the thinner stays on the surface, the better. Therefore, I saturate a paper towel and rub it over the print swiftly. The lacquer thinner evaporates quickly and this necessitates changing paper towels quite a few times. Wipe the photograph until no lacquer remains on the surface. Any area that has been missed won't blend with later coats of spray. It must all be removed. To make sure, hold the print so that the light strikes the surface; any missed areas can be spotted easily. Don't apply so much thinner that it will be absorbed into the paper base

of the print at the edges. If the thinner soaks between the emulsion and the back side of the print, it will cause a permanent stain. Prints that have been mounted on foam board are particularly susceptible to damage. Lacquer thinner will actually dissolve the foam core of the board.

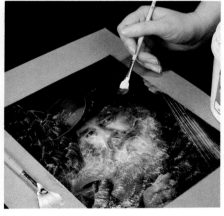

Special textured sprays offer unique finishes that are quite popular. Such finishes tend to subdue artwork that may be too noticeable.
Different brushes can be used to create strokes of a variety of depths and widths. Following the definition lines in the photograph with a larger brush helps to make it look more like a painting. Brush strokes should be allowed to dry thoroughly before finishing.
Perhaps the nicest finish of all is a combination of canvas mounting and brush strokes.

Berol. Prismacolor.

60 COLOR ART SET No. 960

Made in U.S.A. by Berol USA /division of Berol Corporation. Danbury, Connecticut 06810

Chapter Eight

Penciling

Wax-based pencils, which are available in a wide range of hues, are used whenever smaller areas need to be lightened on a print. They are excellent for correcting dark spots, lines, blemishes, and unwanted small reflections. These waxy pencils must be used on a lacquered print, and the finished work must be sealed with a final coat of spray. Until they have been sealed, pencils can be applied and erased at will, allowing the beginner an opportunity to play and experiment with ease.

Many beginners who have struggled with the spotting dyes are much more comfortable with pencils and prefer to use them instead. Although pencils were difficult for me to master and are not my favorite medium, perhaps they will be yours.

For the freelance artist who does not do negative retouching, penciling is the only way to lighten darker areas. I am usually quite happy with my results and find that when I get into trouble, it is often because of trying to do too much. The less penciling you do, the more natural the results are.

Some Limitations of Pencil Work

Unlike the liquid and dry dyes, pencils do not soak into the emulsion. They sit on the surface of the print, actually forming a new layer. This makes pencil corrections noticeable and difficult to blend into a print. A good negative retoucher can often eliminate the need for penciling at all.

Because the pencils are wax-based, they tend to melt a little when sprayed. This is like taking two steps forward and one backward. The artist may be quite pleased with the results and then, after spraying, find that the results are not so good after all. Penciling is very much a repeat process: spray and pencil, spray and pencil,

over and over until the desired results are permanent.

When you are covering an area that is very dark, you'll find that the density often continues to bleed through, requiring many applications of the pencil. Sometimes, after you have reached a certain point, you're better off switching to a combination of pencils, pastels, and oils to get satisfactory results. A combination of different mediums is often especially necessary for working on large areas such as heavy, dark bags under the eyes, or dark shadows. Pencils alone will not suffice.

Some pencil colors tend to change radically when sprayed. This can be quite alarming, and it is difficult to correct. The colors to watch out for are the warm ones—the reds, oranges, and browns. Avoid using these colors heavily. In addition, pay attention to the two different types of gray pencils, the warm grays and the cold grays. Don't use the warm grays at all because of their strong tendency to change color when sprayed.

The smoother the texture of the paper, the better the penciling results. Some of the pebble and silk finishes have rough surfaces that prevent pencils from covering smoothly. When working with paper of this nature, it is advisable to spray and sand the surface several times. This will cover the texture of the paper and give you a smooth working surface.

In warning you about some of the difficulties of this medium, I don't intend to discourage you from trying it. By comparison with negative retouching, the disadvantages of penciling are probably the lesser of the two evils. Your best choice, of course, is to use a combination of both techniques. No matter what method is used, removing dark areas is the major problem faced by photographic art-

ists. If you find yourself struggling with the pencils, know that you are not alone.

Materials and Equipment

Unlike some of the other retouching mediums, pencils require very little special equipment except for an eraser and adequate sharpening tools.

Pencils. There are many types of colored pencils available at art and office supply stores. Some are too hard and do not transfer to a photographic surface very well, but Prismacolors are softer and work well. They can be purchased in sets or individually. A complete set will give you an excellent assortment of colors, as well as a range of gray shades for correcting black-and-white prints. McDonald and Lacquer-Matt are lacquer manufacturers, but they also offer sets of retouching pencils in flesh shades. Purchasing one set of flesh colors would be a good idea, as having a variety of flesh shades on hand is especially important for making corrections in portraits. (Information on how to contact these two companies can be found in the Appendix.)

Derwent also produces some excellent colors, although this brand may be more difficult to find. These pencils can be purchased individually from dealers listed in the Appendix. Some good colors to start with would be Terra Cotta 19-64; Venetian Red 19-63; Pale Vermillion 19-13; Rose Madderlake 19-21; and Chocolate 19-66.

Eraser. The best choice of eraser is the kneaded variety. This type is soft enough not to scratch the photograph's surface and is sufficiently pliable to reach into small areas. (This pliability comes into service less often

with pencils than with pastels, which are discussed in Chapter 9.)

Sharpening Tools. A good pencil sharpener is a necessity. You cannot achieve satisfactory results without a sharp point. The type of sharpener you select will depend on your personal preference and budget. The most convenient, of course, is the electric sharpener, though you should be forewarned that the wax in retouching pencils tends to build up, and the sharpening rod must be scraped periodically. That is a small price to pay, however, for the time you'll save with this type of sharpener. Also keep a scratch board available to refine the tip of the pencil. By rubbing the pencil on its side, you can sharpen it to an exact point.

Preparing the Print for Penciling

A print must be sprayed thoroughly with retouch lacquer before you can apply pencil work to it. Check to be sure the entire surface is evenly coated with lacquer and that no emulsion shows through. To do this, tilt the print to let the light hit the surface. The finish should be completely matte, picking up no reflection at all. Any shiny spots showing through are the emulsion. If these are allowed to remain, they will resist the pencil, and your work will not adhere evenly. The less spray there is on the surface, the less pencil it will accept, as shown in these examples of pencil work applied to varying coats of lacquer.

It is also important that the spray be thoroughly dry before you begin penciling. Spray that is still a little moist will be soft, and the pencil will actually cut grooves into the surface. Allow at least five to ten minutes of drying time after spraying—more, in humid weather.

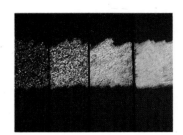

Demonstration 6
Correcting with Colored Pencils

If your practice print has been prepared with retouch lacquer and mounted on a work board, and your materials have been set up conveniently within reach, you are ready to begin penciling.

Step 1. The purpose of pencil work is to lighten the density of an area to match surrounding tones, but to do this, pick out a pencil whose density is several shades lighter than that of the area to be matched. Choosing an exact match would result in the density showing through the pencil, and the area would continue to be darker.

In correcting color photographs, don't worry about the color of the pencil at first. Once the density matches, getting the color to blend in is easy. If the area goes too light, it's not difficult to go back and add more density. The major problem is reducing the density satisfactorily in the first place.

Step 2. *Beginning in the lighter areas, pencil over the smaller spots that are too dark. Strokes should be made with very small back-and-forth, round-and-round movements not much larger than the sharpened point of the pencil itself.*

When density only needs to be lightened a little, not totally removed, use a very light touch. Barely graze the surface with the pencil, leaving only a slight residue of the lighter color. Once the density has been reduced sufficiently, change to a pencil that is the correct color.

Step 3. *With a slightly darker shade than you used for correcting the lighter areas in Step 2, begin to cover the very dark lines. Although you probably will not be able to eliminate them completely with pencils alone, this medium can accomplish a great deal.*

When the density must be lightened a lot, use very hard, firm pressure, and only touch the area that is too dark. You will notice that when you apply this much pressure, the surface very quickly becomes slick and will accept no more pencil. The darkness may still show through at this stage, giving your correction a bluish tint. This means you'll need to spray again in order to give the surface fresh tooth. The process may have to be repeated several times.

Step 4. *As your photograph improves with each new correction, and the most obvious flaws are eliminated, you will begin to notice details that had escaped your attention before. Some flaws will stick out like a sore thumb. But also pay attention to areas where the pencils could be used for enhancement, not just corrections: lightening the catchlights and whites of the eyes, for example, will help them command attention.*

Step 5. *When you correct a portrait, always try to keep the face symmetrical. Eyes, eyebrows, corners of the mouth, and ears should match each other as much as possible. In this photograph, removing the raised eyebrow helps to accomplish this.*

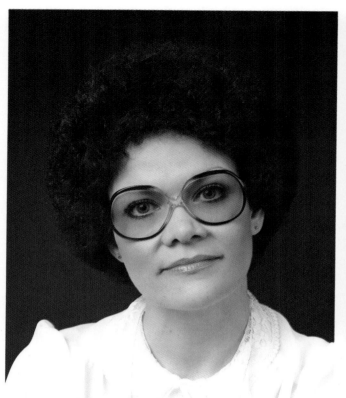 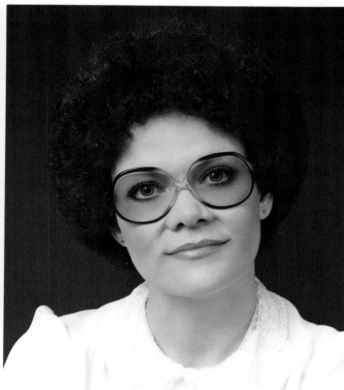

After Penciling. When you have completed the penciling process, compare your finished work with an uncorrected proof, if one is available. Your photograph may not be satisfactory yet, but with each step, it gets much closer.

Tips for Getting Better Results

Do not even hope to get the desired results with just penciling. Count on needing to repeat the process several times, as a certain amount of pencil will melt away with each coat of spray.

After you have applied the first thorough coat of spray, subsequent sprays can be directed very lightly at the area to be worked. It's not necessary to spray the entire print each time. When a print has been sprayed a number of times, the surface can become undesirably rough, and sanding is necessary to make the surface smooth and workable again. (Sanding the surface is discussed in Chapter 7.) Be sure to check the overall print for lint or dust that might be getting caught each time the print is sprayed. (The proper technique for removing this debris is also discussed in Chapter 7.)

Avoid getting such a heavy, waxy coat of pencils over a large area that it becomes too smooth and artificial-looking. This can be a common problem in portraits, especially under the subject's eyes and on particularly dark wrinkles. In the next two chapters, you will learn how to use pastels and oils in conjunction with pencils in order to avoid this.

With time and practice, you'll enjoy penciling more and more. The best part is when you view your finished work and know how far it has come.

Using Pastels

Pastels are soft colored chalks that come in a stick form and are available in a large range of colors. Using these chalks is similar to using dry dyes, except that the pastels also have a covering quality, whereas the dry dyes are transparent. Pastels can be used to make drastic color and density changes quickly.

For correcting color and density in large areas, the pastels are invaluable, especially for working on scenes. Colors added to grass, sky, trees, and related areas can look both natural and dramatic. Using pastels in coordination with pencils will give you smooth, natural retouching on portraits. The proper use of pastels on a woman's complexion can result in the velvety, flawless skin we see so often in advertisements (even though we know it doesn't exist in reality).

Although pastels cover well, they do not have the ability to actually lighten an area. What they do instead, however, is act as a blending medium. A very precise dark line can be softened by pastels to produce a rounded, graduating effect. This is often much more desirable than total removal of the density, which would create a flat, unnatural look. The contouring of facial features should always remain, but gently rounding flaws such as major wrinkles can have a very flattering effect.

Pastels are an enjoyable medium. They not only make very dramatic changes but also are easy and lots of fun to use. Mistakes are corrected easily, and opportunity for experimentation is wide open. This is a medium where your imagination can go wild and you do not have to fear the results.

Limitations of Pastels

Once you have learned the techniques for using them, there are hardly any limitations to pastels. Like pencils, pastels must be applied to a lacquered print surface and must be sealed with a final coat of lacquer to become permanent. And they can be applied and sprayed repeatedly until you have achieved the desired effect.

Until they have been sprayed, pastels can be applied and removed at will. They come off quite easily with a kneaded eraser, or even light rubbing with your finger. There is lots of room to play with this medium.

Perhaps the chief disadvantage of pastels is the fact that they don't reduce density very well. When you need to lighten a large area, your best choice would be either oils or air-brushing.

In addition, a certain amount of chalk tends to blow off the surface with each spraying. For this reason, it sometimes takes several coats until you are satisfied with the results.

When successive coats of spray begin to build up on the print, the surface gets much rougher. This causes chalk to collect in the crevices, and it becomes impossible to apply the pastels smoothly. If this occurs, sand the surface lightly and respray. Also

Pastels are an excellent medium for blending. They can transform a precise, dark line into a gently rounded curve.

Keep the Effect Natural-Looking

Pastels are ideal for adding a soft blush or some contouring to a face, but don't get too carried away. Cheeks should graduate in tone and should not be too red. A warm brown is often a better color choice than a red pastel for this. Smooth out the color so that the effect is subtle and natural.

The same principle holds true for pasteling smaller areas such as lips, eye shadows, and eye colors. Lips should not have a strong line where the color stops and the adjacent flesh tone begins. Keeping the edges soft and feathered will produce a more natural look. When adding eye and lip color, you may find it necessary to come back later with a pencil to brighten highlights.

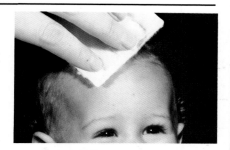

Removing Pastel from a Print

All unwanted pastel must be removed from the surface before a print is sprayed with a final coat of lacquer to seal the artwork permanently. A kneaded eraser can be shaped to the appropriate size for removing chalk from small areas. It can also be given a slight twist to soften, rather than erase, an area. And it is helpful for cleaning excess chalk from highlights to make them crisp and clear. For removing chalk from larger areas, a wet cotton swab makes a handy "eraser."

Stay within boundaries when you are cleaning off pastel; an unfortunate swipe into a colored area could be difficult to correct. Also take care not to fingerprint the powdered surface. Until the pastels have been sprayed, they are very susceptible to damage.

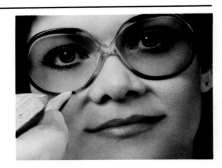

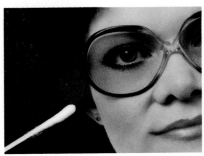

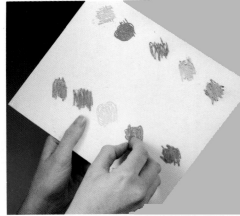

A scrap piece of white illustration board makes a good palette for pastels.

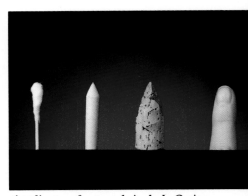

Applicators for pastels include Q-tips, paper stumps, chiseled corks—and, of course, your fingers.

be aware that any pieces of lint and trash caught in the spray will cause the same problem: pastels will build up wherever the surface is not smooth, and your final product could look very messy. Careful attention to the fine, minute points will help you avoid this.

Overusing pastels is probably the biggest problem for beginners. It is very easy to apply so much color that natural highlights are totally eliminated, resulting in a very flat, artificial look. Oils can sometimes be used to backtrack and put highlights back in, but it's better to avoid having to do this.

Adding very strong colors also can be a mistake. The sky should not be too blue, nor the cheeks and lips of a portrait too red. With time and practice, you will learn how to achieve more subtle, natural color.

Materials and Equipment

Pastels don't require a great deal of special equipment for working with them. The most important thing is the pastels themselves.

Pastels. Colored chalks come in a wide variety of brands, colors, and degrees of hardness. Some brands, and in particular some of the very soft pastels, can be quite expensive. For our purposes, however, it isn't necessary to go to such expense; the more

moderately priced, harder chalks will work just fine. These can be purchased at variety and art supply stores.

Pastels should be purchased on the basis of color. I have a very large selection, and it is not unusual for me to purchase an entire box for one desirable hue. For most artists, an assortment of basic colors, a selection of flesh tones, and a range of grays will suffice nicely. These chalks can be mixed with each other easily to get the variations you need.

Palette. Even the softest pastels are much too hard to be applied directly to the surface of a photograph—they will scratch the emulsion. For this reason, you need a pastel palette. A piece of mat board or even corrugated cardboard will work fine. The pastel stick is rubbed on the board until a "puddle" of powder has formed. This residue is then dipped into and applied to the print. I use three separate pastel palettes: one for the basic colors, one for flesh tones, and one for the grays.

Applicators. Pastels can be applied with a variety of tools, which are a matter of personal preference. My personal favorite is my fingers. I believe in really getting into my work.

Homemade cotton swabs (see the instructions on page 18 for making

them) are also quite good. The cotton swabs are especially handy for adding color to small, confined areas. Another popular applicator is the paper stump Available at most art stores, stumps look like pencils made out of paper. They come in an assortment of sizes and can be shaped to a fine point with sandpaper. A soft cork (like the kind that comes in wine bottles) also makes an excellent applicator. When chiseled to a fine point, cork is perfect for applying pastels to very small areas, and for adding detail. It works quite well for adding eyelashes, eye color, and sometimes, soft definition in teeth.

Eraser. The kneaded eraser is used to remove unwanted pastel from a print. Its pliability is valuable when erasing must be done in very small areas. It can be shaped to the finest of points to alter areas such as the nose, eyes, and mouth. This eraser also can be flattened and pressed over an area to remove only part of the pastel when too much has been applied.

Demonstration 7
Making Color Changes with Pastels

As in penciling, a thorough coating of retouch lacquer is essential before applying pastels to a print. Check the surface to be sure that no emulsion is showing through (these areas will appear shiny when the print's surface is tilted to the light). Pastels will adhere only to lacquered areas. Also be sure there is no lint or other debris caught in the coat of retouch lacquer. It is not necessary to wait for the spray to dry thoroughly before applying pastel; this medium differs from pencils in this respect. As soon as the spray is dry to the touch, you can begin.

Step 1. *Choosing the correct color and density of pastel is important. You'll need to use a chalk that is a few degrees* deeper *than you want the final results to be. When you work in lighter areas, the added color will be very obvious. In the shadow areas, you'll have to apply more pastel in an even deeper shade for it to show up. The very darkest areas will not be affected by the addition of pastel. Their density would have to be reduced before any color change could be noticed.*

Step 2. *Thoroughly saturate a Q-tip with the pastel and apply it lightly to the desired areas. Avoid putting pastel directly in areas that protrude, such as cheeks, nose, chin. The highlights need to be kept as clean as possible.*

Step 3. *Rub the pastel down thoroughly with a clean white tissue, taking care to blend the deep tones smoothly into the highlighted areas.*

Step 4. *Spray your first application of pastel with retouch lacquer to seal it, and then go back with more pastel to areas that require more density or color. Toning down a bright forehead or similarly distracting area can often be accomplished better with pastels than with dry dyes.*

Step 5. *Now check your photograph for areas where pastel could be used to blend pencil work, as well as to blend unsatisfactory spotting—perhaps in combination with more pencil work, if it seems to be called for. (Very dark areas, however, may also require oils as well for a completely smooth correction.) With the addition of a little red to warm the shadow areas, you can begin to see results.*

Combining Pastel and Pencil Work

When you use pastels in conjunction with pencils, it is necessary to apply the pastel first and then the pencil over it. Then the print can be sprayed, and the process repeated. When you are working to lighten very dark areas, such as wrinkles and heavy bags under the eyes, it is almost always necessary to combine the two mediums. Oils are also beneficial in this process, and their use is discussed in Chapter 10.

Step 6. *In addition to making corrections and subtly enhancing your photograph, you may want to try your hand at making more drastic color changes with pastel. The white blouse in the demonstration photograph offers an opportunity to experiment with this. To work a large area that needs drastic color or density changes, select a base color, apply the chalk very generously over the entire area, and then rub it back down. Be sure to use uniform pressure to keep the color smooth. If you want graduated tones, use heavier pressure in the areas that you want to be lighter. Spray and repeat the process until you have the effect you want. If you are working a modeled area and highlights are needed, these can be left until the next stage and then added with oils.*

After Applying Pastels. *Drastic changes have been made in the original picture, and the completely pasteled photograph now needs only a few final touches.*

Use Care in Making Large-Scale Corrections

When you use pastels to make drastic color changes in a large area, such as a sky, background, or clothing, take special care to get the color smooth. Do not rub with cotton: if the print's surface is rough, small pieces of cotton fiber will be left behind, as this photograph illustrates. Use tissue instead. You also should take care not to leave an overabundance of chalk powder on the surface; this could cause it to look blotchy when the spray lacquer blows some of it off. If one coat of pastel is not enough, spray and repeat the process until you have achieved the effect you want.

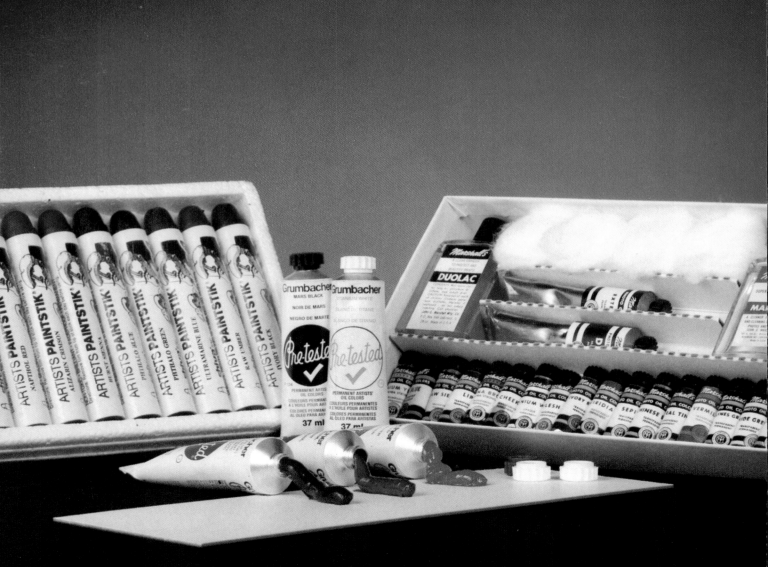

Chapter Ten

Applying Oils

Oils are a fascinating medium, and many corrections would be impossible without them. They can be used for large, elaborate corrections, and often, when an airbrush is not available, they will suffice for making drastic changes in a photograph. Adding color to black-and-white photographs, which is one of the most exciting uses of oils, is discussed separately in Chapter 15.

Because oils flow, they sink into every crack and crevice of a photographic surface, allowing for a smooth coating. This is why many people prefer oils to pastels for adding color to large areas. Any degree of correction may be made with them, from a slight tint to an opaque covering.

Their opacity and good covering quality makes oils useful for reducing density smoothly. Objects can be removed, toned down, or even added to a photograph. Entire backgrounds can be changed. The extent to which oils are used for retouching lies entirely in the hands of the artist.

Oils are invaluable for difficult facial corrections such as dark wrinkles and shadows. Lightening them with pencil often makes these areas look rough and grainy, but oils can accomplish the task smoothly and naturally. When they are used in conjunction with pencils and pastels, the results can be very nice.

Teeth and the whites of the eyes can be whitened easily with oils, which are the only medium with the capacity to whiten these small areas smoothly enough.

Because of their opacity and excellent blending ability, the oils are a natural for adding clouds to a dark sky. This may require a gradual buildup, but the results can be very beautiful.

Limitations of the Medium

The limitations of oils as a medium are determined primarily by the ability of the artist. When handled properly, oils will produce satisfactory results in most circumstances. But if you are an untrained artist, you can easily find yourself in over your head with this medium. It is best to limit your oil corrections to smaller and easier things until you have developed a certain amount of expertise. Attempt more difficult corrections only when you are comfortable with the medium and confident in your ability.

Oils, like all other retouching mediums, should be used with restraint. Over-correcting can lead to very artificial-looking results, particularly when you are working on facial areas. Used alone, oils can have a pasty look that does not blend into the texture of the subject's skin. It is for this reason that oils are often used in conjunction with pencils and pastels to achieve a natural look.

Like the pencils and pastels, oils must be applied to a thoroughly lacquered print and then sealed with lacquer afterward. Any dust caught in

Heavily applied oil paint will crack and separate when sprayed with lacquer. If oils must be applied heavily, they should be allowed to dry naturally; another alternative is to build up coats of oil gradually, between coats of spray.

the surface of the spray will create areas where the oil can collect. A smooth, even surface is necessary for smooth, even results.

Even though oils have an excellent covering quality, one coat is often not enough. It is usually necessary to repeat the spray-and-apply ritual a number of times to reduce density satisfactorily.

The correct color can be difficult to achieve with oils. It is often necessary to use the oils primarily to reach the desirable density and then to color-correct with pastels. Never apply pastels directly over oils, however. They will cling to the oils and go dark and uneven. A coat of spray should be between the two mediums. It is also not advisable to pencil directly over oils, as the oily surface is too slick to permit pencils to adhere properly.

Oils are more difficult to remove than other mediums. Linseed oil can be used as a remover, but I have reservations about its being left on the surface. I have seen yellowing that I believe to have been caused by linseed oil. For this reason, it is best to apply oils only where needed, and to avoid the need for removing them.

Oils should not be sprayed immediately after applying unless the application is very light. A heavy, thick coat should be allowed to dry naturally, as spraying over it too soon could cause the oils to crack and separate. Oils dry very slowly, and a thick application could take days to dry. It is rarely necessary to apply oils heavily, and this should be avoided. By building up your correction gradually in light coats, you can avoid an artificial look. The only time I use this medium heavily is when I am adding color to black-and-white photographs.

Extender makes a very good remover for oils, but as a safety measure, you should avoid leaving any residue on the surface of the photograph.

You'll need a palette if you are planning to use the oil paints that come in tubes.

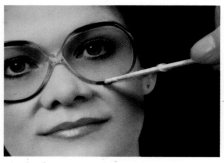

Oils can be removed from small areas with a Q-tip, but sometimes it is necessary to exert heavy pressure in order to remove all of the oil. This is safe as long as the Q-tip is properly made and the end of the toothpick does not protrude.

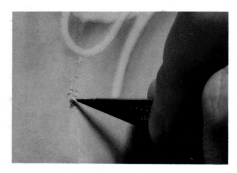

An X-Acto blade can remove oils from very small areas that are too small to be cleaned with a Q-tip.

Materials and Equipment

Like pastels, oils don't require very much paraphernalia. The crucial factor is the medium itself.

Oils. There are three different types of oils that can be used for retouching.

The oil paints in tubes are the very same ones that artists have used for years, and they are available in art supply stores. Always use good quality paints. They may be a bit more expensive, but the colors will be durable and less likely to change over a period of time. These paints are used for covering large areas smoothly.

Oil sticks are a fairly new medium on the market. They are actually a combination of oil paint and pastel in a stick form. This medium has a thicker consistency than oil paint, and the stick form makes it very convenient with less mess. I prefer these oils for adding strong color to smaller areas such as eyes, lips, and teeth. The thick consistency allows for heavier, faster covering, although it is a bit harder to keep smooth in the larger areas.

Most photographic stores carry Marshall's Photo Oils, which are transparent paints designed for the photographic surface. Similar to dry dyes, they add color but allow the detail to show through. These paints are made specifically for coloring black-and-white photographs. They are rarely used on color photographs. These paints come in very small tubes, but the color is extremely concentrated, and a very small amount goes a long way. Although they are expensive, and not a necessity, these colors include some very good flesh tones and are a nice addition to the retouching artist's palette.

Extender. Marshall's also produces a valuable medium called extender, which is sold separately. Extender can be added to regular oils to make them more transparent, and it can also be applied to the surface before oiling to make the oils more blendable. And to a certain extent, it can even be used as a remover. I have never noticed a problem with this medium changing color, but I recommend you refrain from leaving the greasy residue on the surface, as a safety precaution.

Palette. For the tube paints and transparent photographic oils, you need to have a palette. Art stores carry many varieties, including a handy disposable type with tear-off sheets. A glass palette, like the kind used in spotting, is also convenient, as colors can be labeled. (See the instructions on page 38 for making this palette.) It is important, if you are using a permanent palette, that the oils be cleaned off after each use. Don't allow them to dry on the surface, as they are difficult to remove later.

Applicators. Oils are applied to small areas with homemade cotton swabs, which are also useful for removing oils from a print. Larger areas may be blended with a tissue or even your finger. The latter is actually a better choice because it will not absorb the paint.

Knife Blade. An X-Acto blade can sometimes be used to remove oils from certain areas. When a precise, straight line is required, the blade is essential to achieve this. It is also invaluable for removing oil from very tiny areas that even the smallest Q-tip cannot reach, as in eyelashes. You also can use a blade to create certain textures, such as blades of grass or patterned clothing. This type of effect should be patted down with your finger afterward to avoid an obvious, scratchy look.

Demonstration 8
Retouching with Oils

This demonstration shows a range of techniques for enhancing photographs with oils—from the easy corrections such as toning down hot spots and adding highlights and touches of color, to the difficulties of reducing density in very dark areas. As is also true for pencils and pastels, oils cannot be applied to a photograph's surface unless it has been sprayed first with retouch lacquer.

Step 1. *A small amount of titanium white applied to highlights will brighten whatever contrast has been lost in the other steps. It also helps to create a very smooth complexion. Tube oils must be applied to the lacquered print with a Q-tip. Paint in stick form can be applied the same way—just dig a hole into the side of the stick for picking up the pigment—or it can be applied directly from the stick. Your choice of method will depend somewhat on the size of the area to be worked.*

Step 2. *With a clean Q-tip or your finger, spread the oil and wipe it down to the point where only a light film of oil is left. Avoid allowing the oil to flow into areas where you do not want it, especially the darker areas where it could be difficult to remove. Spray the area, and repeat the process if necessary. With the combination pastel/oil sticks, it is not necessary to wait very long for the spray to harden. As soon as the surface feels dry to the touch, it is safe to go on.*

Step 3. *Next, put a little oil over small areas where other mediums may not have reduced the density sufficiently, such as the dark areas at the corners of the model's mouth in this photograph. Use white oil to reduce the density, even though it may give your correction a slight blue-gray cast. This is caused by the density bleeding through the lighter oil, and you may begin to feel your correction is headed in the wrong direction—but, as you'll see, this is not the case.*

Step 4. *Now dust a little pastel over the bluish area to color-correct the oil and blend it into the surrounding area. If one coat of oil was not enough to complete the correction, spray and repeat the process, color-correcting between coats of oil, until the density no longer bleeds through. It is best to color-correct as you go so that your final correction is not a stark white that is difficult to correct for color.*

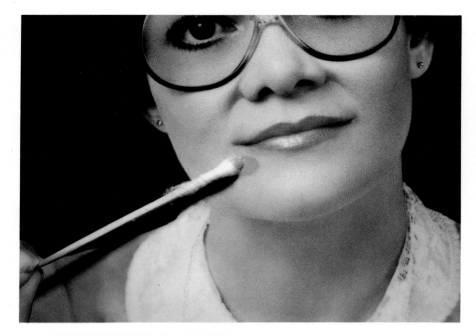

Step 5. *Adding oil to brighten the whites of the eyes usually gives much better results than pencil, which often looks too grainy. The oil makes a very smooth correction. Be careful not to get too carried away, however; a dab will do. Blend these highlights carefully, as in steps 1 and 2.*

Correcting Density with Oils

Whenever the purpose of oils is to reduce or add density, just add either white or black, respectively, to make the correction. Color can be corrected by dusting the oil with pastels as you go—between coats of spray, if successive coats of oil must be applied. By alternating pastel, pencil, and oil, you can make density and color corrections smoothly, but never very quickly. It is a slow process, and it can become tedious and frustrating at times.

When you add black oil paint over an area that is too light, the method is the same as for lightening an area with white, but it is usually much faster. Often one coat is enough to knock the brightness out of an area and make it less distracting. By repeating the process, you can black out the area totally. This method is used often to correct scenic and other location shots where there may be hot spots or reflective objects in the background.

Step 6. *Now add some oil to the area whose color was changed with pastels in Chapter 9. When using oil to add color to an area, choose the color closest to the one you need. In this case, blue is being applied to shadow areas beneath the collar and in the folds of the blouse. It's especially important to retain a sense of dimension when you are using oils on clothing; you don't want the photograph to take on a flat, artificial look.*

Step 7. *Color variations also can be created by adding black or white to enhance or maintain shadows and highlights. To emphasize highlights in clothing, apply the oil in the direction in which the lighter areas are flowing; then blend well, in the same direction, just until the different shades begin to merge softly. If you blend the oil down too much, you'll only undo what you are trying to accomplish. Because the oil may be a little thick in some areas, apply spray sparingly and build up a thorough coat gradually.*

Step 8. *Although it is often done with an airbrush, changing a background also can be done successfully with oils. Begin by lightening the immediate area between the hair and the background. In a portrait, this area needs some separation. Blend carefully with your finger to gradate the tone.*

Step 9. *Lightening the area nearest the model's head has helped to separate her from the background, but bringing out a little shine in the bottom lip will go a long way toward focusing even more attention on the face.*

Step 10. *After the initial reduction of density in the background has been sprayed and is dry, you can go in again with a second coat. This time a little color can be added, and the shape of the background can be developed. Notice that there is much more black toward the top of the head, and less from the eyes down. This is because the backlight should not form a halo around the entire head, but should be centered instead on the lower half of the face and the shoulders. This step can be repeated as many times as necessary, between coats of spray, until the background is just the way you want it.*

Step 11. *Be sure to keep the edges looking natural when you change a background. Because this subject has curly hair, and a cut-out look must be avoided, pencil and pastel are used to soften the edges of her hairdo. When your corrections are completed, be sure to remove mistakes or oil that has gotten into the wrong areas before giving the print a final spray to seal it.*

After Retouching with Oils. Because this print has undergone so many steps in correction, the changes have been very gradual. But when it is placed side by side with the unretouched original proof, the difference is quite amazing. Rarely does a photograph need to go through every stage of correction, despite the fact that this demonstration photograph has been taken to such extremes to illustrate all the basic techniques. And I always believe that underdone is better.

Removing Oil from a Print

If oil is allowed to smear into areas where it isn't wanted, it must be removed before spraying with lacquer. The best way to do this is to rub very hard with a Q-tip. If this fails, you can either use extender on a Q-tip or scrape the medium from the surface with an X-Acto knife. The method you use is really a matter of personal choice. But if you use extender, be sure to remove all the residue from the surface with a clean tissue. This will help to prolong the life of the photograph.

If you absolutely don't like your results, or if you feel you got carried away with the oils, as many beginners do, you can always strip the print completely and begin again. Of course, this means that all artwork applied above the spray will be removed in the process.

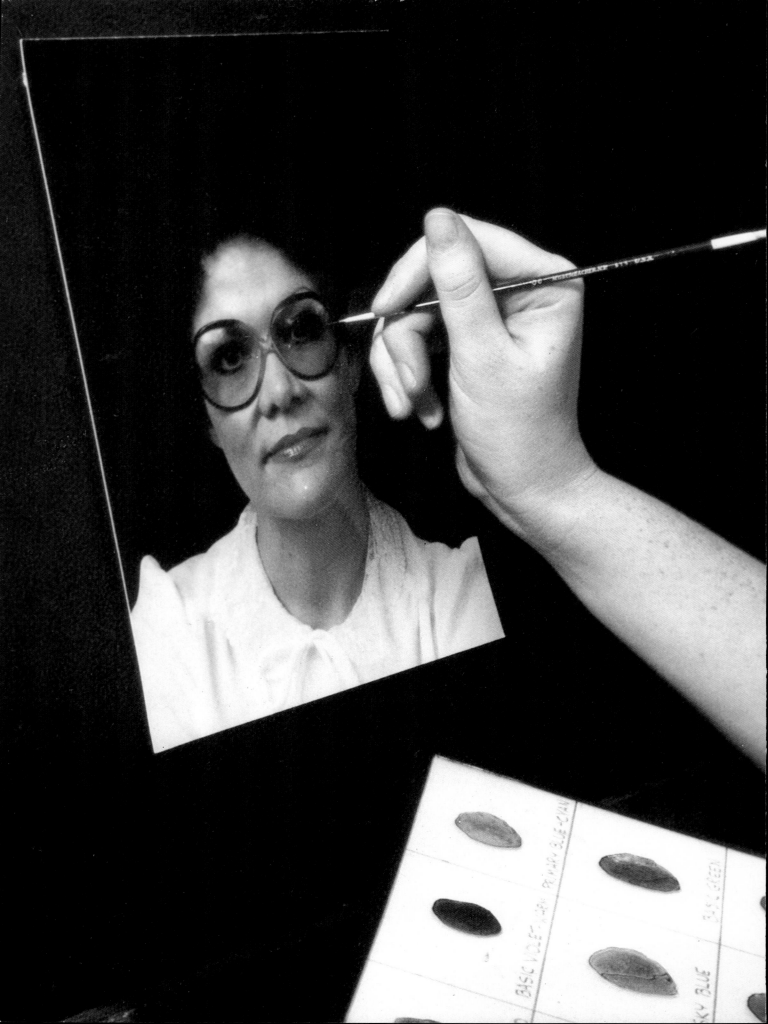

Chapter Eleven

Correcting Specific Problems

With the ability to use the mediums and techniques discussed so far—negative retouching, spotting, applying dry dyes, spraying, penciling, and using pastels and oils—you probably can handle most art correction problems that come up. Indeed, when you have conquered these mediums, you'll need to resort to the airbrush only in the most extreme circumstances. The purpose of this chapter is to show, step by step, specific corrections that can be made with the materials already covered.

Demonstration 9
Correcting a Black-and-White Photograph

Although the same mediums are used on both color and black-and-white photographs, you will quickly realize that working only in the gray tones is a whole new ballgame. When you correct a color photograph, achieving the right density is your main concern, and only a small amount of color-correcting is necessary. But with the black-and-white print, matching the exact tone can become an insurmountable problem. Because you are dealing only with the grays, the slightest variance in warmth or coolness of the tone can be detrimental to your final results. And precisely because of these tight limitations in color control, the spotting dyes are much more difficult to manage and should be used only for very small areas. Other corrections, such as removing eyeglass glares and blending, are handled better with other mediums. Many people prefer to skip the dye work completely and use pencils for spotting, as will be done here. This, of course, means spraying the photograph with retouch lacquer before beginning the retouching. (If a glossy surface is needed to give your black-and-white print impact, you can give it a final coat of high-gloss spray after the retouching is completed.) When your coat of retouch lacquer is dry, you are ready to begin correcting the photograph.

Step 1. The graphite pencils used in negative retouching work very well for many black-and-white print corrections. The different hardnesses give you a variety of gray shades that blend in nicely. It is important to use a sharp lead, select the proper hardness, and avoid sharp lines.

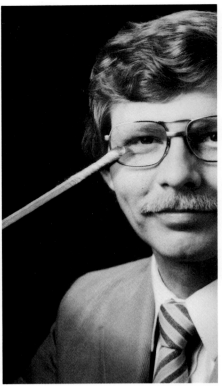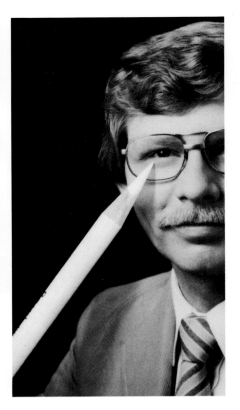

Step 2. *The only problem with using graphite pencils for spotting comes into play when you are working in very dark areas. To obtain enough density in these areas, graphite must be applied so heavily that it leaves a shine which is very difficult to eliminate. For this reason, you should switch to wax-based pencils in darker areas.*

When you use wax pencils for reducing density on a black-and-white print, you must be very sure to use only the cold gray tones, and to avoid the warm grays. These warm grays change color when sprayed, and once this happens, the print must be stripped to remove them. Trying to cover them up does not work well because the warm colors tend to keep bleeding through.

Step 3. *To add density in large light areas, switch to pastel, which can accomplish the task much faster and more smoothly than graphite pencils. Pastel is the only medium that seems to have been truly created for the black-and-white print. The gray tones blend in beautifully and will give you few problems if they are used properly. However, be careful not to go overboard with them and tone down the print too much. In correcting black-and-white prints, it is important to maintain the high contrast between the darks and lights, toning down only the very hottest, most distracting spots.*

Step 4. *Dark areas in a black-and-white print can be lightened with wax-based pencils in the same manner as color photographs. If the print is to be used for reproduction purposes, as black-and-whites often are, a perfect color match is not necessary. Controlling the density will be your only concern, as color variations will not show up when the picture is reprinted.*

Using Dry Dyes on a Black-and-White Print

Dry dye often works very well for toning down hot spots, and for adding contouring to faces without changing the surface of the photograph. Naturally, if you decide to use dry dye, this must be done before the print is sprayed with retouch lacquer, as discussed in Chapter 6.

Included in your set of dry dyes is a shade called "neutral," which should add only density when applied to a black-and-white photo-graph. However, depending on the overall temperature of the grays in your particular print, this neutral dye can often be slightly warmer or colder. This means you'll need to use a color chart (see Chapter 2) and properly read the color in order to add the correct hue to counteract the problem. The color match must be very exact in black-and-white corrections, as the slightest variance will stick out like a sore thumb.

Step 5. *Adding white oil paint to highlight areas enhances contrast and allows for higher-quality reproduction, which is especially needed in newspaper photographs. However, when you work with oils on a black-and-white print, keep them to a minimum. Often, for example, the black oil paint is not the same black as the other deep areas of a photograph, and this difference can be noticeable.*

Step 6. *The oil paint should be wiped down thoroughly, as whites easily become pasty and cold in color if they're applied too heavily. You may also want to use oils in conjunction with pencils and pastels to help eliminate these problems.*

After Retouching.*The overall blending in the finished photograph is subtle enough to be almost undetectable. It is noticeable only when you carefully scrutinize the work and compare it with the unretouched print. A little oil blended into the highlights brings out more contrast for reproduction purposes.*

Demonstration 10
Removing Braces

Removing braces from a portrait is a correction that is not entirely within a photographer's control, but the kids will love you forever if you can hurry nature along. Orthodontic braces are much smaller nowadays, making the artist's job easier than it once was. But often, eliminating the orthodontic hardware is the least of your problems. Once the braces have been removed, crooked teeth remain and must be straightened. This is what makes brace removals extremely difficult.

The steps you follow to remove braces are the same as for other corrections. Spotting dyes are used to darken light, shiny reflections in the hardware, and pencils lighten the metal that is dark. A combination of oils and pastels is necessary to achieve the very smooth surface teeth have.

Step 1. Closely examine the braces and notice which reflections are too light. With the spotting dyes, darken the light reflections.

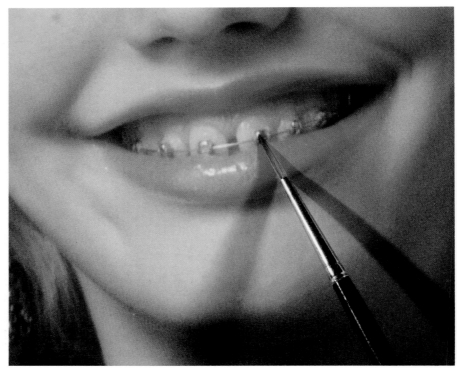

Step 2. *When the reflections have been spotted properly, you can see the remaining dark areas that need to be lightened. Apply a light shade of wax-based pencil over these darker areas. This step may involve spraying the print and repeating the process several times.*

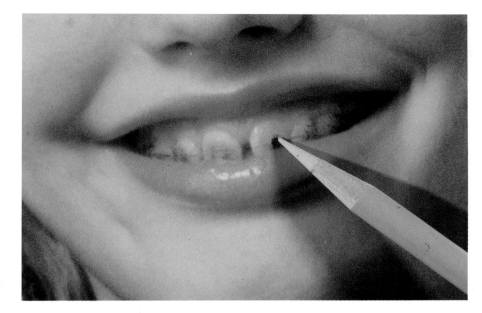

Step 3. *Even after you've penciled out the braces, rough and grainy teeth remain. The teeth also may need to be rearranged and moved over, but it is important that the braces be almost completely removed before you begin this process. This will allow you to see the natural shapes and contouring of the teeth in order to avoid making too drastic a change.*

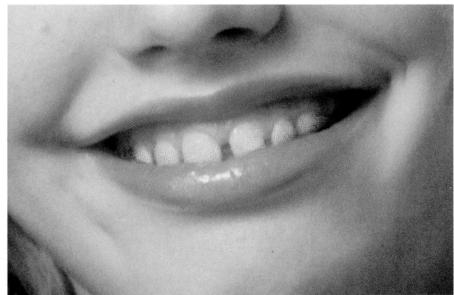

Step 4. *If the teeth need to be "pulled together," your best choice is to widen and enlarge the front teeth slightly until the gaps are filled. Be sure to follow the shape of the original teeth, and make sure the new line matches before you remove the old one. When drawing in and outlining teeth, you must be very careful to avoid dark, precise lines, as they will only look artificial. Separations between teeth should be indicated very softly.*

Step 5. *When gaps have been filled in, the teeth will be natural-looking except for the surfaces, which will not be smooth enough because of the graininess of the pencils.*

Step 6. *Applying a coat of oil over the teeth will alleviate the roughness left by the pencil. This is one circumstance in which the heavy, pasty look of oils can be quite beneficial. But be sure to wipe the oil down to a thin coat. More than one light coat may be needed before a smooth surface can be achieved.*

Step 7. *Lightly dusting pastel onto the teeth will give each tooth its own individual contouring, and tonal variations. This will keep the corrected teeth from looking artificial. It also keeps them from being too white; you don't want the teeth to shine out so brightly that everything else is overshadowed. A good rule of thumb is to match them to the whites of the eyes, which will lean toward either the warm or cool middle tones, depending on the individual photograph.*

After Retouching. *The final result, hopefully, will be much like the subject's teeth will actually look in the future. With time and practice, your ability to remove braces will be one of the most valuable services you can offer, as this correction can only be accomplished with artwork.*

Demonstration 11
"Opening" Closed Eyes

Most photographers have faced the terror of trying to photograph the "blinker." There are people in this world whose eyes seem to be synchronized to close with the camera's shutter. One of the most frustrating experiences a photographer can have is to shoot a wedding and find out afterward that the bride closed her eyes in nine out of every ten shots—and it does happen!

The eyes are windows to the soul, and that is why they are the attention-grabber in most portraits. If the eyes do not look natural, the whole photograph is lost. For this reason, eye corrections must be made meticulously and perfectly. If you cannot do them well, it is better to not do them at all.

For an artist learning to open eyes, it is best to begin with a close-up photograph in which the eyes are relatively large. Admittedly, correcting a large eye is much more involved than correcting smaller ones, but it is essential to your understanding of specific details. This is important even when you are working on a small scale.

Step 1. Although it is very helpful to have a reference photograph of the person with eyes open, it is amazing how much detail you can obtain by closely observing the closed eye. The shape of the eye and the size of the pupil usually can be read. Only the color of the eyes cannot be determined this way. Close examination of the eye will allow you to plan the steps necessary to correct it, and you can picture the results in your mind before beginning.

The Visible Structure of the Human Eye

Study these sketches of the human eye, which is actually a ball partially covered by layers of skin. The top of the round area forms the crease above the eye, and the bottom of the round area forms the gentle curve directly below the eye. The iris and pupil actually protrude slightly from the white portion of the eyeball.

When the eyelids are down, the curves and shapes of the eye show through the thin layer of skin. The dark line directly above the closed eye is exactly the same shape as the edge of the opened eyelid, and when the eye is opened, it once again becomes the eye fold. By dropping down a short distance and drawing another line along the same guideline, you can recreate the natural shape of the eye.

Notice the curvature and highlights of the closed eye. The highlight will be prominent in the area of the pupil because it is a raised area. Once you have located this, very close scrutinizing and a little imagination will also reveal the size and shape of the iris.

Remember that when the eyelids are open, they actually drop over the iris a little, preventing the full circle from showing. In addition, the eyelid and eyelashes cast a shadow over the very top of the eyeball, affecting the appearance of the iris as well as the white areas. When this shadow is not put in by the retouch artist, the iris may give the subject a dazed expression.

Step 2. *On the unlacquered print, start with some neutral spotting dye and sketch in the basic structure of the eye with your brush. The first line above the eye becomes the eyefold and is darkened to deepen it. Just below this line, draw in the top of the eyeline, following the same curve. Next, sketch in the outline of the iris, establish the pupil, and locate the catchlight.*

Generally, the single catchlight in the iris should fall at either eleven o'clock or one o'clock, depending on the direction from which the light is coming. You may find some exceptions to this rule of thumb, among them outdoor portraits and photographs of babies. Outdoors the lighting is much different, and the catchlight may squiggle softly across the length of the iris. A baby's eyes are usually brimming over with catchlights everywhere; putting in just one catchlight might give the child an inappropriately mature, knowing look.

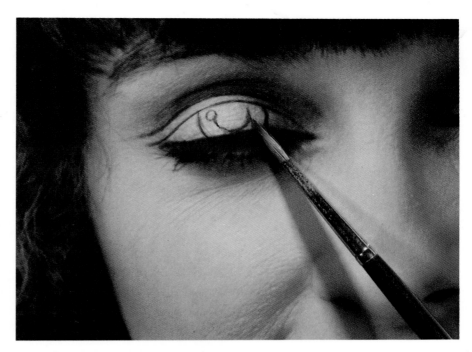

Step 3. *When you establish the eyelashes and darken the pupil, the eye begins to take on some life. Don't forget to fill in the shadow cast over the top of the iris.*

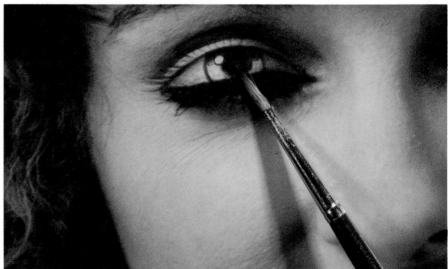

Step 4. *Continuing with the spotting dyes, strengthen the eyelashes and add color to the iris. At this stage, you will have achieved a somewhat realistic-looking eye with just the spotting dyes. Before going on to the next step, you'll need to spray the photograph with retouch lacquer so that the surface will accept further artwork.*

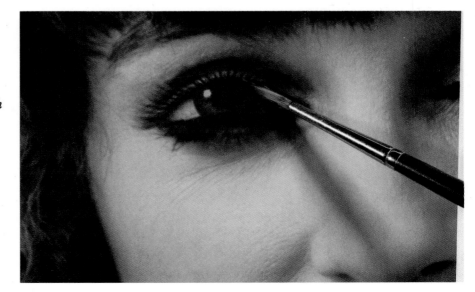

Step 5. *When the retouch lacquer is completely dry, select a light wax-based pencil of the desired density, and begin covering the dark areas within the white portions of the eyeball. Then switch to the correct color to begin bringing out color and detail in the iris. If you study the detailed sketch of the iris on page 88, you'll see that eye color is actually a combination of many tiny streams of color coming out of the pupil in a starburst effect. These streams, which consist of many different values of the same basic color, are darkest adjacent to the pupil, and they become darker once more as they reach the outer edge of the iris. The lighter the eye color of your subject, the more obvious the starburst effect will be. Observing these details will help you create a more realistic eye.*

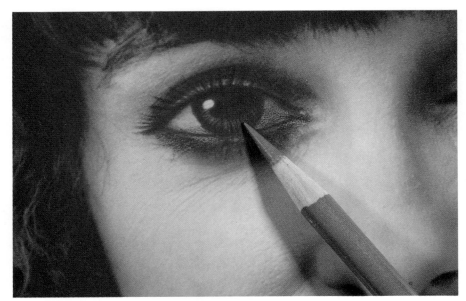

Step 6. *After giving the print a fresh coat of retouch lacquer, use a cotton swab to apply some white oil paint to all the lighter areas. This step will seem rather drastic, and you may worry that it will destroy the careful work you have done so far, but it is necessary in order to finish the correction smoothly and give it a natural look.*

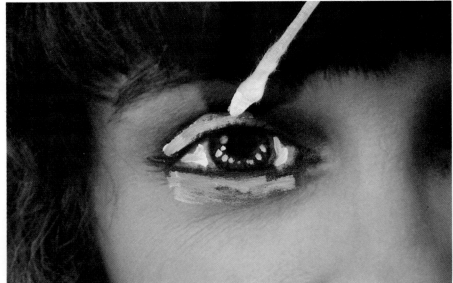

Step 7. *Rub the oil back down until only a light film remains. Then pick up some pastel on a clean Q-tip and dust it into the flesh areas to counteract the blue tint of the oil correction.*

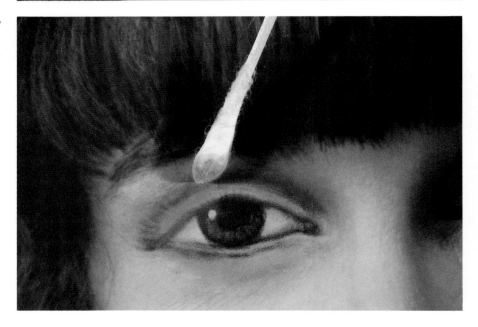

Step 8. *With a darker pencil, begin to outline the folds of the eye and bring back some of the detail that was lost when the oil was applied. Continue to repeat the applications of oil, pencil, and pastel until you have brought back the detail and sharpness.*

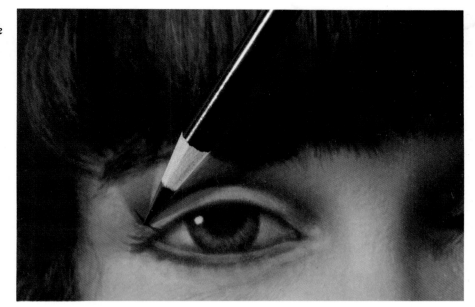

Step 9. *Finish penciling the eyelashes, and bring out the highlights with oil. Pay special attention to the corners of the eye: on the outer end, the upper lid hangs over the lower one. Within the inside corner, a bit of pink tissue shows. Shading the whites of the eyes slightly above the lower lid helps to create a convincing appearance of roundness, along with the bright highlight in the area that is highest and catching the light. But keep the effect natural, and do not make the whites of the eyes a stark white; this will make them look artificial.*

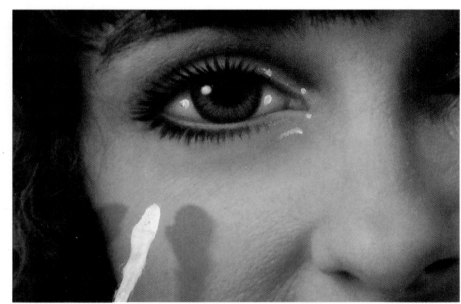

After Opening the Eyes. *The finished correction looks natural and believable. Most of the photographs that need artwork to re-open eyes are candid and group shots in which the head size is reasonably small, and therefore the corrections require much less detailed work than the portrait corrected in this demonstration. However, it is very helpful to have a complete understanding of how the eye is structured. Often, with this knowledge, you can put in just the right touch to achieve a more natural look.*

You may find that a person's eyebrows are raised when his or her eyes are closed. When the eyes are reopened, you'll need to correct the eyebrows also in order to avoid leaving a goofy expression on the subject's face.

Demonstration 12
Smoothing a Bad Complexion

Skin blemishes are best corrected with a combination of negative retouching and artwork on the print. Many artists, however, do not have an opportunity to work on the negative first, and will have to face the fact that all corrections must be made on the print. For this reason, this demonstration will be limited to print corrections.

Retouching complexions usually gives the most satisfactory results on female subjects. This is because heavy art corrections often leave the subject's complexion looking silky-smooth and quite feminine. It is difficult to accomplish a heavy retouch job without changing the texture of the skin a little.

Special care must be taken to ensure that the natural highlights and contouring of the face are not changed when you correct skin blemishes. Because it is so easy to get carried away before you realize it, it is important to have an extra photograph for reference.

Step 1. Examine the print closely, and study the area where you'll begin work. Notice that many dark blemishes are actually raised areas that have highlights. The first step is to tone these down with the spotting dyes to blend them into the flesh color of the surrounding areas.

Step 2. When the spotting of the light areas is completed, you can see a big improvement already. The skin appears much smoother, and it will need a minimum of penciling to lighten the dark blemishes. Spray the print with a thorough coat of retouch lacquer and let the surface dry completely before you begin pencil work.

Step 3. With a wax-based pencil several shades lighter than the color you want to match, begin to cover each dark area. Use a very light touch in the darker areas and a heavier touch in the lighter areas.

Step 4. Often, spotting and penciling are all you'll need to correct skin blemishes. However, if the pencil work looks obvious and grainy, more needs to be done, and the following steps will be necessary.

Step 5. *If heavy spotting and penciling have darkened the highlight areas, they can be brightened up with a little oil paint after applying a fresh coat of retouch spray. This will give the complexion a smooth, velvety look. Be sure to rub the oil down well to blend it and prevent its looking pasty.*

Step 6. *Pasteling over the oils (but remember to spray first) will correct any color changes caused by the oil. The pastels also will contribute toward making the surface totally smooth.*

After Retouching. *The final product should look natural even under close scrutiny. If you are doing retouching professionally, remember that customers usually examine this type of work very carefully.*

Demonstration 13
Retouching an Elderly Face

Retouching the portrait of an elderly person can be difficult because the face will usually have quite a few major "character lines," and it is confusing to decide what should stay and what should be removed. The important thing is not to get carried away. Most elderly people accept their age with dignity and don't expect too much. They would not want to look young again, and their special character lines are an integral part of their personality and beauty. There will always be an occasional crank, however, who will expect a complete face lift and swear that the artist must have added a few lines.

Although most older people do not expect essential character lines to be removed, they are usually delighted with a photograph in which very obvious, stark lines and wrinkles have been gently softened. Subtle blending of these major lines, along with removing the very tiny, fine ones, will result in a professional-quality portrait that will be treasured for years to come.

Step 1. As always, the first step is studying the print to decide what needs to be corrected and how to proceed. Closely examine the print to see which are the major character lines, as well as those that are essential in contouring the face. You'll want to soften these, but not remove them entirely.

Step 2. *On the unlacquered print, use spotting dyes to tone down the light areas between and around the lines, blending them together as much as possible.*

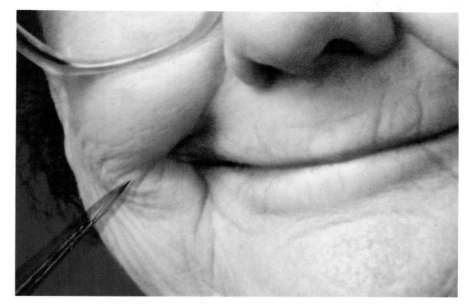

Step 3. *Don't overlook the usual spotting corrections, such as eliminating glare reflected on eyeglasses and sharpening catchlights. In this particular photograph, the bifocals are particularly obvious, and the light lines across the lenses also must be spotted down.*

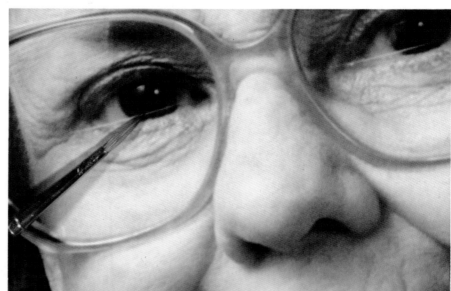

Step 4. *When the spotting is completed, you can see that a great deal of smoothing has been accomplished; only the major lines remain now. Spray the print thoroughly before going on to the pencil work.*

Step 5. *A little penciling will blend in the smaller lines softly. Larger lines can be lightened a little, but they should not be removed.*

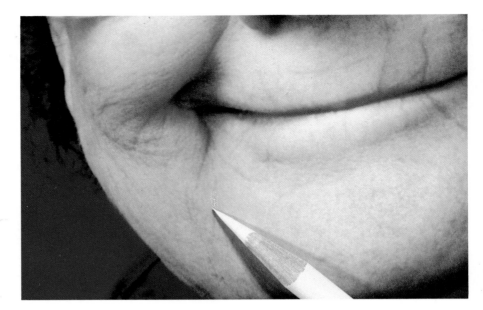

Step 6. *Spray the print again with retouch lacquer, and when it is dry enough, dust some pastel over the remaining lines to give the face soft contouring.*

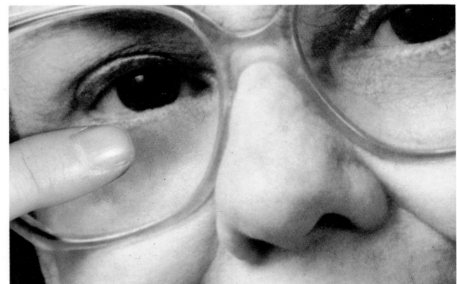

Step 7. *Again, don't forget the usual corrections. Warm the complexion with a blush of pastel, buffing down well to retain the highlights.*

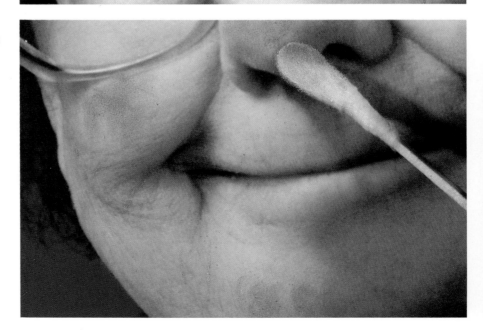

After Retouching. *Your finished portrait should show a smooth complexion with soft contouring where the deepest lines were before.*

Demonstration 14
Sharpening an Out-of-Focus Print

The results of sharpening a photograph will depend largely on how poor the focus actually is. The softer the photograph, the more obvious and limited your corrections will have to be.

When the clothing is patterned or the background very busy, your options for correction can be quite limited.

Few artists have the patience for such corrections and it is better to center attention on the focal point of the photograph instead. If the subject is sharpened properly, chances are the clothing and background will not be terribly noticeable.

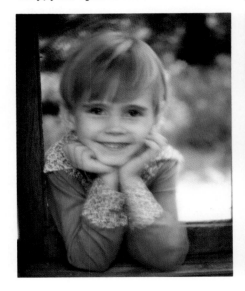 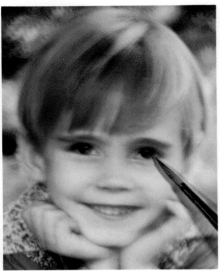

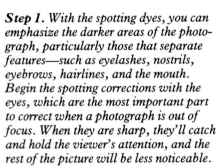

Step 1. With the spotting dyes, you can emphasize the darker areas of the photograph, particularly those that separate features—such as eyelashes, nostrils, eyebrows, hairlines, and the mouth. Begin the spotting corrections with the eyes, which are the most important part to correct when a photograph is out of focus. When they are sharp, they'll catch and hold the viewer's attention, and the rest of the picture will be less noticeable.

Step 2. Continue darkening and sharpening all the dark lines in the face, hair, clothing, and background. All lines that separate and define should be strengthened, but don't apply the dye so heavily that areas look drawn-in. Subtly sharpening these lines will be enough to make a drastic difference. If they have become too harsh, wash them back down a little with a Q-tip.

Step 3. *When the spotting has been completed, the photograph will look much better. Notice that the shoulder and sleeve on the right side have been filled in and defined also. This correction alone alleviates much of the undesirable softness.*

Step 4. *Now it is time to concentrate on lighter areas of the photograph, spraying the surface with retouch lacquer so that it will accept pencil work. When it is completely dry, sharpen and brighten the catchlights in the eyes and enhance the highlights on the forehead, cheeks, nose, and chin. This should bring all the features into sharper focus. If you find it necessary to use a combination of pencils and oils, don't forget to spray with retouch lacquer as you work.*

Step 5. *With the wax-based pencils, lighten all the lighter lines in the photograph. Some light pencil work adjacent to separation lines will also help to sharpen them.*

Step 6. *Finally, use pastels to minimize distracting hot spots in the background and allow the face to be the center of attention.*

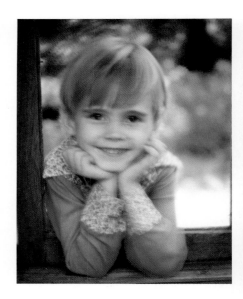

After Retouching. *A comparison of the finished work with an unretouched proof shows that, although the overall effect of the photograph is still soft, much of the unpleasant, disorienting blurriness has been eliminated. Attention is focused on the subject, whose features have been defined nicely.*

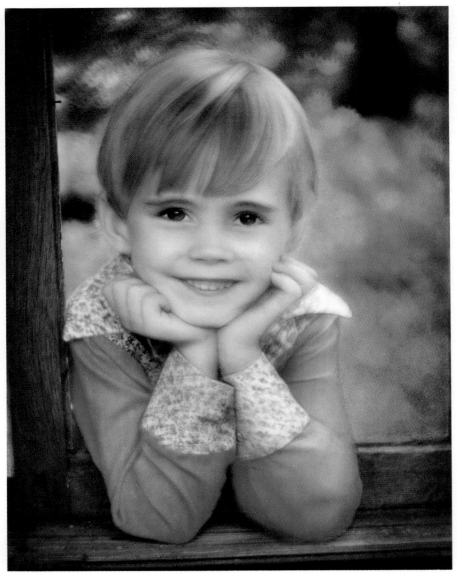

Demonstration 15
Correcting Wrinkled Clothing

Wrinkled clothing is much easier to take care of in the camera room than on a finished print—but the artist does not usually take the pictures and therefore can't control the situation. Because it is difficult to match the colors, textures, and patterns of clothing, eliminating fabric wrinkles can be a particularly challenging correction to make.

Step 1. Wrinkles in clothing are a twofold problem (no pun intended). They have a highlight that must be darkened and a shadow area that must be lightened. The first step is to brush a base color into the highlight with spotting dyes, working on an unlacquered surface. If the area is too large to be handled with spotting dyes, spray the print with retouch lacquer and make this correction with pastels.

Step 2. Next, go over the base color with a little density. If you are working with pastel, you'll need to respray before applying the next coat.

Step 3. *Spotting down the highlight softens the wrinkle without removing it. Often, this is enough to take care of the problem without further corrections.*

Step 4. *Correcting the deep, shadowed area of a wrinkle is usually the most difficult part. For smaller prints, a little pencil work will lighten the shadow nicely—and in this situation, the pencil's graininess may be an asset, enabling it to blend in with the texture of the clothing rather well. Larger prints in which the shadow covers a bigger area may require a combination of oils, pastels, and pencils to reduce the density sufficiently.*

Step 5. *Oil paint will reduce density smoothly, but several coats may be required to lighten the area sufficiently. Color-correct and blend with pastels as needed between coats of oil and retouch lacquer.*

After Retouching. *The finished correction is smooth and blends well with the rest of the clothing. Obviously, a plain fabric is much easier to correct than a patterned or textured one, where attempts to remove a wrinkle completely could prove futile. It's best not to try a correction that could become more obvious than the original problem. Simply deepening the highlight slightly, and gently lightening the shadow, will transform a deep wrinkle into a softer, more acceptable fold.*

Demonstration 16
Toning Down Hot Spots with Spotting Dyes

Eliminating distracting hot spots from the background is usually a relatively easy correction. There are several different methods for dealing with this problem, and your choice will depend on either the nature of the correction to be made or your personal preference.

Dry dyes will only add a little tone, which is sometimes all that is needed to prevent a bright area from being distracting. But when stronger coverage is needed, you'll have to use spotting dyes, which are demonstrated here. Both mediums allow you to retain the natural gloss of the photographic paper.

Step 1. *Spotting dyes generally work very well for toning down hot spots if you use the wet-washing technique. To fill an area as large as this with spotting dyes, wet it down first with clean water on a Q-tip in order to ensure smooth coverage.*

Step 2. *With a wet brush, mop in a base color. To prevent blotchiness, make sure the dye is well diluted. Don't worry if this first application of color doesn't seem to make much of a difference. Extremely diluted dye covers slowly, and you must build the density gradually.*

Step 3. *Change to a darker color and continue to mop the area. As you build up the density, avoid letting the dye flow out of the light area; unconfined dye will result in a dark outline around your correction.*

Step 4. *When the desired value has been reached, change to a drier brush. Blend the sharp edges into each other.*

Step 5. *Refine and add detail. Steaming the print will remove water rings and surface marks caused by the heavy washing, and the print will be deliverable without your having to use a spray finish.*

Alternative Methods for Correcting Hot Spots

When you are not confined to doing only emulsion work, correcting hot spots is much faster and easier. One or two coats of pastel or oil, and perhaps a little pencil work, will usually minimize any hot spot, and a few more coats will totally remove it. These corrections must be done on a surface that has been sprayed with retouch lacquer, with intermediate coats of spray as needed, and then sealed with a final coat of lacquer.

Your best choice for correcting hot spots is actually a combination of all mediums. No matter what method is used, however, the final result should be a photograph without distracting hot spots.

Pastel. A coat of pastel will fill bright areas quickly and smoothly

Pencil. Detail can be added with pencils to modify the soft effect of the pastels.

Oil. Another fast alternative for hot spots is covering or toning them with oils, which are smoother and faster to use than pastels but also a little more difficult to work with.

Demonstration 17
Adding Clouds

Most photographers have experienced the problem of having to wait for a pretty day for a special shot. If you do outdoor portraits and commercial shots, you will thoroughly appreciate the advantage of being able to add clouds to a print.

Clouds are often added with an airbrush, but you can also achieve very nice results with oils. Because they are applied over retouch lacquer, which seals and protects the print and any other artwork that has been applied below the spray, you have the freedom to play and try out different styles. The various types of clouds shown in this demonstration can be created with oil sticks and blending techniques.

Step 1. With an oil stick, sketch in the basic form of the cloud you want to create.

Step 2. With your finger, blend the oil out, softening it at the edges. Use a horizontal stroke for the stratus clouds which are usually found lower in the sky.

Step 3. If you want to make a fluffy, billowy cumulus cloud, blend the oil in a circular motion.

Step 4. One coat of oil may not be enough. If more contrast is needed, spray the print and add more oil.

Cumulus Cloud

Stratus Cloud

Color Variations. *Subtle colors re-flected in the clouds often add interest to a picture. These can be created by adding pastel or oil colors—but keep the effect soft and subtle, and blend the colors well.*

Demonstration 18
Repairing a Scratched Photograph

Whether the fault lies with the customer, photographer, printer, or artist, it is a fact of life that photographic surfaces are easily damaged when handled improperly. Most scratches in the emulsion of a photograph occur while the emulsion is wet. At this time the emulsion is very soft and fragile, and it is easily scratched by a slight scrape with a fingernail, or by a toothpick protruding from the end of a cotton swab. Every artist will come across scratched photographs, and often it is the artist who creates the problem. Needless to say, if you damage it, you'd better know how to fix it. It is a matter of professional survival. This demonstration shows how to correct shallow, medium, and very deep scratches.

Step 1. Study the color of the scratch to determine which layers of the emulsion have been removed. If the scratch is red, only the cyan layer has been removed, and a little cyan spotting dye applied to the raw emulsion will usually correct the problem.

Step 2. A yellow scratch indicates that both the magenta and the cyan layers have been removed. Begin correcting this by applying magenta dye.

How to Judge the Depth of a Scratch

The deeper the scratch, the more drastic the correction problem. The depth of a scratch can be judged by its color, since the dyes in the photographic emulsion are layered in this order: cyan, magenta, and yellow.

Red. If the scratch is red, this means that only the cyan layer has been removed and the magenta and yellow remain. A red scratch usually will accept spotting dyes, and adding a little cyan may do the trick. You may need to add some density also. These shallow scratches are the easiest to correct.

Yellow. A yellow scratch means both the magenta and cyan layers have been removed. You can try spotting with magenta and then cyan over that, but the yellow layer of emulsion is usually too thin to accept the dyes sufficiently.

White. If the scratch is white, it is indeed deep, as all three layers have been removed and no emulsion is left; the paper itself is showing through. This type of scratch will not accept spotting dyes at all, and your only option is to try to repair the damage with oils. This is the *only* case in which oils should ever be applied directly to the raw emulsion.

Step 3. *Applying cyan dye over the coat of magenta should correct the yellow scratch.*

Step 4. *All three layers of color have been removed when the scratch is white, and the paper is showing through. A coat of yellow dye, followed by magenta and then cyan, would help to reduce the scratch but not remove it. The deepest part of this scratch is not able to accept the dyes.*

Step 5. *An extremely deep scratch can be filled with an initial coat of oil before the emulsion is sprayed to accept further work. To do this, choose the color closest to that of the surrounding area and apply it generously over the scratch. With a cotton square, buff the surface until the only oil remaining is in the scratch itself. Drastically deep scratches can usually accept enough oil to blend in well, but shallower scratches cannot be helped in this manner because all the oil would be buffed out.*

Step 6. *Even when oil will color the scratch sufficiently, the marring of the smooth photographic surface usually remains noticeable. The only way to correct this is to spray and sand the surface until it is level once more. Sanding was discussed in Chapter 7, and the very same rules apply here. Extreme care must be taken to protect the emulsion from the sandpaper. There is nothing worse than sanding through a thin layer of spray right into the emulsion, suddenly making the original scratch much, much worse. It is advisable to spray the print heavily three or four times before sanding. Be sure to allow the spray to dry thoroughly, as damp spray cannot be sanded.*

Step 7. *The spraying and sanding procedure should be repeated until no indentation from the scratch remains in the surface. Between coats of spray, you can use pencils, oils, or pastels to correct color and build density. Obviously, the deeper the scratch, the more repetition is necessary. It may take the patience of a saint, but the correction eventually will be made.*

Demonstration 19
Mending a Torn Photograph

Any artist who handles a lot of photographs cannot help but have a few accidents. But having the ability to correct them will save you the terrible embarrassment of returning damaged prints to your customers. It only takes a few of these corrections to teach an artist the value of being careful. Time spent repairing a damaged print may not seem so bad when it's someone else's mistake and you are being paid to correct it. But when your time must be given away because of your own carelessness, it becomes of paramount importance.

As with a deep scratch, spraying and sanding is the basis for correcting a torn photograph. But I do not suggest using this method on very old photographs, as their surfaces are often fragile and irreparable damage could result. Old photographs should be copied and new prints made for correction. (Restoration of old photographs is discussed thoroughly in Chapter 14.)

Since the damage from a tear goes all the way through the paper, you need to mount the photograph permanently to a board before beginning to work on it. Dry-mounting is the best choice because spray adhesives and rubber cement often do not have enough tack. Using a great deal of spray can cause the paper to loosen and curl up. With dry-mounting under a heat press, there is no danger of this.

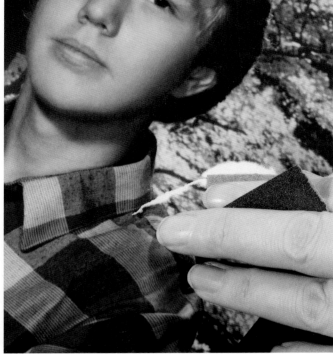

Step 1. *Once the picture is mounted, you have a sturdy surface on which to work. The damage from a tear is so great that spotting dyes will be of no use at all in correcting it, and you shouldn't even try to use them. Instead, you must begin spraying and sanding the photograph to restore the surface to a smooth, level condition. As the torn area is gradually smoothed, the area to be corrected will become much larger than the original tear. Don't even worry about this now; your goal is to achieve a level surface.*

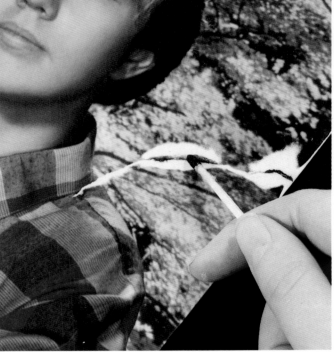

Step 2. *Oil can be added to the deepest areas of the tear in order to counteract the bright white of the paper and bring its tone closer to that of the surrounding area. Don't be concerned about color; just concentrate on the density.*

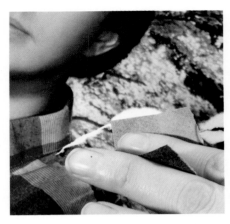

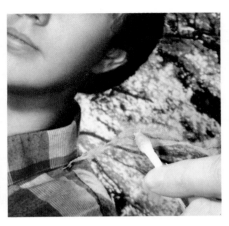

Step 3. *Continue spraying and sanding; your corrections will always be detectable until the surface has become completely smooth. Have patience: though it may seem impossible at first, it will smooth out eventually. Be generous with the spray in between sanding steps, and always allow it to dry thoroughly before sanding again.*

Step 4. *When the surface is close to being smooth, you can begin to add pastel between the sanding steps. Matching the density should be your first objective.*

Step 5. *Next, add the base color over the density with pastel. Continue putting on more density and color until the overall tone is fairly close to that of the surrounding area.*

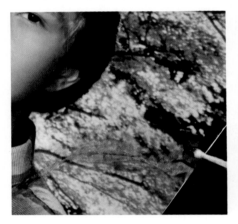

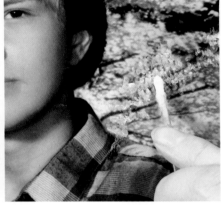

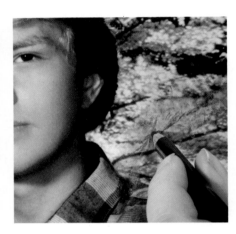

Step 6. *Now you can begin to refine detail with a combination of mediums. Black oil paint can be applied to add more density to the deeper areas.*

Step 7. *Adding white oil over the area will lighten and blend it. Color-correct over this, and continue to add coats of oil and pastel, gradually blending the torn area with the rest of the photograph.*

Step 8. *Use pencils to add detail that must be sharp, repeating the steps as many times as necessary until you have achieved the results you want. Hopefully, your sanding and coloring will meet at the point of perfection.*

After Correction. *Your finished work should not be noticeable to the average person, although a professional will usually be able to detect this kind of correction.*

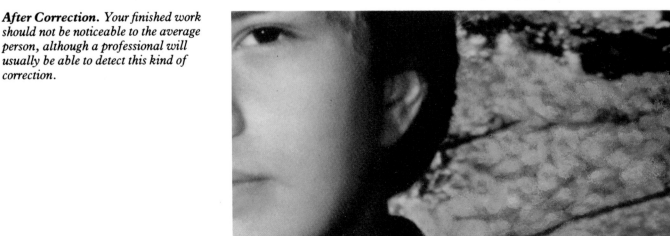

Part Three

Advanced Techniques

Competence with the materials discussed in Part Two should be considered a prerequisite for attempting the more advanced methods that will be discussed in this section of the book. Opaque paints can be difficult to handle, and you'll need to develop your artistic skill in order to master advanced opaquing techniques. Many airbrushing corrections can be either eliminated or minimized if you know how to use the other mediums. Restorations also require, along with the airbrush, a combination of many of the mediums previously discussed.

Airbrushing and restoring old photographs are very complex subjects, and these techniques alone could easily constitute an entire book. It is impossible to elaborate on either of these two subjects properly in just a single chapter. The purpose of these two chapters is merely to give you a general idea of the techniques, and of the possibilities available with them.

Adding color to a black-and-white photograph truly requires artistic ability. If you have managed to come this far, you certainly have this ability and should thoroughly enjoy the magic of this last chapter.

luma
BLEED-PROOF
WHITE

The original
genuine
opaque
Covers
markers.

Always

1 FL Oz.

Steg
Lakewood

WINSOR & NEWTON

DESIGNERS
GOUACHE

522
Permanent White

37ml ℮

Fluoro
GRAPHIC

HIGHLIGH
WHITE

1 FL. OZ.

MADE IN U.S.A.

Chapter Twelve

Opaquing

Water-based opaque paints are used when total coverage of an area is needed. Usually used in conjunction with airbrushing, this medium can also be used along with the other photographic mediums.

Applied with a brush, opaques will cover an area immediately in one coat. Available in a variety of colors, they can be blended for close color matching. Mistakes can be removed easily with water. Although many corrections could be made without using opaques, other methods would take much longer. The opaques are definitely a time-saver for reducing deep density.

Limitations of the Medium

The opaque paints may be used on either a raw or a lacquered print, but they must be sealed with lacquer to become permanent. One disadvantage of the colored opaques is that they tend to change color and density when sprayed. This necessitates repeating the correction process until you achieve the results you want. Because of this tendency, I very rarely use the colored opaques. I prefer to use white or grays for coverage and the pencils, pastels, and oils for color-correcting and blending the opaqued area into the rest of the photograph.

Opaques do not soak into the emulsion of the print as some of the dyes do. They sit on the surface, actually forming a new layer. Because they are a thick medium, their consistency is a bit difficult to control. It is very important to get the consistency correct before applying an opaque

paint to a print. Opaque that is too thin will "ball up" on the lacquered surface. If it is too thick, it will leave a built-up area that is not only obvious but also difficult to blend in. The proper consistency is obtained by mixing a small amount of water with the opaque and drying the brush slightly before applying it.

Opaques can be used for covering large areas with difficult textures. This type of correction is most likely to look a bit artificial and take on an airbrushed look. The only way to avoid this is by developing your artistic skill so that you can recreate an area properly.

Materials and Equipment

You won't need a great deal of paraphernalia for working with opaque paints, and what you will need is relatively simple. Your chief concern will probably be selecting paints and brushes of good quality that will help you achieve the best results.

Opaque Paints. While any brand of opaque watercolor paint will suffice for retouching, my preference is Windsor & Newton Designer's Gouache, which is carried by most art supply stores. This high-grade paint is also used in airbrushing, and you'll find more information about its characteristics in Chapter 13. For most opaquing purposes, you will need just a few tubes of basic colors: red, green, blue, yellow, black, white, and brown. These paints are used on the same kind of palette that is used for oils. Because the opaque paints are

water-soluble, you can rewet and re-use them whenever they're needed.

Opaquing Brushes. You'll need brushes in a variety of sizes. Keep an assortment similar to that used in spotting. (Refer to Chapter 5 for information on how to choose a brush, as well as suggested sizes.)

It is very important to designate special brushes for opaque use only. I mark my opaque brushes with tape to prevent any mixup. Opaque paint is very difficult to remove from a brush completely, and no matter how clean the brush may seem, even the smallest amount of residue could create havoc if it were used with spotting dyes. Even dipping a spotting brush into opaque rinse water could cause detrimental results. This is because the spotting dye soaks into the emulsion of the photograph, but any opaque residue mixed with this will remain on the surface, creating a slight film that obscures your view of the spotting dyes. You can't tell how much you are applying. When you take a Q-tip and remove the opaque from the surface, you'll usually find that the area underneath has gone too dark. That's why it's very important not to mix your spotting and opaquing brushes.

Water. You'll need two glasses of water—one for mixing, and an extra one for washing out your brush.

Tissues. For blotting, white facial tissues are best because they allow you to see the color of your paint most accurately.

Opaque paint will cover a very dark area much more quickly than any other medium. It may be used on either a lacquered or an unlacquered print, but when the opaquing is finished it must be sealed with a final coat of lacquer to become permanent. When your coat of lacquer is dry, you are ready to begin opaquing.

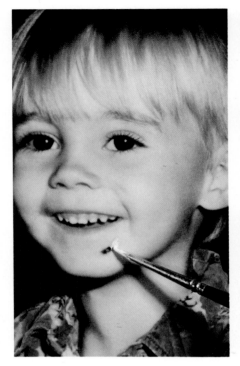

Step 1. *Stroke the opaque directly over the area that needs to be lightened. The paint should be heavy enough to cover the density thoroughly in one coat. If its consistency is correct, the opaque should go on smoothly, with total coverage. Once it has been applied, don't attempt to stroke over the same area again. The wet brush would pull up your first application of opaque, undoing your work. Don't worry about the color. Your concern at this point is thorough coverage, with no darkness showing through.*

If the darkness isn't obliterated in one coat, you can wash it off with a wet Q-tip and try again with a thicker consistency, or you can spray the print and apply another light coat. It may actually be better to build the coverage between coats of spray than to apply a coat so thick that it can be felt and seen on the surface.

Step 2. *When the density has been completely covered, a bright area will remain. This can be color-corrected and blended into the surrounding area with pencils, pastels, or oils—or a combination of the three. The smaller the area being covered, the easier and better your results will be.*

After Opaquing. *The completed correction should not be noticeable. Be sure to seal your work with a final spray of lacquer.*

Finding the Right Consistency

To begin opaquing, dip your brush into the paint slightly. Don't saturate the brush. Only the tip should be covered. If you are using designer's gouache fresh from a tube, it can be left out and used even after it has dried—just remoisten it with a little water and mix it to a thick consistency. When it is used straight from the tube, it also must be thinned with a little water to a slightly thinner consistency.

Before applying the opaque to your photograph, test its consistency by stroking the brush against the side of your hand. Your skin is a much more reliable testing surface than blotting tissue, which is too absorbent and would draw too much moisture from the brush—and the opaque washes off easily.

If the opaque doesn't leave a smooth line when you stroke it against your hand, and it tries to ball up on the skin's surface, it is too thin. Either add more opaque or continue to stroke the brush on the surface of your hand until the excess water has evaporated and the paint goes on smoothly. If the opaque is too thick, it will not spread smoothly, and it will leave a rough surface. More water must be added. The proper consistency is somewhat like that of Elmer's glue.

Demonstration 21
Creating a Large Textured Area with Opaques

Opaques are useful for filling in grass, adding trees, and sometimes removing objects from backgrounds and other large areas of a photograph where there are textured surfaces such as bricks and gravel. The technique for creating these textures is different from that used in covering smaller spots. This wetter method requires more water and a larger brush.

In opaquing the sample photograph in this demonstration, the goal is to transform the barnyard setting into a grassy pasture.

Step 1. Mix a base color appropriate for the undercoat, make sure it is of the proper consistency, and take advantage of the spread-out bristles as you apply the opaque to the photograph in an up-and-down blotting motion. Don't worry about the paint getting into the wrong areas. Concentrate on covering the area with a uniform texture.

Step 2. Before the edges are completely lost, stop and clean them off with a wet Q-tip. Then repeat the process. Changing colors with each coat will produce depth. At a certain point, the surface will have as much paint as it can hold, and the wet brush will remove paint instead of adding it. This is the time to spray the print lightly with several coats of lacquer before proceeding further.

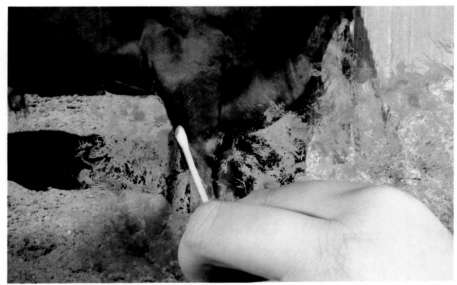

Paint Consistency for Texturing with Opaques

1. To create a textured surface, the brush should be totally saturated with the opaque paint.

2. Blot the excess moisture from the brush so that it isn't drippy wet, yet it remains saturated.

3. Maintain the spread-out effect of the bristles. This will prevent the opaque from going on too smoothly.

Step 3. *Continue to build the paint, using different colors to achieve contrast. Spray and continue until you have built up the color, density, and contrast in the textured area. When you spray, it is important to build up the spray lightly and cover the surface thoroughly. A heavy coat could cause the opaque to crack, and incomplete coverage could cause unlacquered paint to be removed with the next application. Be sure that all washing has been completed before you add the lacquer.*

Step 4. *As both the covering capacity and texture of your work are built up to satisfactory proportions, use a lighter touch with the brush. Barely grazing the surface with the tip of the bristles will bring out the final detail, allowing for a more realistic look. Refrain from adding this final detail to the shadowed areas.*

After Opaquing. *Although real grass would have been preferable, the opaquing has created an acceptable substitute. When the rest of the background is retouched with oils or airbrushing, the change is complete. Always remember to seal your work with a final coat of lacquer.*

With practice and experimentation, you'll find that the opaques not only act as a valuable asset in enhancing prints but also offer the opportunity to be bold with major corrections and changes. Cars, signs, and practically any other object can be removed from a scenic photograph; trees and flowers can be added. Because opaque paint is easily removed with water, there's no reason not to dig in and have fun with it.

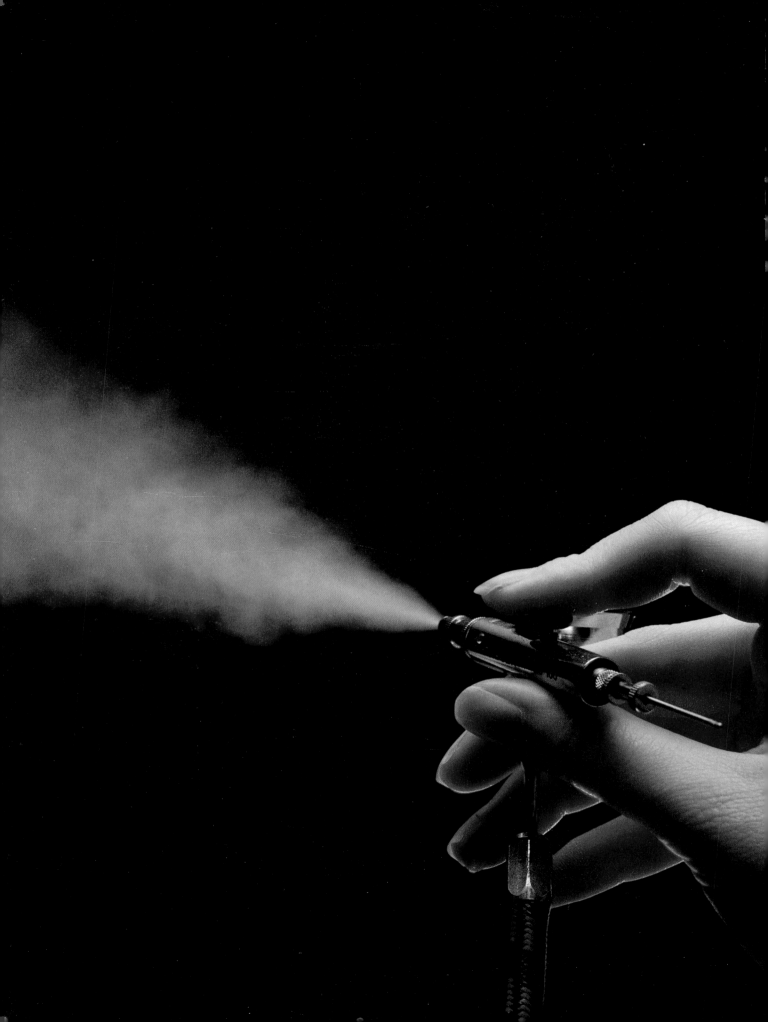

Chapter Thirteen

Airbrushing

Airbrushing—what a myth has been built around that word. Since the first Vargas girl appeared in *Playboy* magazine, the airbrush has been considered the ultimate tool for making photographic art corrections. It is often the first word uttered by a photographer needing help. There is absolutely nothing that customers won't dare to ask of an airbrusher. People who have no knowledge of retouching procedures can find themselves paying a premium airbrushing rate at labs for a spotting job, simply because they checked the "airbrushing" box on their order form and the order was automatically sent to that department. Once the job is there, the airbrush artist simply spots it and logs the amount of time spent. Having once been employed at a major lab, I learned that a surprising number of orders are incorrectly marked "airbrushing."

Other mediums can accomplish many of the same corrections as the airbrush. However, the airbrush has the advantage of being much faster and smoother. Basically a paint sprayer, the airbrush is used primarily as a blending and covering tool. Only a minimum of knowledge and expertise are needed to produce incredible results.

The airbrush is used when a large area, such as a background, needs to be covered or drastically changed. A person or object can be removed from a photograph, and major clothing changes can be made. Damaged photographs often require extensive airbrushing.

Once you have mastered a few blending and smoothing techniques, you will soon find yourself making unbelievable changes in your prints. With practice, the airbrush will become easier to control, and good results will come more easily. Air-brushing isn't that difficult if you are able to control the airbrush, along with the other mediums needed to finish the work properly. You're sure to fall in love with the speed and smoothness of the airbrush.

The Limitations of Airbrushing

Airbrushing is excellent for covering and density purposes, but other changes, such as color and detail, often must be added over it. And the airbrush isn't the best choice for correcting small areas or facial features, which can be handled more easily with other mediums. In facial areas, airbrushing creates a surface that is too smooth and artificial-looking.

Airbrushed corrections have their own unique look, and they are usually distinguishable. As always, in competition, the judges frown on airbrushing that is obvious. If a competition print must be airbrushed, have a reputable artist do it to ensure the highest quality possible. Many beautiful photographs have received low scores from jurors because the artwork was noticed.

Materials and Equipment

In addition to the paints used, airbrushing also requires more complicated and expensive equipment than some of the other retouching techniques. Select your tools and materials carefully to get the most from your investment.

Airbrush. There are many types and brands of airbrushes available on the market, but many of these are for hobbyists and aren't suitable for professional retouching. A quality airbrush is necessary for good results. My personal preference is the Badger

The Badger 100XF airbrush is easy to handle and maintain.

Compressors designed especially for airbrushing can be purchased from most dealers and manufacturers of airbrush equipment.

100XF (extra fine). This airbrush gives you a full range of possibilities—from painting a very fine line to covering a large area. Relatively inexpensive and easy to use, it allows maximum control. There are other models and brands which also allow for fine detail.

Air Source. After purchasing an airbrush, your next major consideration is a source of air. Your choice will hinge on three factors: cost, the amount of air required, and the acceptable noise level.

Most airbrush manufacturers and suppliers offer a variety of compressors specifically designed for airbrush

use. If you choose a compressor that is not specifically designed for the airbrush, be sure that the air emitted is nonpulsating. The small, less expensive compressors are fine for most retouchers, although the noise level can be terrible. Silent compressors are more expensive. If you expect to do a great deal of airbrushing, the silence can be well worth the cost. Larger compressors are also available which will handle several airbrushes at one time. Perhaps the biggest problem that artists have with compressors is that of moisture control. Moisture can build up in the air hose and unexpectedly spurt out onto your work. Moisture filters can be installed, in the hose, but it still must be checked frequently.

A popular source of air for many artists is the CO_2 tank, which is silent and provides clean, dry air in a nonpulsating stream. A regulator is required with the CO_2 tank, as air pressure should be kept between 20 and 30 lb. The biggest disadvantage of the CO_2 tank is that it needs to be refilled regularly. It is heavy and cumbersome if you have to take it out for refilling, and it always seems to run out right in the middle of a project, necessitating an extra backup. I originally used the CO_2 tank and had a fire-extinguisher company come to my home regularly to refill it. But as the demand for my airbrushing increased, my three-times-a-year fill-up changed to a weekly one, and this source of air was no longer economical. However, even though I have made the change to a compressor, the CO_2 tank is still my preference.

Airbrushing Paint. There are several different airbrushing mediums available. The opaque paints, which offer excellent covering quality, are preferable for photographic work.

Badger Air-Opaque is available in a ready-to-use liquid form in a wide range of colors. This medium is excellent for its quick coverage. The medium adheres well to the photographic emulsion, yet it washes off easily with water as long as the washing is done shortly after application. Immediate washing keeps the edges smooth, whereas washing after the paint has been allowed to set for several hours will result in rough, jagged edges. The greatest problem I have had with this medium is in using it on lacquered surfaces. It adheres so well to lacquer, that the only way to clean the area completely is with the special Badger Airbrush Cleaner. This cleaner makes washing the lacquered surface easy, and it also works well for cleaning paint from the airbrush when you run it through the machine. However, this opaque cleaner can be harmful and should never come into contact with the raw print. The chemical reaction will break through the cyan layer, causing it to turn orange. Unless a photograph's surface is sealed off completely with lacquer, don't use this medium on it.

Windsor & Newton Designer's Gouache, which is also used for opaquing, can be thinned down considerably with water and used for airbrushing. Colors can be premixed and kept available for use in plastic bottles. For airbrushing the gouache should be thinned to a consistency close to that of cream. If it is thinned too much, it will tend to bead up on the photograph's surface. If it is too thick, it will clog the airbrush.

When you purchase tubes of designer's gouache, notice that there is a permanence rating on the back of each tube. You'll have no problem with those rated A or AA. But the colors with B and C ratings, which are the more intense colors, are likely to penetrate the emulsion of the paper, permanently staining it. If they are applied over lacquer, they will stain it also. If it becomes necessary to use one of these colors, be sure to apply it the way you want it on the first try, so that no washing will be needed. Avoid using these colors whenever possible. With the exception of these few difficult colors, gouache is the easiest medium to wash from both the emulsion and a lacquered surface. It comes off easily with plain water.

Gouache doesn't cover as quickly as the other mediums, and it is usually not the best choice for covering an area with strong contrast. I usually use the other mediums on raw emulsion and confine the gouache to my work on lacquered surfaces.

Shivair Airbrush Color has properties that place it somewhere between designer's gouache and the Badger airbrush paint. It offers good covering quality and, for the most part, it washes easily from both lacquered and unlacquered surfaces. Like the Badger Air-Opaque, it sometimes leaves a rough edge if it is allowed to sit for a while before washing. I occasionally have a little trouble washing it from a lacquered surface, but usually it works just fine. There seems to be a connection between the darkness or lightness of a shade and the difficulty with which it is removed. There is also a definite link between ease of washing and the evenness of the lacquer. If the lacquer has built up so much that it is rough, the paint will adhere to it and will not come out.

Getting to Know Your Airbrush

The first thing to do when you bring your new airbrush home is to familiarize yourself with it thoroughly. Take it apart very slowly, paying attention to how it came apart and in what order the pieces were attached. When removing the needle, be very careful with the point. It is fragile and easily bent. Put the airbrush back together. Practice doing this over and over until it comes naturally. Reinserting the back lever can be a difficult endeavor, but I have found a method that makes it a little easier: Balance the lever on a toothpick and carefully feed it through the back. When it is in place, pull the front lever back to hold it securely. Continue to hold the back lever in place, withdraw the toothpick, and screw in the tube shank, fully assembled. The spring action of the tube shank will then exert pressure on the back lever, and you can release your hold on the front lever.

Taking the airbrush apart and cleaning it thoroughly should be a regular ritual. Paint can build up inside the airbrush rather quickly, creating numerous problems. It should be thoroughly soaked and scrubbed in water at least once a week. Clear water or special opaque cleaner, depending on the type of paint you use, should be run through the airbrush after each use.

I also keep a supply of extra parts available for quick changes. The following list describes the parts that must be replaced frequently, as well as the problems that can occur with them.

Airbrush Tip. The needle is seated in this piece. If air begins bubbling back into the cup or the airbrush is spitting, check this part. If it has become partially unscrewed, a quick tightening may be all that is needed. If the flow of paint spray can't be shut off, it means the needle isn't seated properly.

The tip could be clogged with dry, gummy paint which, if forced through the opening of the tip, could cause the end of the tip to split. This problem can be avoided by cleaning the inside of the tip regularly with a three-sided reamer (available from your airbrush supplier). Once it has split, the tip must be replaced, or it will create a horrible spitting problem. The tip is screwed on and off with the three-sided reamer. When replacing a tip, lightly coat the threads with a small amount of beeswax, and heat the tip briefly over an open flame before screwing it in. Failure to do this will cause an intermittent spray.

Needle. The needle is removed often, and it is very easily bent. Even the slightest hook or bend on the tip will cause spitting or will divert the paint to one side. I sharpen my needles regularly on a knife-sharpening stone to prolong their life. Even with this kind of care, needles soon lose their long, tapered effect and have to be replaced.

Color Cup. It's always nice to have extra color cups so that you can change colors quickly without going through the clean-out ritual each time. Also available are jars that fit directly into the airbrush, and I keep several of these on hand, filled with frequently-used colors. If dried particles get into the bottom of the cup, it will stop up. No paint will be emitted, and bubbles may come up through the cup. This will necessitate taking the cup apart, letting it soak, and then cleaning it out thoroughly. It is sometimes difficult to get the blockage out of the small chambers, but a sewing needle can be used to force the paint residue through. Because the cup is put on and taken off so often, its stem becomes weak and can snap off eventually. This is when the cup must be replaced.

Spray Regulator. This item doesn't have to be replaced regularly, but it receives so much wear that I do it for good measure. Paint tends to build up on it quite often, and it has to be scraped off. This buildup will result in some spitting if it is not watched carefully. If the color cup becomes stopped up, the regulator can be turned out. This will force air up through the cup, and often it can dislodge the stoppage. If air is bub-

bling up through the cup, tightening the regulator could correct the problem. If the flow of spray is restricted, this could be caused by the regulator being screwed on too tightly.

How the Airbrush Works

Before attempting to use your airbrush on an actual photograph, you should experiment with it and familiarize yourself with how it works. Learn which methods produce which results.

The trigger in the Badger 100XF (and in most airbrushes of this type) is a double-action trigger. When it is depressed, air is emitted. More pressure releases more air. When the trigger is pulled back, paint is emitted. The farther back it is pulled, the more paint is released. Smooth airbrushing requires coordination of these two actions. The proper combination will come more naturally with a little practice.

Because the airbrush emits a cone-shaped spray of paint, the amount of space between particles of fluid increases in direct proportion to the nozzle's distance from the paper. Given the same amount of paint being sprayed from the nozzle, the broader the area covered, the more sparse the coverage.

To achieve uniform paint buildup, hold the airbrush at the same distance from the photograph throughout the sweeping motion. Air should be released first, and then the trigger should be pulled back very gradually to release the paint into the air stream. Many beginners tend to push the trigger down and back completely,

TIP

NEEDLE

COLOR CUP

SPRAY REGULATOR

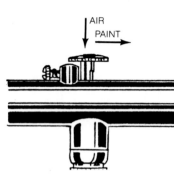
AIR
PAINT

The double-action airbrush trigger performs two functions: depress it to release air, pull back to release paint.

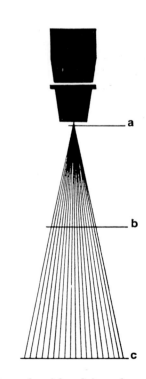
a
b
c

The closer the airbrush is to the surface being sprayed, the narrower the area covered and the more concentrated the paint. The farther away it is held, the larger the area covered and the lighter the coverage.

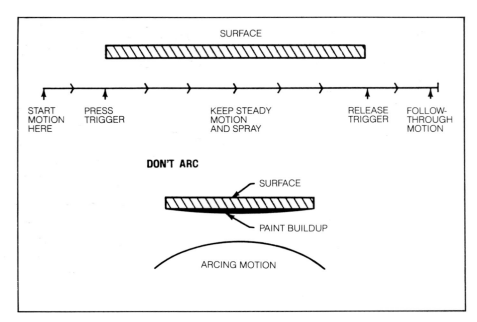

You'll achieve the best results with the airbrush if you use a steady, constant motion. Start the motion before the trigger, and follow through after releasing it. Spraying in an arcing motion causes the paint finish to build up unevenly.

Just for Practice

Practice making a tic-tac-toe diagram with a dot in the center of each square. This exercise is a good way to learn to control the airbrush. You should practice it until you are completely comfortable with it.

Avoid These Common Airbrushing Problems

"Centipedes" are caused by spraying too much paint too close to the surface. Try using less air and pulling the trigger back gradually, until paint begins to be released; then hold it at that point. When there are dark spots at the beginning or end of a line, you are probably hesitating in those areas, caus-

ing the paint to build up. Try to keep your hand in motion when you spray. Splattering is usually caused by allowing the trigger to snap back into place. It also can be caused by dried paint on the needle or tip, or by paint that is too thick and needs to be thinned down with more water.

releasing both too much air and paint, and to sweep the area in an arcing motion. This results in a curved line with uneven paint buildup on the surface. The motion should be a smooth one, without abrupt starts and stops. End the motion as gradually as you begin it. Releasing the trigger suddenly and allowing it to snap back to the forward position will cause spitting.

Compensating for Overspray

Overspray, excess pigment that sprays into other areas of a photograph, is one of the most difficult airbrushing problems to deal with, as removing it can often damage other artwork beneath it. Whenever possible, I do my airbrushing on the raw emulsion, even before spotting is done. This allows for not only the best paint adhesion but also the easiest removal of overspray.

When airbrushing on a lacquered surface, you can take special precautions to ensure the least amount of overspray. Shields and friskets can be used to guide the paint into the desired areas and protect those that need to remain clean.

Friskets are masking materials that adhere directly to the surface of the photograph, completely sealing off areas that must be protected from overspray. Shields are hand-held cutouts, which are placed over areas of the photograph to catch the overspray.

Friskets and shields that are flush to the surface create very clean, distinct edges. Holding the shields up and off the print softens the edges. Sharp edges are often desirable in commercial photography, but in portrait work, they can give the subject an undesirable cut-out look. In these cases, the softer method works best.

There are several different types of stick-on and liquid friskets for airbrushing on the market. I haven't had good luck with these, and I don't use them. The stick-on friskets must be cut out with an X-Acto knife after they have been applied to the photograph. It is very easy to cut too deep and nick the emulsion, and the damage is difficult to correct. When you use liquid masks, you never know exactly what chemicals are in them or how they will react to the photographic surface. I had a bad experience with one of these, even though its

label specifically stated that it was for photographic use. I used it above a coat of lacquer as an added safety precaution, but it stained right through the lacquer and down to the emulsion, causing it to turn orange. This was a competition print, and ruining it was quite distressing. Now I stick with my tried and proven methods.

When I need a liquid frisket, I use rubber cement, but I never apply it to the raw emulsion. Rubber cement has a warning on its label that it may discolor photographs. I take the manufacturers at their word and apply it only to a thoroughly lacquered print.

Hand-held shields are used most often to produce softer edges on portraits. Shields can be made from any material. I am constantly collecting whatever small objects I happen across that have different curves or edges. One of the most unique I have found is the perforated insert from a box of tissues. This perforation creates a very soft edge, and it is great for working around frizzy hair-dos. Because it is cardboard, this shield doesn't last long, but I go through a lot of tissues and can keep extras on hand. Shields made from sheet film can be cleaned and will last forever.

If an extra scrap print is available, you can made an exact cutout of the subject. This is nice when it's possible, as it makes the airbrushing process smoother and faster.

When a shield is held flush with the surface, it creates a clean, distinct edge. Holding it up and off the surface creates a softer edge.

How to Use Rubber Cement as a Liquid Frisket

Step 1. On a print that has been given a thorough coat of lacquer, brush rubber cement over the area to be masked. Thick, heavy coverage will provide the best protection. Take care not to get cement into the outside areas. However, it should be flush with the edge of the background, in as smooth a line as possible.

Step 2. Once the subject has been protected with the rubber cement, you can airbrush right over it without worrying about overspray.

Step 3. When the airbrushing has dried, the rubber cement will pull off easily. Only a minimum of washing and cleaning up the edges is required. After cleanup, seal the airbrushing with several light coats of lacquer. (A heavy coat would cause the airbrush work to crack.) Once the airbrushing is sealed, the photograph can be handled safely and further artwork can be done.

Demonstration 22
Removing Figures and Backgrounds with the Airbrush

This photograph is of a couple, and a portrait of the man alone has been requested. To do this, a new print is made and then cropped so that he is in the center. Airbrushing will be done directly on the unlacquered emulsion to remove the other figure as well as distracting background clutter.

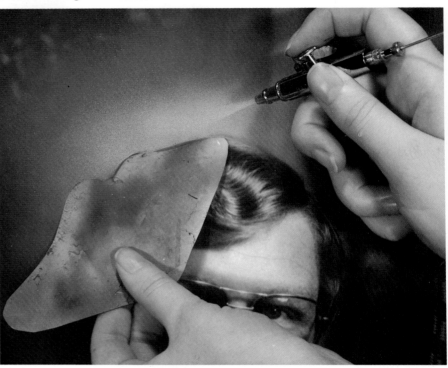

Step 1. *Using a hand-held shield, apply the paint in an outward direction, away from the subject. The spray should begin on the shield and phase out toward the outer edges of the photograph.*

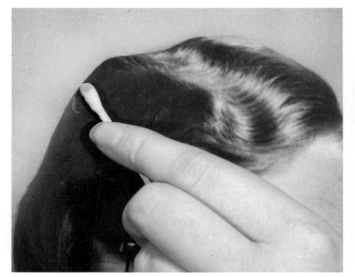

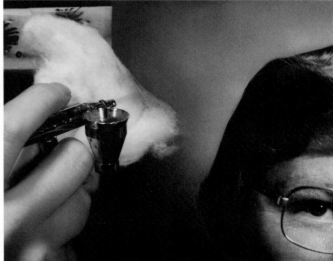

Step 2. *Before the edges become lost, stop and clean them off with a wet Q-tip. Washing should be done slowly and meticulously. An unfortunate swipe into the airbrushed background would be difficult to correct. Wash in a small, circular motion, and keep the edges as smooth as possible. Because the shield prevented most of the spray from getting into the hair, there should not be too much paint to remove, and the separation line won't be too sharp. If it is, it can be softened later with a little pencil. If you got carried away with the airbrush and the edges have been obliterated, you can see them better by placing the print over a light source. With the light showing through the back of the print, the edges can be defined easily.*

Step 3. *Continue airbrushing the background and cleaning up the edges until you've achieved the results you want. Work your way to the edges of the photograph gradually, changing to a darker shade at the outer edges to create a "burned-in" effect. Small bursts of subtle color can be added to the background by using a cotton shield, which creates an extremely soft, erratic edge. (Cotton shields also work well for airbrushing clouds into a sky.) When the background is completely airbrushed and all the edges have been cleaned up, seal your work thoroughly with several coats of lacquer. A complete seal is especially important if other areas of the print are to be airbrushed also, as overspray could get into your completed background.*

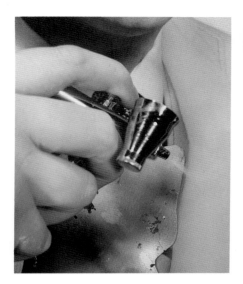

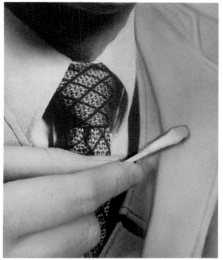

Step 4. *Now go on to other areas that need work with the airbrush. Clothing can be a bit more difficult than backgrounds, and for that reason my goal with the airbrush is not perfection but covering the area with paint of the appropriate density. Begin with a gray that is closest in density to the surrounding area. A little color can be mixed with the gray, but I rarely worry about color at this point. If the density is correct, the color can be adjusted with pastels later.*

As you spray, use a shield to protect areas where you don't want overspray. When the density is a reasonable match and the surface is smooth, stop. Wash off any overspray, and even though the area may not be the right color, seal your work with lacquer. You may notice that the lacquer causes your airbrushed colors to deepen a little.

Step 5. *Next, choose the correct color of pastel and apply it to the airbrushed clothing. Alternating pastels and oils at this stage will help to build the contrast gradually, and it will bring out the desired depths and form. Coats of lacquer must be applied and allowed to dry between applications of color.*

Step 6. *As your correction progresses, you can bring out sharp detail with pencil.*

After Airbrushing. *Your finished photograph should have artwork that blends well and isn't terribly noticeable—at least to the average lay person. If you can fool a photographer, you should feel very proud of your work, indeed.*

Memories Forever

Yesterday. she came walking through my door.
She took out a photograph. all weathered and worn.
Her fingers trembled. as she handed it to me.
The print was precious. it was easy to see.
Through the tears in her eyes. the sadness shown
As she said "This was my son. who is now gone.
He was in the war. and it took his life.
He left behind a young child and a wife.
Is there any way that you can see
To correct the damage. and return it to me?"
As I took the photograph from her hand
I could feel her grief. and understand
The surface was worn. and stained with her tears.
"I can fix it." I said "It will last for years."

Today. she came walking through my door.
She took out a photograph. terribly torn.
Her fingers trembled. as she handed it to me.
The print was special. it was easy to see.
"This was my father. who died in the war.
My young daughter found it. and now it is torn.
This print was a gift from my grandmother.
Is there a way to fix it. and make another?"
As I lay the pieces into their proper place.
I suddenly recognized a familiar face.
The image the same. the surface now torn.
That first photograph. I'd done years before.
As my mind drifted back to that mothers' tears.
"I can fix it." I said "It will last for years."

Tomorrow. I'm sure many more will come.
Bringing their photographs of the old and the young
Willing to spend their very last dime.
Attempting to save that one moment in time.
With their sighs of relief. they'll be so glad
That I can fix them. after being damaged so bad.
Sharing with me. their special memories.
I will listen intently. because I'm so pleased
To know that my work will be treasured for years.
It will bring joy. and sometimes bring tears.
The daily routine quickly becomes worthwhile
When I see on my customers. a beautiful smile.
Retire? I know that I could never
Stop trying to preserve memories forever.

JM - '86

Chapter Fourteen

Restoring Old Prints

Retouching is always sentimental work because you are enhancing prints that will be treasured for years. But restoring old photographs is the most personal retouching work of all. Each photograph contains its own history, and customers are always delighted to share it with someone who is truly interested.

Old family photographs are considered priceless treasures by their owners. People bring them to the restorer, wrapped in old, musty-smelling newspapers, and are frightened to entrust them to another person. These photographs are often so fragile that the slightest bump could create a crack.

There is no doubt that restorations are a challenge. This type of work never gets boring because no two restorations are alike. I recommend that beginners practice and become capable before offering this service to their customers. Restoration work draws a premium price, and there is a big demand for competent artists in this field. If you have the talent and the desire to do it, there will be no lack of work.

Establishing Realistic Expectations

Always handle an original photograph with the utmost care. Let your customer know that you also appreciate its sentimental value. Assure the person that you'll handle it with the greatest care, but don't promise the moon. Eventually, one of these pictures is likely to be damaged, no matter how careful you are. Don't guarantee that this won't happen—just assure the customer you'll do everything possible to avoid damage. Some studios require that customers sign a release exempting them in case of an accident.

Artwork is never applied to an original photograph. No matter how tempting it may be, don't touch it. The original should be returned to the customer in the same condition as when it was first brought in.

Explain the procedure to your customers, and keep them involved in the project. They should understand that a copy negative is taken, and a work print and reference print are made before the picture ever reaches the artist, and that a final copy negative of the artwork is made before the final print is made. When people realize this, they will have a better understanding of the amount of time restoration work often takes. When you restore a picture that is in extremely bad condition, it's a good idea to have the customer come in and approve the artwork before the final copy negative is taken. This will eliminate extra expense if additional work is requested. Customers expect a lot from the restorer, and they are usually willing to pay well to have it done correctly.

When a photograph requires extreme corrections, it is important that the customer's expectations not be too high. When backgrounds are extended, missing limbs added, clothing finished, and major facial work done, all these corrections run the risk of looking a bit artificial in the final print. Your customer should be made to understand that these things are actually painted onto the photograph, and as such, will look more like artwork than photography. Explain that you'll blend in the corrections as much as possible, but that such work is usually noticeable. If people's expectations are sensibly lowered a little, they are often pleasantly surprised to see how close to reality the artwork actually does come.

The retouch artist is rarely the one who communicates directly with the customer. If the work is assigned to you by a photographer or by lab personnel, be sure these people understand your limitations. If a certain correction gives you trouble, explain this to them, and explain why. If a similar circumstance arises again later, they will know which are the problem areas and which are not.

I never refuse a restoration job, even though some of the photographs are in such bad repair that I cringe. I do, however, place a higher price tag on extremely difficult orders, and I insist on payment regardless of results. I let the customer know unmistakably that I will do my best, but that when features must be guessed at, there is no guarantee that what I picture in my mind will be the same image the customer has visualized. If the customer is willing to trust my judgment, I will do the job. If another picture of the same person is available, I will try to match the features, but I won't try to satisfy ridiculous demands. I once accepted a restoration job with three reference prints. The customer wanted "dad's eyes, brother's nose, and daughter's mouth." Needless to say, I have learned the hard way when to draw the line. You can spend the rest of your life on such projects and still never achieve what the customer wants.

The Work Print

The size of your work print should be dependent on the size of the final print. As a general rule, an 8 × 10 work print is the best size for any photograph whose final print size will be 11 × 14 or less. If the final print will be 16 × 20 or larger, you should

have an 11 × 14 work print. This is because the image on an 8 × 10 work print begins to weaken and look grainy when it is enlarged to 16 × 20 or larger. Anytime the work print is enlarged, your artwork is enlarged also, and obvious artwork will look even more obvious. If the final print is going to be larger than your work print, take extra care to keep the artwork smooth. The opposite situation can work to the artist's advantage, however. When the final print is going to be smaller than the work print, the reduction will make artwork less obvious. An 11 × 14 work print, of course, takes more time to restore than an 8 × 10, and the work should be priced accordingly.

The finished work print should never be given to the customer because it will have such a buildup of paint and lacquer that it can't be considered permanent. These prints tend to yellow quickly, and they become brittle. When the final copy negative is made, the artwork is safely preserved forever.

Materials and Equipment

Each chapter in this book lists specific art materials and tools needed for a particular type of retouching technique. However, it is not really possible to go into such detail in this chapter on restoration, which requires a combination of all the materials, paraphernalia, and techniques explained previously. Each restoration job is unique. One assignment may be so drastically different from the next that it requires completely different materials.

By now you'll be familiar with the various retouching procedures and the specific materials they require. But don't hesitate to refresh your memory by reviewing the appropriate chapters before attempting to solve a particular restoration problem.

Generally speaking, restorations of fine flaws and relatively small damaged areas can usually be handled with the basic mediums discussed in Part Two. Whenever feasible, try to avoid airbrushing, as this medium, more than any other, tends to make corrections look artificial.

In restorations that require larger overall corrections, it's not always possible to avoid using the airbrush. The smoothing and covering qualities of the airbrush become a must. Although it is feasible to use oils instead of the airbrush, the amount of time involved could become astronomical. Even with the airbrush, such a major restoration takes a great deal of time. Sometimes the amount of time involved reaches a point where it is no longer feasible to charge the customer a premium hourly rate. When this happens, you may need to set a maximum fee and spend more time restoring the print than you can reasonably charge for.

Demonstration 23
Restoring Fine Cracks in an Old Snapshot

Brittle old black-and-white snapshots may develop tears or cracks in the emulsion which allow the white paper to show through. These are not difficult to correct on a work print, using the retouching mediums discussed in Part Two.

Step 1. Adding density to small areas should be the first phase of restoration. This can be done in the darker areas by applying spotting dyes to the raw emulsion, or by using graphite or wax-based pencils after the print has been sprayed with retouch lacquer.

Step 2. On the lacquered print, dark flaws should be lightened with wax-based pencils or opaques.

Step 3. Finally, larger areas that lack contrast can be brightened with a little oil. The finished work should be sealed with a protective coat of lacquer, and then the copy negative and final print can be made.

132

Demonstration 24
Making Major Restorations

To make extensive restorations in a very old photograph, you follow the usual procedures for making a work print. Then you plan the steps that are needed to restore the image.

Step 1. *Begin as usual with small areas that are too light, and add density with graphite or wax-based pencils over a coat of retouch lacquer. Because the background is so damaged it will require airbrushing, there is no point in making small corrections there.*

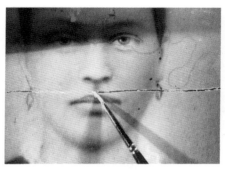

Step 2. *Next, small areas that are too dark should be lightened. Wax pencils work fine for most dark spots and lines, but those that are extremely dark and in high contrast to the surrounding area should be covered with white opaque paint.*

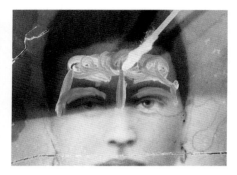

Step 3. *Larger dark areas in the face or clothing should be lightened with oils. This kind of correction may require numerous coats of retouch lacquer and oil.*

Step 4. *As the oil gradually builds, the corrected area will take on a blue tint. Don't concern yourself with this. When the print is copied, any discoloration will disappear. A smooth, even match in density should be your goal.*

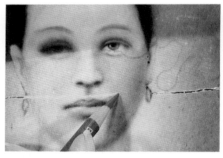

Step 5. *Work over the entire print with each fresh coat of retouch lacquer. By the time the larger areas have been built up satisfactorily, the smaller corrections will be nearing completion also. Continue to apply coats of oil over the larger area until the difference in density is very slight. Your perseverance will pay off.*

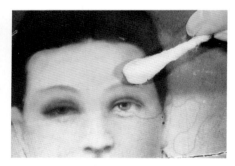

Step 6. *When the density is very close to being the same, you can bring out some contouring with pastels. After all, a flat white forehead is not much better than the all-dark forehead was. It must have some shading to give it depth and make it look realistic.*

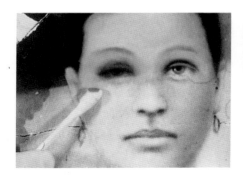

Step 7. *Adding a slightly darker value of pastel directly under the separation line will help pull the two areas together.*

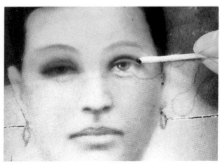

Step 8. *Dark pastels can be used softly to bring out depth and contrast in the facial features.*

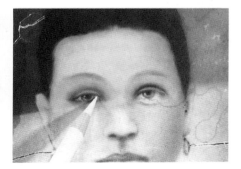

Step 9. *A light wax-based pencil can be used to lighten small dark areas and to clarify detail. With the light pencil, smooth and blend the separation line between the restored area and the rest of the face.*

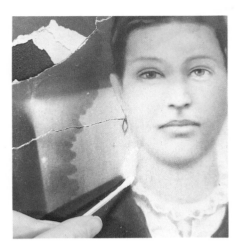

Step 11. *A combination of light and dark oils can help to produce a striking contrast in the clothing and give it the depth it needs.*

Step 10. *Use oil to add soft highlights, which are needed to enhance the hair and clothing, as well as to bring out detail that may have been missing in the original photograph.*

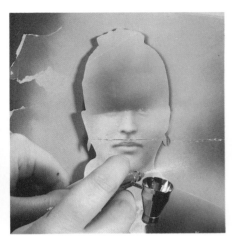

Step 12. *When your restoration of the subject has reached a somewhat satisfactory stage, you are ready to use the airbrush to smooth out not only the background but also the areas already worked. Using a duplicate print to make a cutout shield of the subject will make the airbrushing go quickly.*

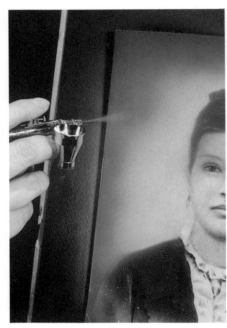

Step 13. *A combination of light and dark grays in the background will produce a soft, blended effect. Avoid using the warm grays, however, as they'll change color and darken when lacquer is applied over them. Just use the cold grays, and ignore the bluish tint for now.*

Step 14. *If the facial area isn't as smooth and bright as you want it, give the brightest areas a small amount of airbrushing with white opaque. Avoid going overboard, and don't attempt to wash the overspray off the features. This will only give them an artificial, pasted-on look. They can be brought back out later.*

Step 15. *Vignetting with the airbrush in the clothing areas can be a special problem because the paint must gradate into details of the clothing without obliterating them. It helps to pull the airbrush farther away from the surface as you move it into the clothing.*

I lacquer thoroughly before vignetting, so that mistakes can be removed without disturbing any of my previous work. I often do the vignette in two steps, separated by a coat of lacquer: one light pass that blends into the clothing area, and a heavier one for better coverage at the bottom.

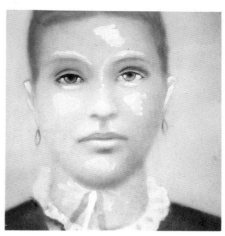

Step 17. *Repeating the last step with dark pastels, and then bringing out highlights again with white oil, will gradually bring back depth in the face.*

Step 16. *After the airbrushing has been completed and sealed in, detail that has been softened by overspray can be darkened with pastels, and with pencil in the smaller areas. The overspray has evened out tones considerably; all that is lacking now is contrast.*

Step 18. *The sharpness of the photograph at this stage will depend somewhat on whether the edges were washed during airbrushing or saved for this step. When edges must be washed in a photograph that is already a little soft, they take on a cut-out look. Darkening and blending these edges with pastels will restore their natural softness.*

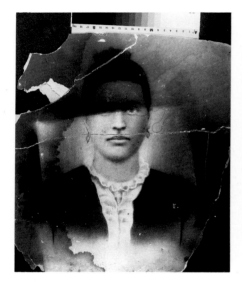

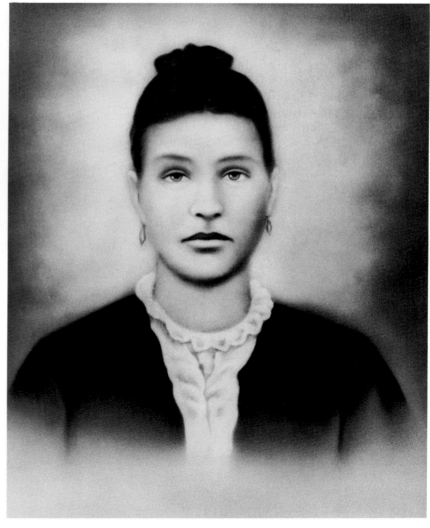

After Restoration. *Although this restoration was a tedious and lengthy process, it is rewarding to see what has been accomplished. A comparison of the portrait before and after restoration reveals amazing changes. When the work print is copied, the customer will have the artwork preserved forever on the copy negative, and good prints of any size and quantity can be made from it. The final print will look much nicer than the work print because the differences in color temperature will have evened out.*

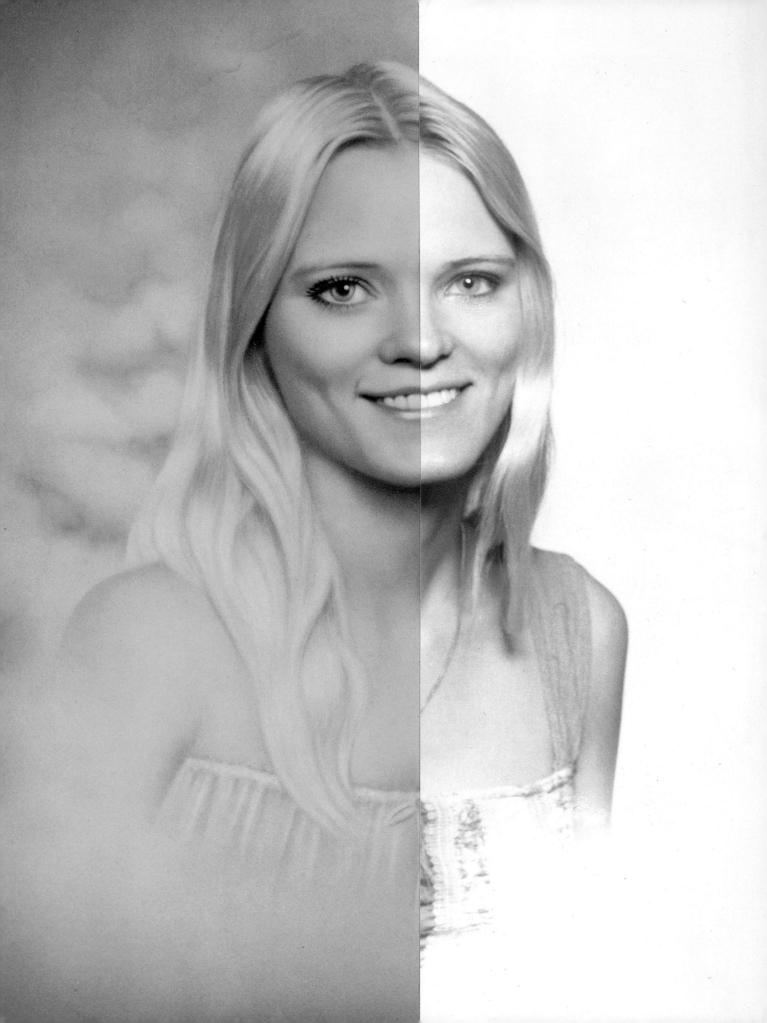

Chapter Fifteen

Adding Color to Black-and-White Prints

Before the evolution of color photography, adding color to black-and-white prints was considered a necessity. It was the only way the photographer could reach toward realistic color. Now photographers are reaching back to the past, for inspiration, and coloring black-and-white photographs is again becoming a trend.

The limitations of this art form depend on the results you wish to achieve. Color that looks as natural as you'll find it in color photography is not very feasible. Coloring in photographs usually gives them a painted look, and it is obvious that color has been added.

It isn't unusual to see color-ins that are messy because a color hasn't been kept confined and has bled into another. This is usually caused by impatience. If you take the time to be meticulous, the results can be very rewarding. Hand-coloring a black-and-white print, perhaps more than any other retouching method, allows you to make a drastic difference in the photograph and gives you a real feeling of accomplishment.

This chapter will discuss three methods for adding color to black-and-white prints: using light oils, which are hardly more than a light tint; applying heavy oils for an effect similar to oil painting; and mixed media, which can be used with restraint or carried to extremes.

Light Oil

Light oils are the most popular medium for adding color, and they are usually applied to a print that has been brown-toned. This is because beginning with a warm tone makes it easier to achieve the flesh color. The usual black-and-white print has a cold tone overall, and much more work is required to counteract this.

The technique for using light oils is little more than a wipe-on, wipe-off method. Your expertise comes into play when layers of color are built up between coats of lacquer. The lacquer preserves the previous coat of color, permitting you to rework an area without disturbing the artwork already applied. This allows for depth and shading.

Heavy Oil

Using heavy oils is basically a matter of brush-painting over the entire photograph with them, literally recreating the image in oils. This procedure requires that you allow time for the print to dry between coats, and that you be familiar with oil painting techniques.

An effect that combines heavy and light oils can be achieved by going over an application of light oils with heavy brush strokes in pertinent areas, or by applying a brush-stroke lacquer texture over the finished print.

Mixed Media

The technique of coloring photographs with mixed media is more or less my own thing. I don't know of other artists who utilize this method. Although the colors I achieve tend to be softer and not as intense as those created with the oils, this is still the technique I prefer.

When I began to attempt working with light oils, I found myself struggling with the medium. I couldn't seem to control it as well as the other mediums, and I was constantly thinking, "This would be faster with dyes," or "better with pencils," or "easier with pastels." Experimentation has brought me to the method I now use, which I prefer to either of the two kinds of oil.

You should adapt the mixed-media method to your individual talents. Those mediums that are easiest for you can be utilized to the fullest extent, whereas the most difficult mediums can easily be replaced by others.

Materials and Equipment

Both the light and heavy oils require the mediums and paraphernalia discussed in Chapter 10. The transparent oils are perfect for light oiling. The opaque oils and oil sticks offer heavier covering capacity, and they are also invaluable for making changes in a photograph.

Extender is used to remove unwanted oil from the print, and it should be wiped down afterward to minimize the chance that residue will be left behind. Extender should be used with each coat, wherever needed, before retouch lacquer is applied.

Mixed-media coloring utilizes a combination of all the mediums and techniques discussed in Part Two. Different materials serve different purposes. Refer to the appropriate chapters for detailed descriptions of the paraphernalia required for each technique.

This antique photograph will be colored by hand using the transparent oil colors that come in tubes. As for all restora- tions, the actual coloring will be done on a work print rather than the original heirloom photograph.

Step 1. *First, prepare a palette with your transparent oils. Because these colors are very concentrated, and are therefore very difficult to distinguish from one another, you should label them on the palette. Beginning with the basic flesh color, dip a cotton swab into the paint. Remember that these colors are strong, and a little will go a long way. Blot the excess paint on a tissue, leaving only a small amount on the cotton swab.*

Step 2. *Now apply the paint to the face, taking care to stay within the confines of the area and applying it sparingly. With a clean Q-tip, wipe down the paint until only a thin film of color is left.*

Step 3. *For adding color to larger, less confined areas, any one of the three types of oil will do. Blue is applied to the background here because it will cool the overall warm brown tone of the print, and combining it with yellow will pro- duce a vibrant green.*

Step 4. *Again, always rub the paint down to a thin finish, taking care to stay within the confines of the area. Larger areas can be blended more quickly and smoothly with your fingers; smaller ones, with a Q-tip.*

Step 5. *A little extender on a clean Q-tip will easily remove oil that has gotten into undesirable areas. The extender should be rubbed down so that a minimum of residue is left behind.*

Step 6. *When one application of color has been completed, spray the print to seal the first coat. Allow the spray to dry completely, and then apply the next coat.*

Step 7. *Color and dimension are devel- oped in the clothing by applying subse- quent coats of oil only in the deep, shad- owed areas, allowing the highlight areas to remain lighter. Several coats of oil, between coats of lacquer, may be needed. Then a little white is added to the highlight areas and blended softly.*

Step 8. *A little black is added to the deepest folds of the dress and to the darkest parts of the rest of the photo- graph. In order to minimize the number of lacquer coats needed, always try to work over the entire print with each coat of spray.*

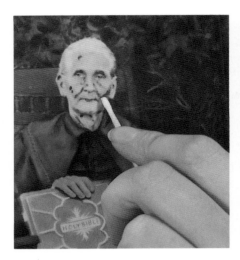

Step 9. *Contrast in the face can be enhanced by blending a little white oil into the highlight areas and then adding a deeper flesh tone in the darker contours. Since warm colors tend to make objects appear closer, making the face the brightest and warmest area of the photograph will help it to command the most attention.*

Step 10. *When the overall color has been developed sufficiently, it is time to work on the fine detail. These areas are usually the brightest and smallest on the print, and are much too small to handle with a Q-tip. For these details, apply oil directly to the print with a fine brush. When the subject's face is relatively small, it's best to avoid heavy brushwork.*

After Hand-Coloring. *Although it is obvious that the color in the retouched photograph is not natural, the overall effect is pleasing. An artist with time to spare could achieve greater brilliance by allowing the oil colors to dry naturally between coats, eliminating the need for retouch lacquer, which tends to have a dulling effect. A comparison of the original print with the finished work shows what you can achieve with hand-coloring. However, it's a good idea to compare the original with your work print throughout the process to ensure that features are not being changed and detail is not lost.*

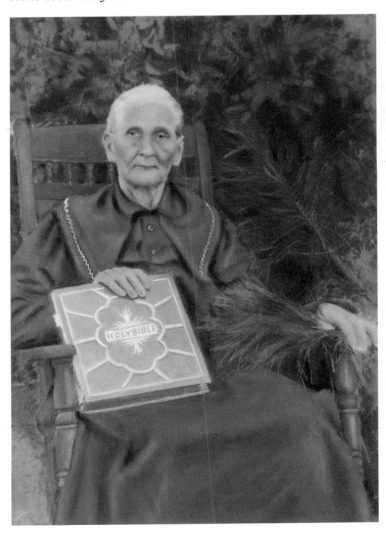

This contemporary portrait will be colored by hand using mixed media. I'll demonstrate my own methods, but you should not consider these set rules. Refine the techniques to suit your own needs.

Step 1. *As is always the rule in color-print work, the spotting dyes are the first step. It is particularly difficult to achieve the right color for blond hair, but wet-brushing a light base coat of dye gives you a beginning foundation.*

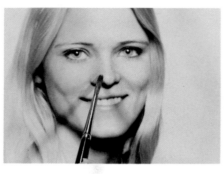

Step 2. *Continuing with the wet-brushing technique, lightly wash a flesh tone over the face. This accomplishes two primary goals: It counteracts the bluish tone of the black-and-white print, and it gives you a base color on which to build.*

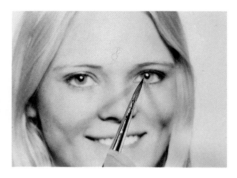

Step 3. *Adding intense color to the eyes and to other small detailed areas such as jewelry is much easier to do at this point, with the spotting dyes, than later on.*

Step 4. *When the spotting has been completed, spray the print with retouch lacquer and begin applying pastels to the deeper tones and to the contoured areas of the face. Pastels are also used at this stage to add soft color to the clothing.*

Step 5. *Pencils can be applied directly over the pastels to strengthen dark, sharp areas that should not be allowed to become too soft. Pencil work in the definition lines of the hair will keep it crisp, and rich color can be added to small areas more precisely with pencil than with oil.*

Step 6. *Lightly dust pastel into the background to provide very soft coloring. When using pastels, don't forget that if a color has gone too far in one direction, it can be counteracted by dusting its opposite over it. If you have gotten pastel into areas where you don't want it, remove it with a wet cotton swab.*

Step 7. *If you want to give the strong highlights bright definition, brush some opaque paint into them.*

Step 8. *After respraying the print, you can apply oils to the soft highlight areas and also blend them into the clothing, using the same technique as for the light oil method. Add density and highlights to bring out contrast.*

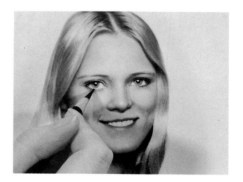

Step 9. *Finally, enhance any detail that may have been subdued during the process of adding pastels or oils.*

After Hand-Coloring. *The finished portrait should have soft, reasonably natural coloring. The different mediums have been used with restraint in this demonstration, but depending on your preferences, you can carry a photograph to whatever extremes you desire with the mixed-media method.*

Appendix

ADAMS RETOUCHING MACHINE CO.
1036 W. 8th Avenue
Denver, CO. 80204
Complete negative retouching needs. Write for literature.

ALBUMS INC.
Box 29724
Dallas, TX 75229
Miscellaneous art-photo needs. McDonald pencils sold individually or by the set. Write for catalogue.

BADGER AIRBRUSH CO.
9128 W. Belmont Ave.
Franklin Park, IL 60131
Complete airbrushing needs. Write for information.

DANIEL SMITH INC.
4130 1st Ave. S.
Seattle, WA 98134
Miscellaneous art supplies: pastels, oils, oilsticks, opaques, Derwent pencils. Write for catalogue.

DONEGAN OPTICAL CO., INC.
1405 Kansas
Kansas City, MO 64127
Opti-visor (head set).

EASTMAN KODAK CO.
Rochester, N.Y. 14650
Liquid retouching colors (negative retouching dyes), dry dyes and many related Kodak products. Write for information.

KEN-KRAFT CO.
P.O. Box 121
San Bruno, CA 94066
Miscellaneous retouching needs. Write for catalogue.

LACQUER-MAT INC.
Box 24
Syracuse NY 13201
Lacquers, pencils, and related products. Write for literature.

McDONALD PHOTO PRODUCTS, INC.
11211 Gemini Lane
Dallas, TX 75229
Lacquers, pencils, and related products. Write for literature.

OPTICAID
Edroy Products Co., Inc.
New York, NY 10001
Clip-on magnifiers.

PHOTOGRAPHERS SPECIALIZED SERVICES
650 Armour Road
Oconomowoc, WI 53066
Photo-oils, McDonald, Sureguard lacquers, McDonald pencil sets, Prismacolor pencil sets, miscellaneous photo-art supplies. Write for catalogue.

RETOUCH METHODS CO. INC.
Chatham, NJ 07928
Retouch Methods spotting dyes. Write for literature.

SUREGUARD INC.
514 Bishop St.
Richardson, TX 75081
Lacquers and related products. Write for literature.

ZONE VI STUDIOS, INC.
Newfane, VT 05345
Electronic static brush. Write for catalogue.

Index